P9-EKY-648

30 OBJECTS
30 INSIGHTS

GARDINER MUSEUM

LIBRARY

NOV 1 8 2014

black dog
publishing
london uk

CONTENTS

30 YEARS, 30 OBJECTS

Objects need narratives to give them meaning; the perception of even the simplest artifact can be transformed by an historical connection or a personal memory. But objects can also give meaning because of the potent association that can be made between an idea and the tangible. The 30 objects in this book, in this way, are simultaneously both rare specimens worth appreciating and a subtle narrative of the remarkable first 30 years of the Gardiner Museum.

George and Helen Gardiner loved ceramics. It was their passion for collecting that eventually outgrew their personal lives to become a public museum. From 1976, when they started collecting ceramics, to 1981, when they decided to share their treasures with the public, George and Helen had assembled several astounding specialized collections in the fields of pottery from the Ancient Americas and European ceramics that would become the core of the Museum when it opened. For instance, in their depth and breadth, the Gardiner's collections of Meissen porcelain, rare Du Paquier porcelain from Vienna (the second factory to successfully produce hard-paste porcelain in Europe) and *Hausmaler* decorated porcelain are of world importance. The Gardiners also established one of the best collections of Italian Renaissance maiolica in Canada, and the most comprehensive collection of figures from the *commedia dell'arte* in a public institution.

The Gardiner Museum of Ceramic Art opened to the public in 1984. Even though their collection moved to a museum, it retained a beguiling idiosyncratic quality as it was their refined collecting interests that shaped it. For instance, a Late Classic Period Maya plate and a Meissen Scowling Harlequin typify both their range of connoisseurship, as well as the personal vision that guided their collecting.

Between 1987 and 1996 the Gardiner Museum was managed by the Royal Ontario Museum, located across the street on Queen's Park Crescent. In 1996, an endowment from George Gardiner supported the Museum becoming an independent institution again.

In January 2004, the Gardiner Museum closed temporarily to implement a major expansion, with funding for this provided primarily by the Government of Canada, the Province of Ontario and Helen Gardiner. Building on the qualities of the original structure, designed by architect Keith Wagland, the architectural firm of Kuwabara Payne McKenna Blumberg added galleries, larger educational, administration and studio space, a new retail shop, and a new café and special events area. During this period, the Museum temporarily relocated to a warehouse at 60 McCaul Street. When the Gardiner Museum re-opened in 2006, the renovation received great acclaim and is often cited as one of the most beautiful buildings in Toronto. This over 1,300 sq. m. of additional space also allowed a broader focus for the Museum, an expanded collections purview, more special exhibitions, and opportunities for greater public participation.

As the Museum grew, sophisticated, dedicated ceramic collectors were attracted to what had become one of the most significant centres of ceramics in North America. For example, The Radlett Collection of Eighteenth-Century English Porcelain is now an important component of the Museum, the 1760 Beer Jug with a portrait of General James Wolfe being one of the best known pieces in this collection. The Robert Murray Bell and Ann Walker Bell Collection of Chinese Blue and White Porcelain is another highlight, including the Qing dynasty *Bianhu* (flask). As well, The Macdonald Collection of Japanese and Japanese-inspired porcelain, including the Kakiemon cup and saucer with the "Lady in a Pavilion", forms a very special aspect of the Museum. It is one of the collections with an intriguing story to tell, particularly one of the connection between the cultures of Japan and Europe in the seventeenth and eighteenth centuries.

The Hans Syz Collection, donated in 1996, is a remarkable assemblage of European porcelain. The Norman and Cecily Bell Collection, donated in 1998, consists predominantly of English transfer-printed wares of unique quality. The Thomas Henry Clark Collection, donated in 1999, comprises important pieces of English and Continental tin-glazed earthenware. In 1991, Helen Armstrong bequeathed the Vernon W. Armstrong Collection of eighteenth-century porcelain. Some of the Gardiner's finest Minton pieces have been donated by Robert and Marian Cumming since 1991. In 2008, Jean and Kenneth Laundy donated a significant collection of eighteenth- and nineteenth-century creamware, and in 2012 and 2013 the Gardiner received outstanding examples of

seventeenth- and eighteenth-century French faience from Pierre and Mariel O'Neill-Karch.

Many others have given exceptional ceramic art to the Museum including Aaron Milrad and Diana Reitberger. One of the recent and transformative donations was The Raphael Yu Collection of Canadian Ceramics, made in 2011, which added 318 objects. The Museum is committed to building the finest collection of Canadian ceramics in the country, as well as ensuring that vital curatorial work about these ceramics is undertaken.

This book features 30 objects that try to reflect the temporal and geographic scope of the collection, as well as diversity of insight about these objects that demonstrates the many ways people love clay. These 30 objects also illustrate the passion that so many have about ceramics, and how their generosity has helped, and continues to build, one of the finest museums of its kind in the world.

The Gardiner Museum is grateful to the following for their support of this book, without which its creation would not have been possible: The Peter and Melanie Munk Charitable Foundation; The Radlett Foundation; The Hannon Family in Memory of Janet Hannon; Richard Rooney & Laura Dinner; The Clarence E. Heller Charitable Foundation; The Macdonald Family Foundation; as well as support from The Ann Walker Bell Fund and The Helen E. Gardiner Fund.

Kelvin Browne
Executive Director and CEO

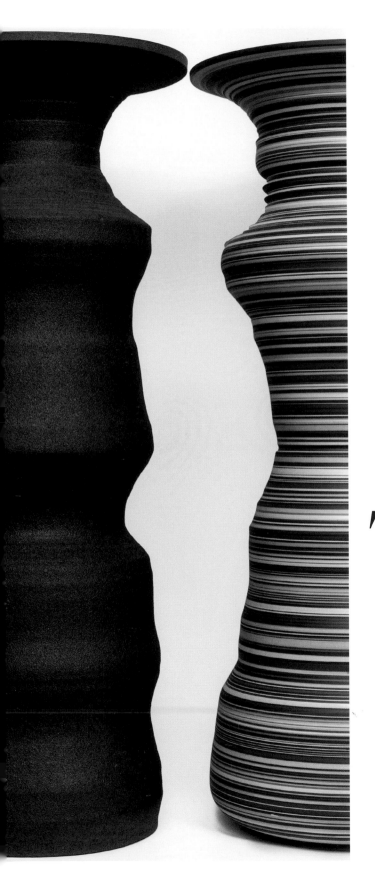

A NOTE FROM THE EDITORS

There are many approaches to writing about ceramics and one of the key objectives of this volume of essays is to celebrate not only the Gardiner Museum's collection on the occasion of its 30th anniversary but also to show the richness and diversity prevalent in current critical writing on historical and contemporary ceramics. We invited artists, collectors, dealers, critics, curators and cultural historians trained in different pedagogies to share their distinct points of view and to provide a variety of narratives to enlighten and complement the Museum's diverse collections. Some authors focus on issues of connoisseurship and making, while others privilege social history and consumption. Objects can also inspire tales that belong to the realms of both fiction and reality. Whatever the methodology, we believe that the authors' perspectives offer important insights on why ceramics matter in everyday life. We thank all the contributors for their lively and inspired insights.

Rachel Gotlieb and Karine Tsoumis

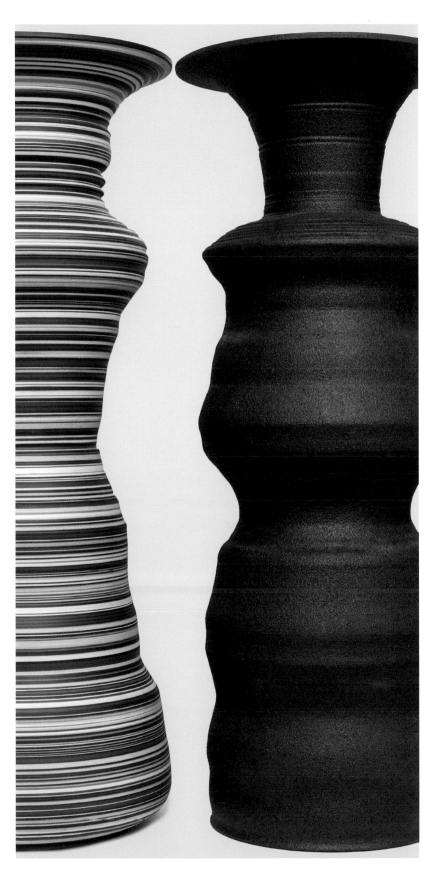

GREG PAYCE (CANADIAN, B. 1956)
APPARENTLY, 1999
Earthenware with glazes • Marks: Signed
"Payce" • Overall: H: 87.6 cm; W: 102.2 cm;
D: 34.3 cm • Purchased with the support of
the Canada Council for the Arts Acquisition
Assistance Program, G04.19.1.1-2; Gift of
the Artist, G05.13.1

A NOTE FROM THE EDITORS

THE ART OF MAYA FEASTING

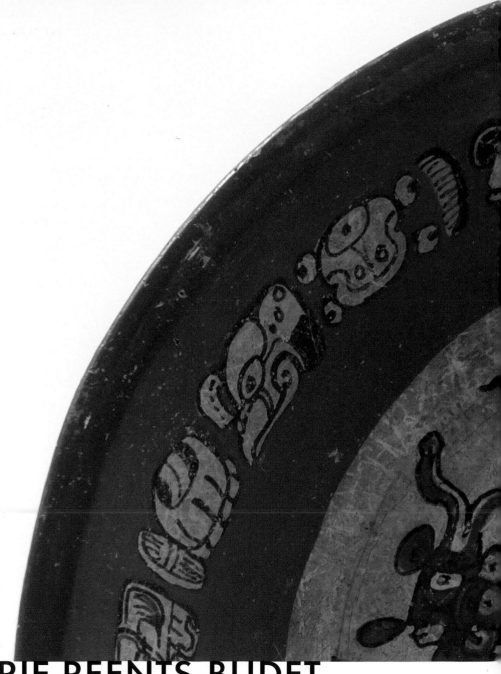

DORIE REENTS-BUDET

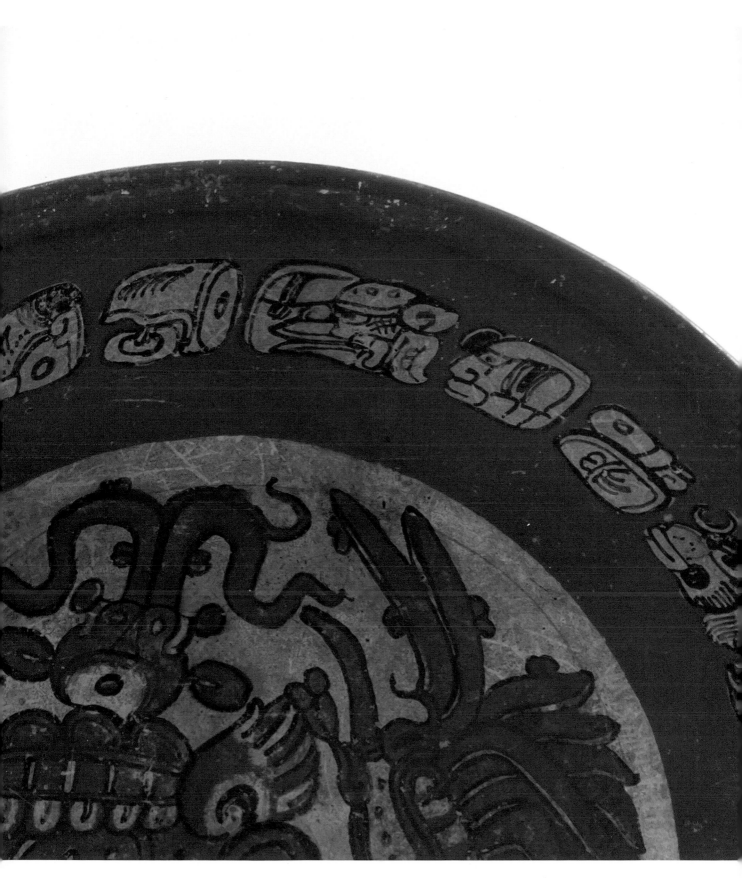

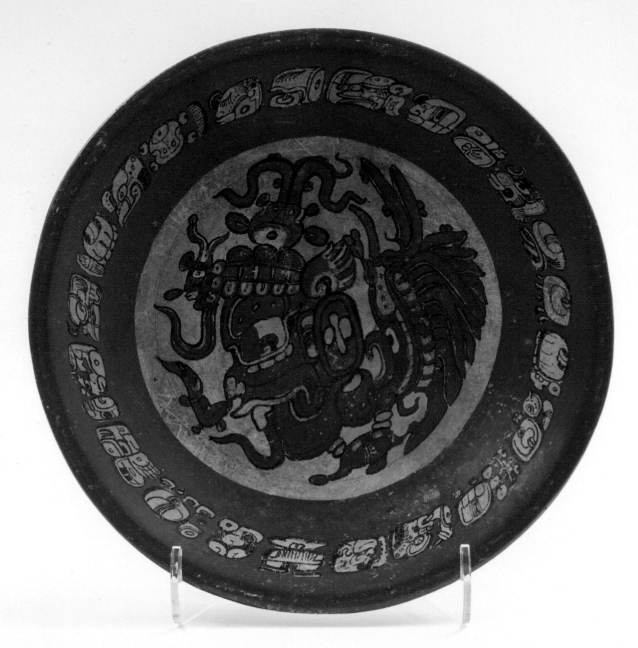

The Classic Period Maya (250–850 CE) created a superb tradition of slip-painted earthenware. The corpus includes cylindrical vases, bowls and plates decorated with hieroglyphic texts and pictorial images, as narrative scenes or iconic motifs, that concern history and religion. Iconic motifs frequently highlight seminal religious and cosmological beliefs at the heart of Maya spirituality and the divine sanction of political power. Palace scenes enliven the now bare stone buildings at archaeological sites, filling them with the requisite furnishings and opulently attired nobility who directed society. The scenes often include representations of painted pottery vessels filled with food, thereby revealing a prime function as service wares among the aristocracy.

This exquisite plate embodies an elegant pictorial tableau blending text and image. It features four embedded circles formed by the plate's rim, the broad red exterior band, the superimposed orange-hued hieroglyphic ring with its precisely delineated edges, and the curved boundary between the broad red band and the yellow-orange field at the plate's centre. This

DORIE REENTS-BUDET

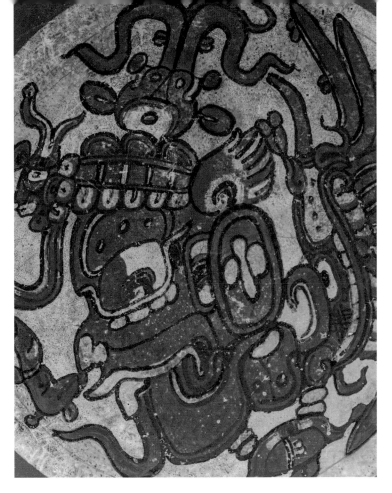

PLATE WITH HIEROGLYPHIC TEXT
Maya culture, Guatemala, Uaxactun area,
Late Classic Period 550–650 CE •
Earthenware with polychrome slips • Marks:
None • H: 5.6 cm; D: 40.6 cm • Gift of
George and Helen Gardiner, G83.1.120

sequence of circles draws the eye into the vessel and fixes attention on the complex symbol ornamenting its nexus. The image is a half-skeletal, half-fleshed version of the Principal Bird Deity (the PBD), a multifaceted being of ancient antiquity among the Maya. This supernatural bird was the avatar of Itzamnaaj (God D), a key god of Creation and the underworld. Here he wears the headband of rulership and an *ajaw*, 'lord', logogram atop his head. The PBD is related to the false sun of the previous era before the creation of humans, and was vanquished by the gods because of his arrogance. In this portrayal, blood gushes from his missing lower jaw which refers to his defeat by the gods as recounted in the *Popol Vuh*, the seventeenth-century K'iche epic that describes the ages of Creation. Perhaps this potent supernatural was an emblem for the plate's original owner/patron.

Yet the question remains why the Maya devoted so much artistic effort to extraordinary paintings on food service wares, especially given the difficulty of painting on small vessels with curved surfaces and the inherent fragility of earthenware, which can be easily damaged during use. The answer lies in the nature of the events and the vessels' functions.

Most were not created as funerary offerings, although many eventually were placed in tombs. Instead, they were made for feasts, especially those with considerable socio-political overtones. Elaborate banquets were held to celebrate life milestones such as marriage, accession to office and war victories. In the broader socio-political arena, feasts reified a community's shared identity and allegiance, and they offered a forum for building coalitions among allies and adversaries alike. During these politically charged gatherings, the prestige of the host and the success of the event were enhanced by the quality of both the food served and the service vessels, some of which were given to the participants as souvenirs of the occasion and a reminder of their obligations. As gifts with politicized overtones, the finesse of the vessels' painting and the contents of the imagery played supportive roles by extolling the stature of the host, honouring the recipient, and alluding to divine endorsement or prominent historical episodes.

A crucial component of prestige was that of painting style. An exclusive artistic style allowed the vessel to be instantly affiliated with its patron, the place where it was created, and sometimes even the painter. In the hands of the receiver, the artwork

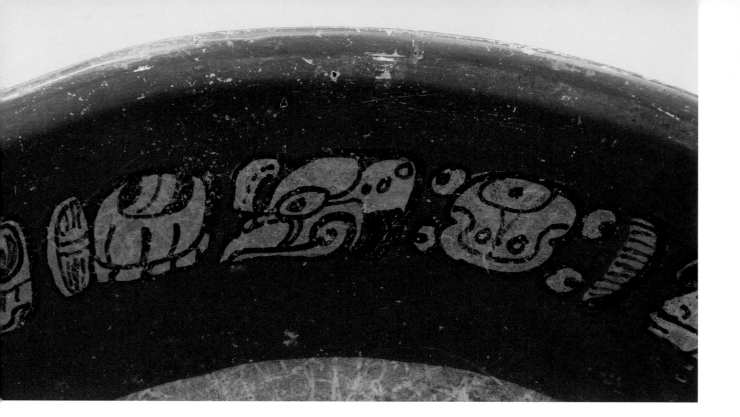

publicized his or her affiliation with the patron, and by association, bestowed the patron's prestige on the new owner. This plate represents a painting style developed during the seventh century in the vicinity of El Zotz', located in Guatemala's Petén lowlands. The location of the pottery style's workshops was first identified by trace elemental analysis of the vessel's ceramic pastes by Dr. Ronald L. Bishop and The Maya Ceramics Project, Smithsonian Institution. The artist who painted this plate was among the very best working in the style somewhere at or near El Zotz'.

The repetitive hieroglyphic text painted on Maya feasting wares confirms their functions. First identified and named by the pre-eminent scholar Michael Coe, the Primary Standard Sequence (PSS) is composed of three parts. The first phrase dedicates the vessel and the second records its contents. This plate is specified for serving white venison tamales (*ta sak chijil waaj we'el*) according to Maya epigrapher Dr. Marc Zender. Venison was, and remains today, an esteemed meat among the Maya. From sixteenth-century Spanish descriptions of venison dishes to Classic Period palace middens (trash deposits) containing sizeable quantities of deer bones and to the remains of a venison stew with *mole* (chocolate-based) sauce discovered in a bowl from Copán, Honduras, deer meat clearly was a prime feasting food.

The final part of the PSS names the vessel's owner, who may have also been its patron. These nominal phrases are especially important because often they identify members of the nobility who otherwise are not recorded in the carved stone hieroglyphic texts which feature the paramount rulers. Without the painted pottery texts, these individuals would be lost to history. The phrases also may specify the person's lineage, political affiliation and even place of origin or residence. The patron/owner of this plate is noted as a ballplayer and a son of the ruler of El Zotz'. Unfortunately, further details of his identity are unknown due to the fragmentary nature of the dynastic history of El Zotz' due, in part, to few surviving stone monuments and poor states of preservation. Yet we may surmise that the plate's owner was not in direct line for the El Zotz' throne because he does not carry the 'divine lord' (*k'uhul ajaw*) title of rulership. Perhaps he was a secondary son who held some other leadership position in the El Zotz' polity; certainly his ownership of a plate painted by one of the best El Zotz' artists reflects his clout and influence.

This feasting plate encapsulates the primary features of the Late Classic Maya painted earthenware tradition. It is a consummate artistic conception in

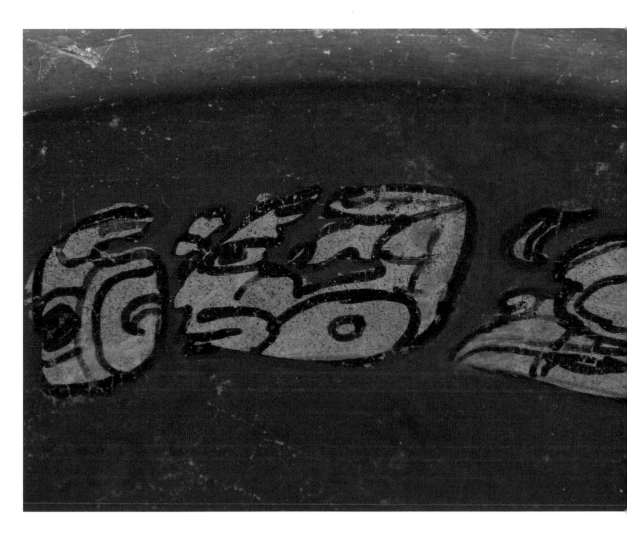

clay and slip paint, the artist being among the foremost painters of their time. The plate's imagery conveys distinctive information concerning vessel function and symbolic connotation, and it preserves the name and titles of an otherwise vanished individual who was an eminent member of the ruling nobility of Classic Maya civilization.

DORIE REENTS-BUDET, PhD, is curator of the arts of the Ancient Americas, Museum of Fine Arts Boston, and art historian for The Maya Ceramics Project, National Museum of Natural History, Smithsonian Institution. She has held faculty positions at The Johns Hopkins University, University of California at Santa Barbara, and Duke University.

BIBLIOGRAPHY

Coe, Michael, *The Maya Scribe and His World* (Grolier Club, New York, 1973).

McNeil, Cameron L., W. Jeffrey Hurst, and Robert J. Sharer, "The Use and Representation of Cacao During the Classic Period at Copán, Honduras", in *Chocolate in Mesoamerica: A Cultural History of Cacao*, Cameron L. McNeil, ed. (Gainesville: University Press of Florida, 2006), pp. 224–252.

Reents-Budet, Dorie, "Elite Maya Pottery and Artisans as Social Indicators", in *Craft and Social Identity*, Cathy Costin and Rita Wright, eds. (Washington: Archaeological Papers of the American Anthropological Association, Number 8, 1998), pp. 71–89.

Reents-Budet, Dorie, "Feasting Among the Classic Maya: Evidence from Pictorial Ceramics", in *The Maya Vase Book* (Volume VI), Justin Kerr, ed. (New York: Kerr Associated, 2000), pp. 1022–1038. (Also on-line at www.mayavase.com)

Reents-Budet, Dorie, Joseph Ball, Ronald L. Bishop, Virginia Fields, and Barbara MacLeod, *Painting the Maya Universe: Royal Ceramics of the Classic Period* (Durham NC, and London: Duke University Press, 1994).

Staller, John, and Michael Carracsco, eds., *Pre-Columbian Foodways: Interdisciplinary Approaches to Food, Culture, and Markets in Ancient Mesoamerica* (New York: Springer Publishers, 2010).

AN UNEXPECTED SUBJECT ON *ISTORIATO* MAIOLICA

SHOOTING AT FATHER'S CORPSE

TIMOTHY WILSON

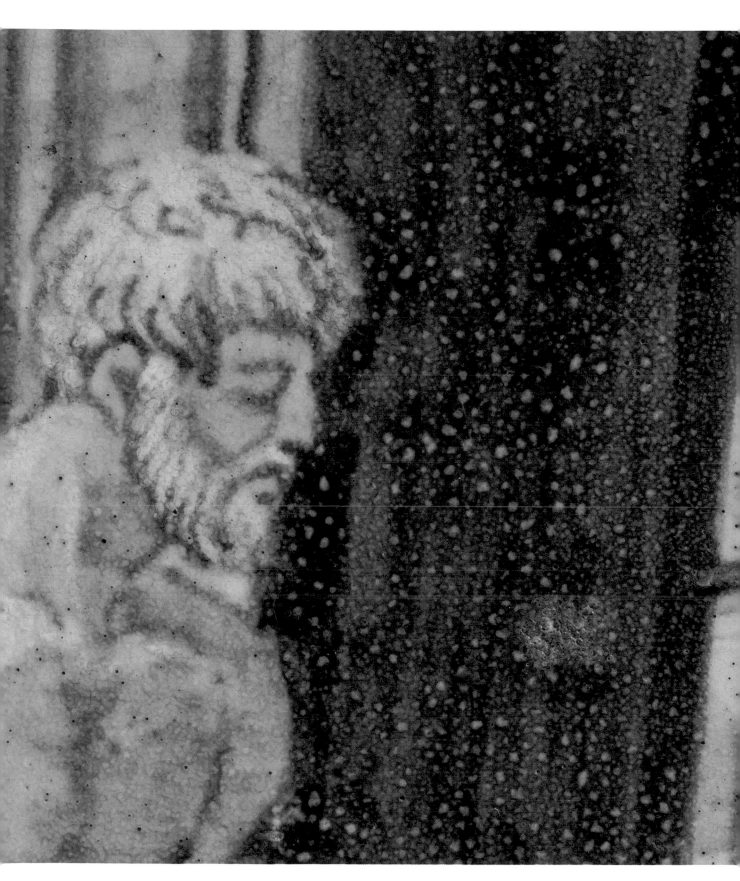

AN UNEXPECTED SUBJECT ON *ISTORIATO* MAIOLICA

Part of the pleasure of the study of historic ceramics is that it bridges archaeology, material culture, social history and various strands of more varied windows on the cultures of the past; and for no period is this more true than for Renaissance Italy. Shortly before 1500, Italian potters, exploiting rapidly improving technical mastery of coloured painting on tin glaze and encouraged by developing interest from grand and discriminating patrons, invented a new kind of maiolica. *Istoriato* ('story-painted') plates and vessels were decorated over the entire display area with narrative subjects; the painters showed increasing ambition in reproducing on ceramic surfaces the command of pictorial space that had been achieved by painters on a larger scale. *Istoriato* was high fashion until about 1570. It was made in numerous towns in north-central Italy, but its heartland from about 1520 was the Duchy of Urbino, the cultured city-state in the hills near the Adriatic coast of Italy, which had been the birthplace of Raphael.

Among the prime glories of the Gardiner Museum is a diverse and interesting group of Urbino-type *istoriato*. Its range of subject matter, including stories from Ovid and other ancient Roman writers, reveals *istoriato* as among the most extensive bodies of varied, especially non-religious, subject matter in any form of Renaissance art.

The plate that is the subject of this note was probably made c. 1535–1550.[1] The painting is broadly speaking in the Urbino style. On the back are blue scrolls and a crossed "P", which might be the initial of the painter, the workshop, the place where it was made, or possibly even the client. This reverse ornament is not normally found on Urbino maiolica, and it may be that the dish was painted by a painter who had trained in or near Urbino but travelled to work outside his home area. However, the fascination of this object is not so much in the style or attribution, but in the subject.

In a pillared interior, with a Renaissance townscape behind, two men aim arrows at the body of an old man bound to a plank; a third man kneels in the foreground, squashing his bow underfoot, before an enthroned figure of authority. This scene has hitherto

TIMOTHY WILSON

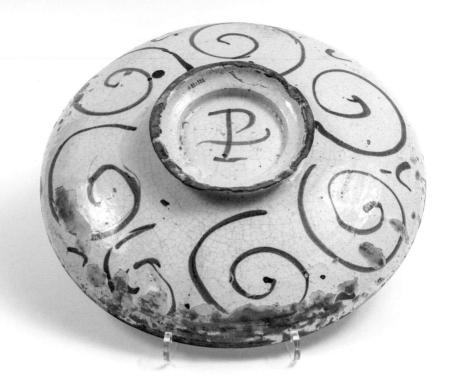

**DISH WITH THE STORY OF
"SHOOTING AT FATHER'S CORPSE"**
(FRONT AND BACK)
Possibly Urbino, Italy, c. 1535–1550 • Tin-
glazed earthenware (maiolica) • Marks: "P"
crossed • H: 6.6 cm; D: 28.7 cm • Gift of
George and Helen Gardiner, G83.1.322

been interpreted as the Martyrdom of Saint Sebastian, but the true subject is more curious and interesting.

The painter has represented an episode from a moralizing tale that was well known in Medieval Europe.[2] According to the story, a king's wife had three sons (two in some versions) by lovers, and one by the king. When he died, the issue of who should succeed arose and a trusted knight was asked to judge the dispute. He told the sons to fetch their father's body from the tomb and tie it to a tree; they were then to shoot arrows at the body and the son who pierced the heart most accurately should be the heir. The two elder sons each shot at the body. The youngest refused to do anything so impious, at which he was immediately named the true heir.

The story may have its origins in Late Antique Jewish texts known as the Babylonian Talmud. In Medieval Europe, it was diffused in several versions. One was the *Gesta Romanorum* (Deeds of the Romans). Despite its misleading name, this was a collection of moral tales from various sources, assembled in England or Germany about 1300, but widely popular throughout Europe in the later Middle Ages.[3] In Italy the story was used by preachers like Bernardino of Siena (1380–1444)[4] and retold by the storyteller Giovanni Sercambi of Lucca (1380–1424) in his *Novelle*.[5]

Solomon is not named in the main Latin texts of the *Gesta*, but so evident was the parallel with the more famous Biblical "Judgement of Solomon"—both stories involving a wise man's trick to unearth truth—that he was often supposed to be the judge in the case; the two subjects were treated as a pair by Sercambi, and sometimes by others in literature and in art.

I have so far traced 12 other versions of the story on maiolica, dating from between 1530 and 1565, most of them attributable to the Duchy of Urbino.[6] Three of these, though not the Gardiner dish, bear inscriptions naming Solomon as the judge.

Some subjects popular on maiolica were regularly based on easily available prints, such as those reproducing designs by Raphael, but this is not the case with the present episode. The compositions of the maiolica versions of the story are varied and none seems to be based on a print, or indeed closely related to known compositions in any other art form.[7] Although there are some recurrent elements, like the enthroned judge and the kneeling youngest son, suggesting some generalized tradition in Urbino maiolica workshops of what the subject 'should' look like, the painters seem usually to have been illustrating from their own imagination a story they knew well, rather than following a model.

OPPOSITE CLOCKWISE FROM TOP LEFT

PLATE
Deruta, probably by Giacomo Mancini,
"El Frate", c. 1540–1550 • Tin-glazed
earthenware (maiolica) • Birmingham
Museums Trust, England

SHALLOW BOWL
Duchy of Urbino, c. 1535–1545 • Tin-glazed
earthenware (maiolica) • Holburne Museum,
Bath, England • © Holburne Museum, Bath

SHALLOW BOWL
Urbino, by the Painter of the Apollo Basin,
c. 1535 • Tin-glazed earthenware (maiolica)
• Private Collection • Courtesy of Paolo
Lukacs, Rome

PLATE
Probably Duchy of Urbino, c. 1530–1540 •
Tin-glazed earthenware (maiolica) • Private
Collection, Pesaro, Italy

I suspect that the main reason for the popularity of this subject on Urbino maiolica was not its moral or allegorical significance, but its picturesque qualities. Indeed, such bizarre and outlandish, or even comical, subjects seem to have enjoyed especial popularity with Renaissance maiolica painters and their clients.[8]

The background of the story on this dish passes from Late Antique rabbinical writings, through a Medieval north European collection of tales and sermons in fifteenth-century Italy, into sixteenth-century tableware. It is a vivid reminder of the wonderful range of reference that enriches *istoriato* maiolica; and of the insights it can give us into the kind of stories—including ones utterly forgotten now—that were widely known among sixteenth-century men and women across social classes. Stories like this made up an essential component of the multilayered culture of the Renaissance. ✄

Thanks to: Alessandro Bettini, Alan Coates, Martin Ellis, Giuliana Gardelli, Rachel Gotlieb, Paolo Lukacs, Carmen Ravanelli Guidotti, Raymonde Royer, Paul Taylor, Karine Tsoumis, Jane Wilson, Matthew Winterbottom and Linda Wolk-Simon.

TIMOTHY WILSON is Barrie and Deedee Wigmore Research Keeper, Department of Western Art, Ashmolean Museum, Oxford, and Professor of the Arts of the Renaissance, University of Oxford. He has written extensively on Italian maiolica and is currently completing a book on the maiolica in The Metropolitan Museum of Art, New York.

NOTES

1 It was bought by Mr. and Mrs. Gardiner in 1979.
2 W. Stechow, "Shooting at Father's Corpse", *Art Bulletin* 24 (1942), pp. 213–225; A. Pigler, *Barockthemen* (second ed., Budapest, 1974), pp. 461–462; J. Miziolek, "'I figli che saettono il padre' in un ovale rinascimentale del Museo Bardini di Firenze", *Iconographica* 5 (2006), pp. 88–105.
3 *Ex gestis romanorum hystorie notabiles collectae* (Venice, 1507), fol. 32v–33v, chap 45. I know of no translation into Italian in the Renaissance. That this was not the source known to maiolica painters is suggested by the fact that the Latin text mentions the body being tied to a tree; maiolica painters tend to show it on a wooden plank.
4 C. Delcorno, *Exemplum e letteratura tra Medioevo e Rinascimento* (Bologna: Mulino, 1989), pp. 163–191.
5 G. Sercambi, *Novelle*, G. Sinicropi, ed. (Turin, 1995), I, pp. 547–554.
6 These are:
 (a) Holburne Museum, no. C11. Uninscribed.
 (b) Sold Piasa, Paris, 25 May 2011, lot 314. Ravanelli Guidotti, "Per il 'Pittore del bacile di Apollo': due restauri e un inedito", *Faenza* 97 (2011), p. 30. Uninscribed.

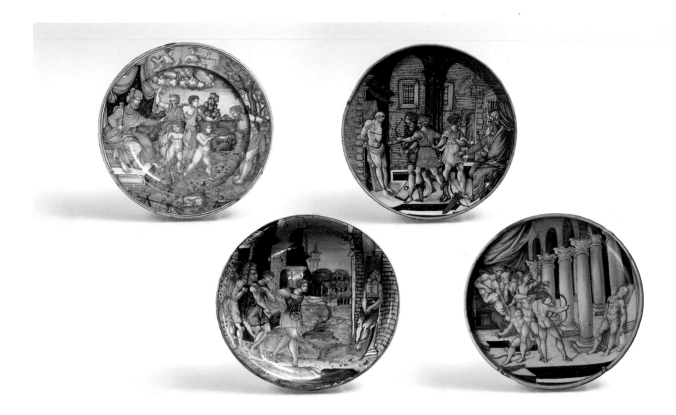

(c) Uninscribed. The figures are distantly reminiscent of a painting by Marco Zoppo.

(d) Birmingham Museums, no. 1885M1563. Uninscribed.

(e) Shallow bowl, probably Urbino, c. 1535–1540. Volponi coll., exhibited in recent years at the Casa di Raffaello, Urbino. Formerly Ernst-Museum auction, Sammlung des Herrn E. V., Budapest, 26 November 1917, lot 56. G. Gardelli, "Urbino nella storia della ceramica. La collezione di maioliche nella Casa Natale di Raffaello", *Accademia Raffaello, Atti e Studi* (2002), no. 2, p. 43, figs. 1, 2. Inscribed "Sente[n]tia d[i] Salamone".

(f) Shallow bowl, Urbino or Castel Durante, c. 1540–1560. Emden sale, Lepke, Berlin, part 1, 3–7 November 1908, lot 99. Uninscribed.

(g) Ewer, probably Urbino (workshop of Guido di Merlino?), c. 1540–1555. Ex-Adolphe de Rothschild, Duveen Brothers, New York, and French and Co., New York (stock no. 47293A). Getty Research Institute, neg. 29089.

(h) Shallow bowl, probably Urbino (workshop of Guido di Merlino?), c. 1540–1555. Strozzi Sacrati collection. G. C. Bojani and F. Vossilla, eds., *Capolavori di maiolica della Collezione Strozzi Sacrati*, exhib. cat., Faenza (1998), no. 41; F. Cioci, "Un gruppo di istoriati tra Urbino, Pesaro e Casteldurante: il Maestro in Bottega di Guido di Merlino", in *La maiolica italiana del Cinquecento. Capolavori di maiolica della Collezione Strozzi Sacrati*, G. C. Bojani, ed. (Florence : Centro Di, 2001), p. 88, figs. 7, 8. Inscribed "La sente[n]tia di Salamone d[e] li tre fratelli ch[e] al patr[e] Sagittavano".

(i) Shallow bowl, by Sforza di Marcantonio, Pesaro, 1551. Musei Civici, Padua. M. Munarini and D. Banzato, *Ceramiche Rinascimentali dei Musei Civici di Pesaro* (Milan: Electa, 1993), no. 305. Inscribed "hEbbe pieta del padre il vero figlio 1551. S.A."

(j) Albarello, Castel Durante, probably Picchi workshop, perhaps by Andrea da Negroponte, 1562–1563. Ashmolean Museum, Oxford. T. Wilson, "Shooting at Father's Corpse", *The Ashmolean 52* (2007), pp. 13–15.

(k) Fluted dish, Castel Durante, probably Picchi workshop, perhaps by Andrea da Negroponte, c. 1550–1565. Museo d'Arte Medievale e Moderna, Arezzo. C.-D. Fuchs, *Maioliche istoriate del Museo Statale d'Arte Medioevale e Moderna di Arezzo* (Arezzo: Centro affari e promozioni, 1993), no. 231. Uninscribed.

(l) Plate, Castel Durante, probably Picchi workshop, perhaps by Andrea da Negroponte, c. 1550–1565. Barilla sale, Sotheby's, London, 14 March 2012, lot 16. Inscribed "quando Salamone dette la sententia per quelli doi figlioli uno legitimo e laltro bastardo. A. B." The letters A. B. may be the initials of the painter (Andrea [B...]?).

7 The exceptions are the three versions attributed to Andrea da Negroponte, nos (j), (k) and (l), which are compositionally similar to each other.

8 Another example is the "Bull of Perillus", an obscure but visually striking mythological subject, involving the roasting of a man inside a bronze bull, of which many maiolica versions exist.

ON THE MEANING OF A RENAISSANCE KISS

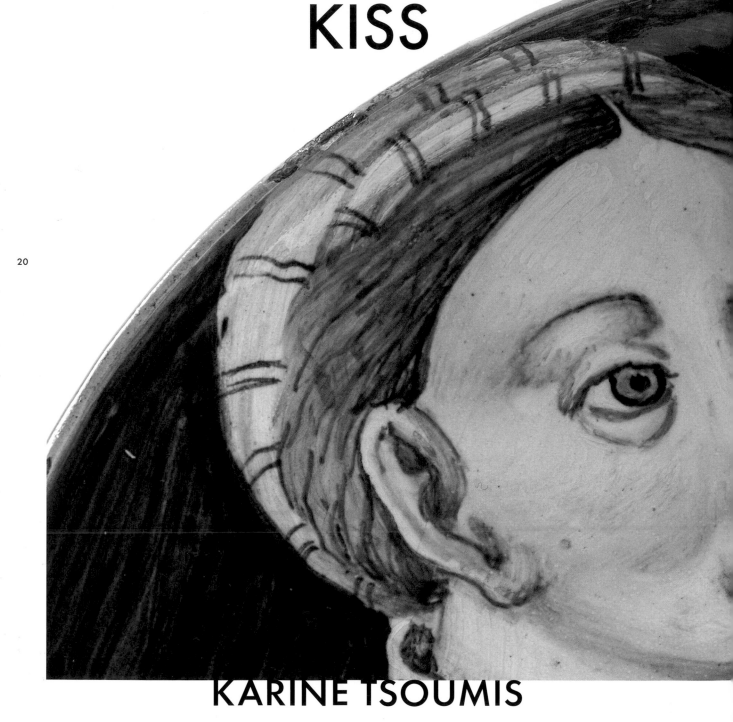

KARINE TSOUMIS

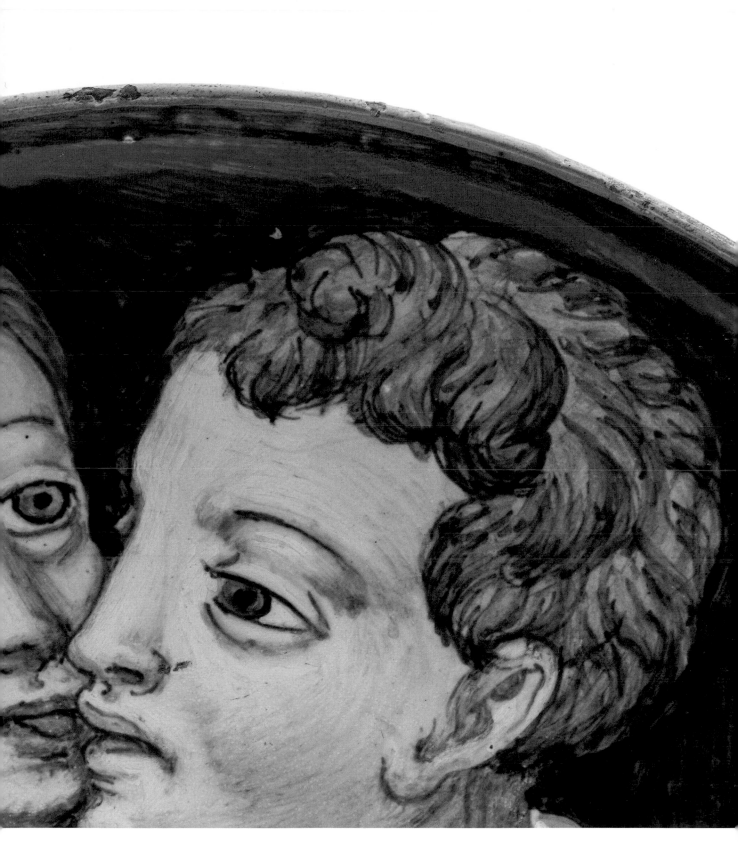

ON THE MEANING OF A RENAISSANCE KISS

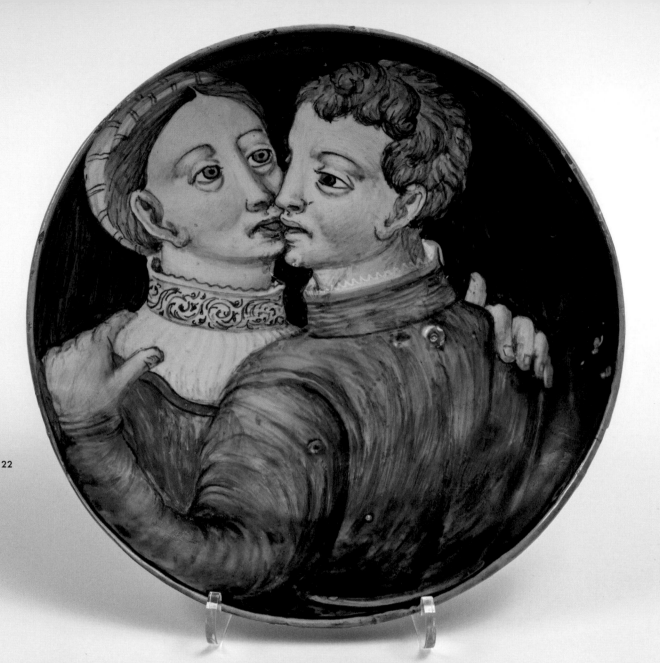

The material world of the Renaissance is rich in objects associated with the family life cycle. Ranging from ceramics and furniture to jewellery, these many things once played an active role as tokens of love, markers of betrothal and celebrations of childbirth.[1] Used, preciously kept and displayed in the home to commemorate the events, they were handed down to future generations as symbols of family identity, carriers of values and history. With centuries of changing ownership and viewing contexts they have been stripped of their original functions, their imagery sometimes puzzling modern viewers. A maiolica portrait dish is one example of an object which at first glance eludes precise definition, and whose multilayered meaning unravels when viewed against the material, social and symbolic practices associated with marriage.

Made in Urbino or Castel Durante c. 1540, the piece is rare for its unique iconography: a young couple stands in a tight embrace, locking lips in a somewhat graphic kiss, the tip of a tongue, a rare sight in Renaissance art, unexpectedly revealed. The intimate encounter and eroticism of the gesture would pose no question were the figures scantily clad deities illustrating the loves of the gods, a theme

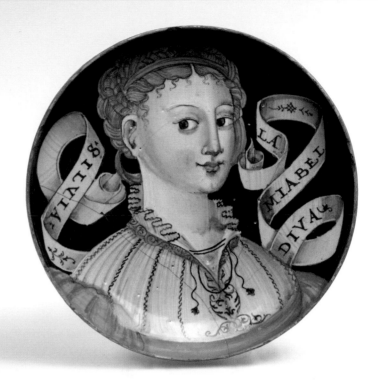

OPPOSITE AND RIGHT

DISH WITH A COUPLE KISSING
Urbino or Castel Durante, Italy, c. 1540 •
Tin-glazed earthenware (maiolica) • Marks:
None • H: 5.8 cm; D: 25.5 cm • Gift of
George and Helen Gardiner, G83.1.411

DISH WITH BUST OF A WOMAN
Urbino or Castel Durante, inscribed "Silvia
diva mia bella" c. 1540 • Tin-glazed
earthenware (maiolica) • Victoria and
Albert Museum, London, 8930-1863 •
© Victoria and Albert Museum, London

frequently depicted in contemporary maiolica, engraving and painting.[2] Nor does the object belong to the rich vein of ceramics with sexual or ribald imagery that offer satirical commentaries on male-female relationships.[3] It is instead the couple's very ordinariness, their unidealized portrayal and modesty of dress, that makes them and the object stand out. The young woman wears a high collared dress, her hair demurely tied under a *scuffia* or hair cap associated with married women.

The piece finds close visual kinship to the *bella donna* ('beautiful woman') dish. Objects forming this category present a female portrait accompanied by a name, and sometimes a quality celebrating traditional female virtues. Their function as betrothal gifts or tokens of love offered by a suitor to a fiancée is generally accepted.[4] While some were possibly commissioned, the generic and repetitive character of the portraits suggests that a serial mode of production was employed. The pieces were probably purchased from stock in a potter's workshop and personalized through the addition of details of dress, physical features and inscriptions. Whereas *belle donne* dishes have survived in quantity —the quality of the pieces varies greatly, therefore suggesting that they reached a variety of levels of consumption[5]—the Gardiner dish belongs to a much smaller group of objects where both men and women are depicted. They adhere to the same visual conventions by presenting bust-length portraits in close-up on a blue ground on a small footed dish.[6] Some include an inscription dedicating the object to a woman or a proverb commenting on love.[7] Others, including the Gardiner dish, focus uniquely on the portraits.[8] The pieces forming this sub-group are notable for the affectionate and intimate gestures displayed.[9] Presenting couples in close embrace, cheek to cheek, kissing or fondling, they challenge our modern conceptions of what constituted decorous behaviour in the Renaissance. Yet rather than breaches of decorum, they should be seen, as Sara F. Matthews-Grieco observes, as "a visual evocation of the types of amorous dalliance expected of betrothed couples, and an acknowledgment of the physical intimacy that the new couple was expected to share".[10] Depending on class, kissing and mutual fondling in public could be considered acceptable, a way of announcing a new conjugal relationship to the community.[11] Nevertheless, the iconography of the Gardiner dish stands out, as within the history and rhetoric of gestures, the kiss on the mouth was, and remains, pregnant with meaning.

A Renaissance marriage was the culmination of the exchange of gifts and the performance of symbolic gestures.[12] The importance of the latter is reflected by their reference on a variety of objects that marked betrothal and that were commissioned to be used or displayed at wedding banquets. A gold-lustred basin from Deruta (1500-1530) at the Gardiner Museum features the *fede* motif, or handclasp, which refers to its performance by male members of the two families to sanction the contractual terms of the alliance as well as by the spouses themselves. Symbolizing the moral obligations contracted by the two individuals and their families as well as ideals of faithfulness and marital concord, the motif commonly appeared on nuptial rings.[13] The passing of the ring was one of the culminating points of the marriage ritual, the moment when the couple exchanged words of consent in front of witnesses and a notary. On the Deruta basin, the ring worn by one of the hands perhaps alludes to this moment. The kiss on the mouth also belonged to the practice of the contract. Performed by male kin to sanction the terms of the alliance, it accompanied the exchange of rings and words of consent by the spouses.[14]

Before the Church regulated marriage practices with the decrees of the Council of Trent in 1563, marriage was an entirely secular affair with many grey areas as to what constituted a valid and legitimate union. The kiss, the handclasp and the passing of the ring were transformative gestures and each could have a binding power.[15] This is revealed by the many court cases where individuals tried to prove, or disprove, that a marriage had been contracted.[16] These cases often involved young girls being kissed by force by men to whom they had not been promised; rings given in front of witnesses; or hands violently touched or grabbed.[17] Given the legal and symbolic implications of the kiss, its performance on the Gardiner dish should be considered as more than an allusion to the sexual license enjoyed by betrothed couples. Displayed in the household for visitors to see, its imagery would instead have been conceived as a visual expression of nuptial consent between the individuals depicted, the object serving as a "material witness" of the events.[18]

The erotic potential of the gesture of the kiss undoubtedly prevented it from being the focus of marriage imagery.[19] Among the few painted marriage portraits produced in this time period the handclasp and the passing of the ring are emphasized as the constitutive moment of the alliance; one celebrated example is Lorenzo Lotto's *Marsilio Cassotti and his Bride Faustina*, 1523. On the Gardiner dish, the erotic potential of the kiss is however diminished by the couple's reciprocal gaze which serves to reinforce the

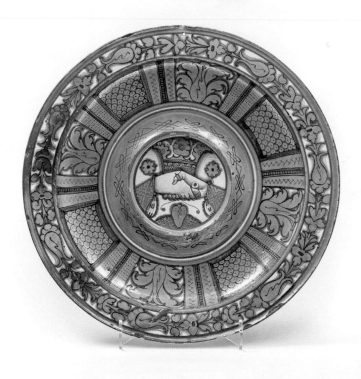

BASIN WITH *FEDE* MOTIF
Deruta, c. 1500–1530 • Tin-glazed
earthenware (maiolica) with lustre • Gift of
George and Helen Gardiner, G83.1.340

marital connotation of the gesture. In the arts and literature of the Renaissance, the mutual gaze has been analyzed as an expression of a form of love that is conjugal rather than lustful.[20]

W hether the object presents a true portrait likeness or an image made from stock and given a specific identity following a client's request, in the manner of most *belle donne* dishes, remains uncertain. Yet despite the lack of documentary evidence, the rarity of the iconography —so far no comparable example of a couple kissing on this type of object has been found—together with the greater naturalism suggested by the portraits, lend credence to the hypothesis that the object was originally produced as a commission. While the identity of the couple depicted has long been forgotten, this unique dish at the Gardiner Museum nevertheless offers fascinating insights into the private lives of Renaissance consumers. ❧

KARINE TSOUMIS received her PhD from the University of Toronto, specializing in the art and material culture of Early Modern Italy. She is currently Curator at the Gardiner Museum.

NOTES

1 See Marta Ajmar-Wollheim and Flora Dennis, eds., *At Home in Renaissance Italy* (London: V&A Publishing, 2006); Andrea Bayer, ed., *Art and Love in Renaissance Italy* (New York: Metropolitan Museum of Art; New Haven: Yale University Press, 2008).

2 Examples at the Gardiner Museum include an Urbino *tondino* with the story of Leda and swan from the Pucci-Medici service by Orazio Fontana, c. 1531–1544 (G83.1.388).

3 Jacqueline Marie Musacchio, *Marvels of Maiolica: Italian Renaissance Ceramics from the Corcoran Gallery of Art Collection* (Charlestown, MA: Bunker Hill, 2004), p. 48. For sexual imagery on Renaissance maiolica see Catherine Hess, "Getting Lucky", in *Sex Pots. Eroticism in Ceramics*, Paul Mathieu, ed. (New Brunswick, NJ: Rutgers University Press, 2003).

4 On this tradition see Marta Ajmar and Dora Thornton, "When is a Portrait not a Portrait? *Belle Donne* on Maiolica and the Renaissance Praise of Local Beauties", in *The Image of the Individual*, Nicholas Mann and Luke Syson, eds. (London: British Museum Press, 1998), pp. 138–153; Luke Syson, "Belle: Picturing Beautiful Women", in *Art and Love in Renaissance Italy*, Andrea Bayer, ed., pp. 248–249.

5 Ajmar and Thornton, "When is a Portrait not a Portrait? *Belle Donne* on Maiolica and the Renaissance Praise of Local Beauties", p. 143.

6 Ajmar and Thornton, "When is a Portrait not a Portrait? *Belle Donne* on Maiolica and the Renaissance Praise of Local Beauties", pp. 144–145.

7 Examples of the former include a Castel Durante dish c. 1540
 (Louvre, Paris) and a dish attributed to Gubbio, c .1530–1540
 (Rijksmuseum, Amsterdam). See Jeanne Giacomotti, *Catalogue
 des majoliques des musées nationaux* (Paris: Éditions des musées
 nationaux, 1974), pp. 248–249; http://hdl.handle.net/10934/
 RM0001.COLLECT.242471, accessed December 1, 2013.
 Examples of the latter include a Castel Durante dish, 1530–1540
 (Hermitage, Saint Petersburg) and a Deruta dish c. 1550 (Victoria
 and Albert Museum, London)—the latter differing stylistically in
 the use of a green background. See Elena Ivanova ed., *Il secolo
 d'oro della maiolica. Ceramica italiana dei secoli XV–XVI dalla
 raccolta del Museo Statale dell'Ermitage* (Milan: Electa, 2003),
 p. 119; Bernard Rackham, *Catalogue of Italian Maiolica. The
 Victoria and Albert Museum*, revised by J. V. G. Mallet (London:
 H.M.S.O., 1977), p. 249, pl. 119, and Sara F. Matthews-Grieco,
 "Marriage and Sexuality", in *At Home in Renaissance Italy*,
 Marta Ajmar-Wollheim and Flora Dennis, eds., p. 116.

8 An Urbino dish in a private collection is most closely related
 to the Gardiner dish. See Giuliana Gardelli, *A Gran Fuoco.
 Maioliche rinascimentale dello stato di Urbino da collezione
 private* (Urbino: Accademia Raffaello, 1987), pp. 64–65.

9 On late fifteenth- and early sixteenth-century maiolica, couples
 had been presented in profile, either facing one another or
 superimposed, without any sign of physical contact. For this
 shift in marital imagery see Marta Ajmar-Wollheim, "'The Spirit
 is Ready but the Flesh is Tired': Erotic Objects and Marriage

in Early Modern Italy", in *Erotic Cultures of Renaissance Italy*,
by Sara F. Matthews-Grieco, ed. (Surrey, UK; Burlington, VT:
Ashgate, 2010), pp. 151–152.

10 Matthews-Grieco, "Marriage and Sexuality", in *At Home in
 Renaissance Italy*, p. 116.

11 Matthews-Grieco, "Marriage and Sexuality", p. 105. See Also
 Ajmar-Wolheim, "'The Spirit is Ready but the Flesh is Tired':
 Erotic Objects and Marriage in Early Modern Italy".

12 On marriage rituals see Matthews-Grieco, "Marriage and
 Sexuality"; and Christiane Klapisch-Zuber, "Zacharias, or the
 Ousted Father: Nuptial Rites in Tuscany between Giotto and the
 Council of Trent", in *Women, Family, and Ritual in Renaissance
 Italy*, Lydia Cochrane, trans. (Chicago and London: The
 University of Chicago Press, 1985), pp. 182–196.

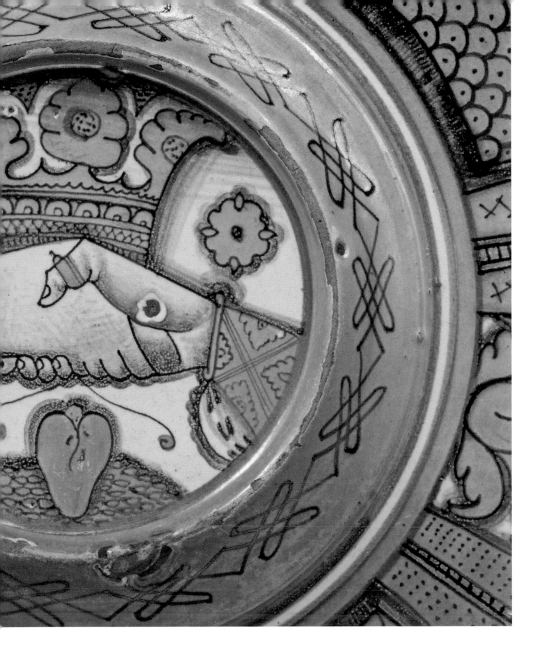

13 See *Art and Love in Renaissance Italy*, pp. 100–102.

14 Klapisch-Zuber, "Zacharias, or the Ousted Father: Nuptial Rites in Tuscany between Giotto and the Council of Trent", p. 183; Yannick Carré, *Le baiser sur la bouche au Moyen Age. Rites, symboles, mentalités. XIe–XVe siècles* (Paris: Le Léopord d'Or, 1992), pp. 153–155.

15 Ottavia Niccoli, "Baci rubati. Gesti e riti nuziali in Italia prima e dopo il Concilio di Trento", in *Il gesto nel rito e nel cerimoniale dal mondo antico ad oggi*, Sergio Bertelli and Monica Centanni, eds. (Florence: Ponte alle grazie, 1995), pp. 224–247.

16 For a well-documented case study see Gene Brucker, *Giovanni and Lusanna: Love and Marriage in Renaissance Florence* (Berkeley: University of California Press, 1986).

17 Mary Rogers and Paola Tinagli, eds., *Women in Italy,*

1350–1650: Ideals and Realities: A Sourcebook (Manchester: Manchester University Press, 2005), p. 133.

18 Ajmar-Wolheim, "'The Spirit is Ready but the Flesh is Tired': Erotic Objects and Marriage in Early Modern Italy", p. 153.

19 See Karen Harvey, "Introduction", in *The Kiss in History* (Manchester and New York: Manchester University Press, 2005), p. 6.

20 See Robert Baldwin, "'Gates Pure and Shining and Serene': Mutual Gazing as an Amatory Motif in Western Literature and Art", *Renaissance and Reformation*, n.s. 10, no. 1 (1986), pp. 23–48.

A COLLECTOR'S TALE ON SHOES

ROSALIE WISE SHARP

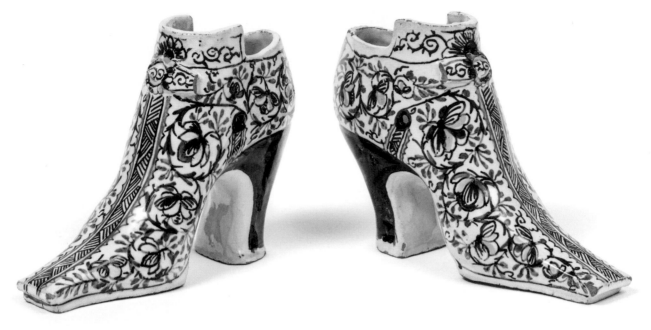

On a sunny Sunday in 1727 in London the Lady Rifke, in her fine black carriage, pulled up to her bespoke shoemaker's on Cockspur Street. She poked out one pointy shoe and slipped on pattens, protective overshoes, for her beige linen shoes embroidered in blue anemones before stepping down to the muddy road. Mr. Sherman's sample shoes were displayed in his window singly; no need for a right and left because shoes were all made as straights. The shoes in the window were brocade, cotton with wool embroidery and an ivory silk shoe with red and green flowers fashioned in silk threads, and fastened with silver and crystal buckles. Lady Rifke had a pair of diamond and silver buckles safely kept in their velvet box in her boudoir. The heels of the footwear on display were about eight centimetres high. High heels were first mentioned in the Hellenistic period and depicted in Egyptian murals. Louis XIV famously wore ten-centimetre red or green heels, and by decree only those granted access to the court could wear red heels.

Lady Rifke ordered the ivory shoes and gave Mr. Sherman a length of brocade in alizarin crimson for a pair to match her theatre gown. After collecting a new Adam and Eve delft charger from the chinaman's shop in Mayfair she was soon settled back in her carriage for the return to her Belgravia Square town house where afternoon tea was set out in one of her numerous blue-and-white Chinese porcelain sets with the small handleless teabowls. That day it was the "Willow Root" pattern. Rifke was rather proud of her sitting room, which she had personally designed with peacock blue silk walls and a whole wall of carved wood gilded shelves to house her bulging collection of the latest Brislington delft earthenware. Featured was a pair of shoes very like the one she had just bought—painted in cobalt blue to simulate floral sprays. They were about 20 percent smaller than real shoes, the same scale as eighteenth-century portraits. They were a wedding present from her mother-in-law Lilly, who at the time insisted that a pair of old shoes be hung in the attic or placed under the floorboards to ward off the evil eye and bring good luck.

Everyone in the square had the latest delft earthenware but not nearly as many pieces as Rifke, about whom many made remarks regarding such egregious displays. And of course, since the formula for porcelain would not be discovered locally till 1744, her friends also had imported functional porcelain from China.

At Brislington, the pottery began in the 1660s by two potters from Southwark, London. It closed about 90 years later. Like many others, the establishment

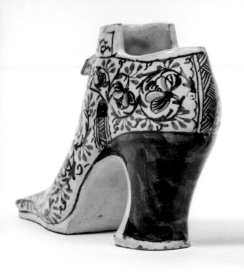

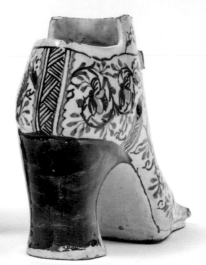

LEFT AND OPPOSITE

PAIR OF SHOES WITH BUCKLES
Brislington, England, c. 1720 • Tin-glazed
earthenware (delftware) • Marks: None
• H: 12 cm; W: 17 cm; D: 6 cm • Gift of
George and Helen Gardiner, G83.1.549.1–2

RIGHT

SHOE
London, England, 1733 • Leather, kid
leather, silk, linen • The Bata Shoe Museum,
Toronto • © 2014 Bata Shoe Museum,
Toronto, Canada

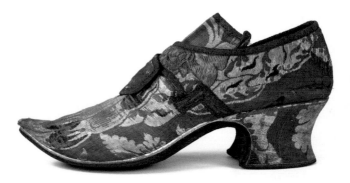

was near a busy seaport for easy shipping. The painters at their long tables might have a real shoe as the model for their floral designs. The slab clay shoe shapes would be fired to the biscuit stage and then dipped in a tin-opacified lead glaze which would be air dried, ready for the spontaneous freehand strokes of the painter's brush. Nothing could be erased once applied.[1]

Back in Belgravia Square, the Lady Rifke put her feet up in the sitting room and over a cup of tea, related the day's events to her husband Lord Itzhak, just back from his day in parliament. King George I had given over his mantle to parliament, so Itzhak shared his MP duties with the likes of Sir Isaac Newton and the *de facto* Prime Minister, Sir Robert Walpole.

Rifke then broke the news to her husband that she had her eye on yet another piece of delft for their already out-of-hand collection. This time it was a charger with a typically rustic portrait of King George I. "There's nothing like china to light up a house." ❧

With thanks to James Bisback, Peter Kaellgren, Victoria Jackson and Elizabeth Semmelhack.

ROSALIE WISE SHARP is an author, painter, interior designer and philanthropist with a passion for the decorative arts, particularly mid-eighteenth-century English and French ceramics and nineteenth-century oriental carpets.

NOTES

1 According to Anthony Ray, "designs on English delftware are (sometimes) drawn in outline first" or (mainly in Holland) "by means of a pricked transfer and a pounce-bag full of charcoal powder" which burnt off in the kiln, *English Delftware Pottery in the Robert Hall Warren Collection, Ashmolean Museum, Oxford* (London: Faber and Faber, 1968), p. 28.

AN EXCEPTIONAL CHINOISERIE CHARGER FROM LYON

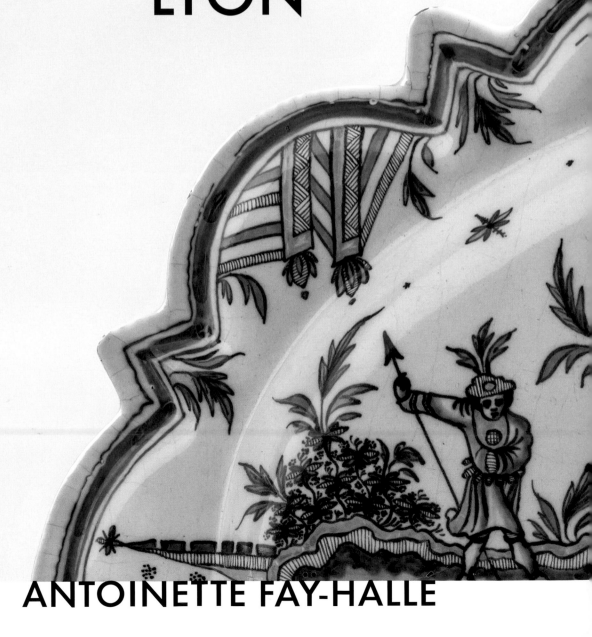

ANTOINETTE FAY-HALLE

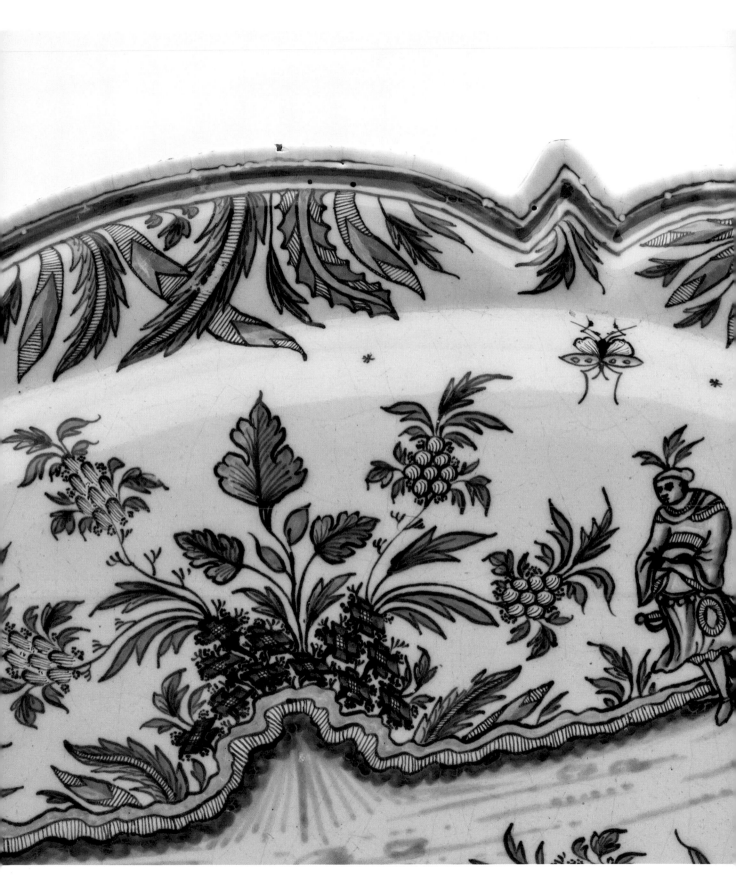

AN EXCEPTIONAL CHINOISERIE CHARGER FROM LYON

34

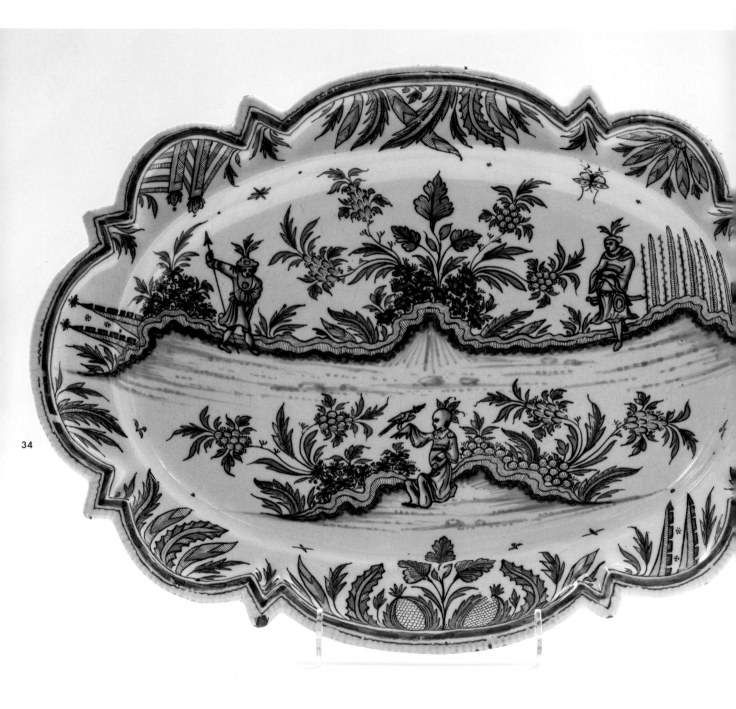

CHARGER WITH CHINOISERIE
Lyon (attributed), France, c. 1750 • Tin-
glazed earthenware (faience) • Marks:
None • H: 34.2 cm; W: 46.1 cm; D: 4.4 cm
• The Pierre Karch and Mariel O'Neill-Karch
Collection, G12.14.1

ANTOINETTE FAŸ-HALLÉ

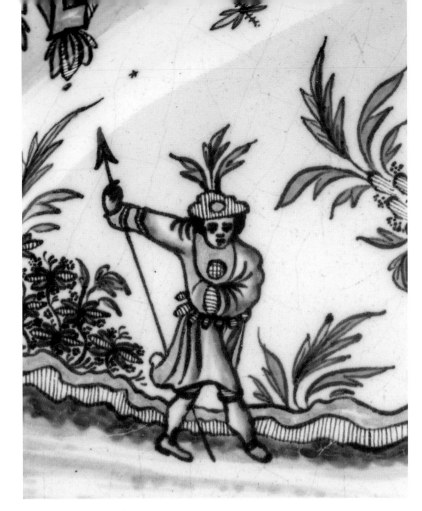

This charger is made of tin-glazed earthenware: its clay is porous and coloured and its glaze is opacified and whitened with tin oxide. It was 'high fired', meaning that the clay and opaque glaze were fired at the same time at a high temperature, reaching at least 900°C. In these conditions, only five colours can be used, and they are all present on this dish: cobalt blue, yellow from antimony, green from copper oxide, purplish-brown from manganese and red, obtained by applying an iron-rich clay in small, tight strokes. The 'high fire' (*grand feu*) technique was the only one used in France until the mid-eighteenth century, when Johann Gregorius Höroldt (1696–1775) in Meissen discovered the 'low fire' (*petit feu*) technique.

Tin-glazed earthenware was invented in present-day Iraq in the ninth century to imitate Chinese porcelain. With the expansion of the Islamic civilization in the Medieval period, the technique spread throughout the Mediterranean area, to Spain, Italy and Marseille in the south of France. It triumphed in Italy in the fifteenth and sixteenth centuries with the production of maiolica decorated with narrative scenes (*istoriato*) derived from engravings. In the sixteenth century, Italian artisans brought knowledge of the medium to the city of Lyon, a hub on the route between France and Italy. Faience production declined in these areas in the following century as Delft in The Netherlands emerged as the most important production centre. In the eighteenth century, it was in France however that the technique reached its apogee.

The Gardiner charger can be attributed to Lyon, France, for two reasons. In the first place its form, with half circles and chevrons alternating on its edge, is characteristic of this centre. Dishes of this kind, all made from the same mould, were most likely produced at the same manufactory. Second, one sees in the decoration a motif which also evidences that this dish originated in Lyon: two posts covered with plants can be seen on the wing in the upper left. The origin of this strange decorative element which appears as a leitmotif in Lyon faience is still debated, but it should certainly be seen as a workshop signature.

ABOVE

CHARGER
Lyon, France, 1740s • Tin-glazed
earthenware (faience) • Marks: Signed by
Pierre Mongis • Cité de la céramique, Sèvres,
France • Photo: Martine Beck-Coppola ©
RMN-Grand Palais/Art Resource, NY

The decoration of this dish is typical of mid-eighteenth-century ceramics in Mediterranean Europe: the grotesque Chinese décor rendered in monochrome blue or in polychrome as seen on pieces made in Alcora (Valencia, Spain) and Marseille. It results from the encounter of two distinctive styles: chinoiserie, which became fashionable in the late seventeenth century in all of Europe through the massive introduction of Chinese porcelain by the Dutch East India Company, and grotesque ornament, the taste for which goes back to the Middle Ages, for monstrous figures in France and fantastic animals in Spain. The engravings which may initially have served as models for this unique faience typology were never found, although it is believed that they were the work of Martin Engelbrecht (1664–1756). Engelbrecht's prints with picturesque figures were often mined for motifs by manufactories which produced chinoiserie of a similar kind, especially in Alcora.

Each faience production centre created its own version of this decoration, especially in polychrome. What differs most is the colour palette employed: in France, touches of bright yellow bring out the fairly subdued blues and greens and a powerful red. On the pieces produced in Alcora the colour palette is more varied, often with a peculiar, yet effective, manganese predominating. The compositions are asymmetrical, and in France take over the entire space, with only a thin line marking the edge. In Spain, plants often appear to be sprouting up from the edge of the dish, isolating the figures in the bowl, as in the Lyon dish but with greater suppleness. Chinese figures and animals are often placed on terraces with undulating contours, with blue strokes and at times a thin yellow line beneath them. The figures are commonly surrounded by a variety of highly unrealistic plants, to the extent that the kinds of flowers used to decorate Marseille dishes were called "asteroids", a reference to their starfish-like appearance.

The Lyon charger in the Gardiner Museum both belongs to this genre and diverges from it: its colours are well-balanced, manganese is amply present, but the yellow is not bright enough to overwhelm the other colours. Its composition is symmetrical, at least across its length: in the centre, a mass of plants above is flanked by two Chinese figures, while below a seated Chinese figure is surrounded by plant motifs. The upper terrace rises in the centre, but the small Chinese figure seated below, sinking under the line, creates a counterbalancing effect. The motifs on the wings, for their part, are perfectly counterbalanced.

ANTOINETTE FAŸ-HALLÉ

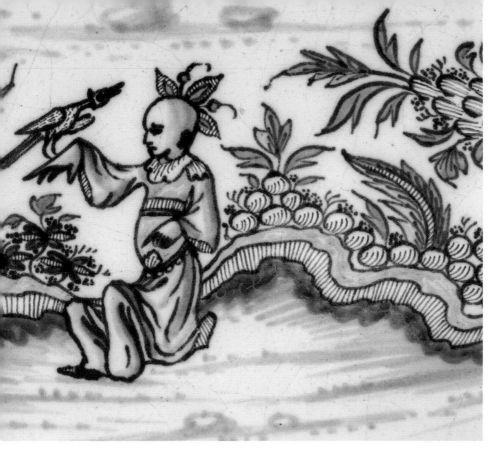

Marseille and Alcora faience pieces belonging to this group are not truly rare, even if relatively few have survived. That said, the Gardiner Museum dish is uncommon if not unique. It is comparable only to a sole and very important dish, preserved at the Musée national de Céramique de Sèvres. It is important because of its size (50.5 cm in diameter) but also because of the signature on its edge, that of Pierre Mongis. This Italian-born artist (Turin, 1712–Lyon, 1774) worked in the so-called "royal" manufactory in Lyon in the 1740s, where he must have made another dish bearing his signature, preserved in the Musée historique de Lyon. The two dishes he signed were inspired by Marseille faience (attributed to Louis Leroy's manufactory, active in Marseille at this time). One is decorated with bands framing an urban landscape and Cupids embodying the seasons; the other, shown here, has a fanciful decoration of Chinese figures, placed on knolls in the midst of stylized plants among which can be seen one of his leaning rods, bearing a vessel full of leaves.

While the Gardiner charger was not made by Pierre Mongis—it does not have the free graphic style of Italian origin that characterizes the work of this artist—it is clearly its continuation. Instead, it shows a certain rigidity and symmetry in its composition which contrast with the usually supple and asymmetrical rendering of chinoiserie. The artist who decorated this dish was a true original. ৬

Translated by Timothy Barnard.

ANTOINETTE FAŸ-HALLÉ has been a curator at the Musée national de Céramique de Sèvres since 1970, and its director from 1981 to 2009. She has curated numerous exhibitions and published on topics ranging from eighteenth-century French faience to contemporary ceramics.

BIBLIOGRAPHY

El esplendor de Alcora, Ceramica del s. XVIII, exhibition catalogue (Valencia: Museo San Pio V, 1995).

Deloche, Bernard, Michel Descours and Léon Sublet, *Faïences de Lyon* (Plouguerneau: Beau fixe, 1994).

Maternati-Baldouy, Danielle, *Faïence et porcelaine de Marseille, XVIIe–XVIIIe siècles*, Collection du musée de la Faïence de Marseille (Paris and Marseille: Réunion des Musées Nationaux, 1997).

EXPERIMENTATION WITH COLOUR AND DESIGN

AN EARLY OVERGLAZE ENAMEL JAPANESE PORCELAIN FLASK

NICOLE COOLIDGE ROUSMANIERE

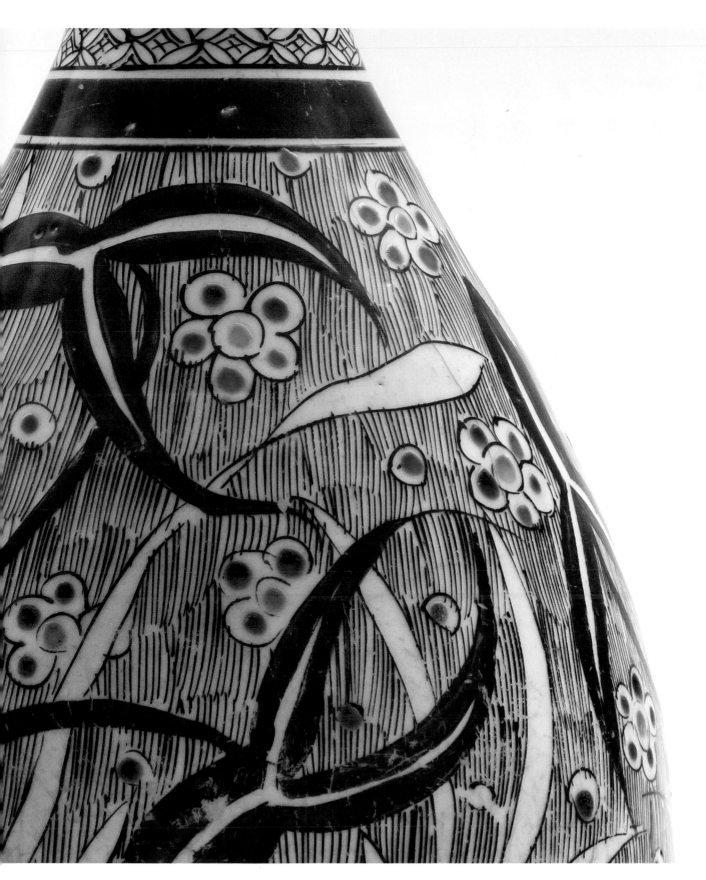

EXPERIMENTATION WITH COLOUR AND DESIGN

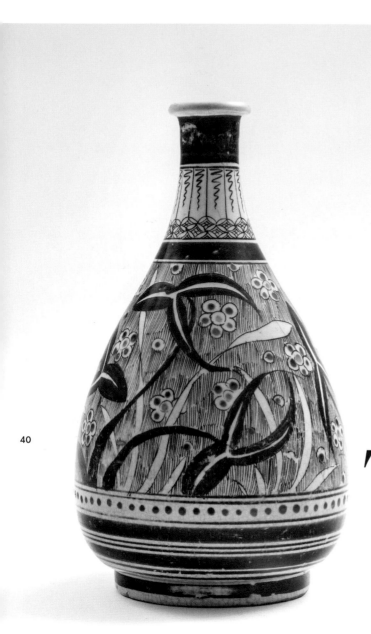

IMARI WARE FLASK

Arita, Japan, 1655–1660s • Hard-paste porcelain with overglaze enamels • Marks: None • H: 25 cm • The Macdonald Collection, G11.13.8

This brightly coloured porcelain flask, dating from 1655 to the 1660s, decorated with a design of water plantains against a stylized ground, still appears fresh after 370 years. This work is a wonderful example of early Japanese overglaze enamel porcelain made in the Arita kilns in response to a fledgling export industry in the mid-seventeenth century. The form and design of this compelling work merit further examination.

The form of the flask, which has parallels in earlier Chinese and Korean ceramics, has been transformed with swelling hips and a rolled lip resembling a glass Dutch onion wine bottle. A depiction of water plantains (*omodaka*) spring from the border of the lower band and cover the central area of the flask.[1] The fluid painting of water plantains in a vivid red enamel alternate with the stylized floral plum rosettes highlighted in green and yellow enamels over a red enamel vertical line background (*shiba-gaki*). The neck and the base of the flask provide visual contrast to its central design with bands of geometric patterns of mostly horizontal lines. A band of green dots on the base (*renjûmon*) and the linked concentric circle design (*shippo tsunagi*) of the neck were intended to ward off negative influences. These auspicious designs

ensured that the contents of the vessel would fortify the body and soul of the consumer.

This work is a classic example of the best of early Japanese porcelain design. Japanese porcelain painters placed emphasis not just on the motifs themselves but also on the negative space around the designs, in other words the areas where the forms are not drawn. This tension between the positive and negative space (motif and ground) is essential for any successful Japanese design on porcelain, the effect of which is best recognized on the flask in the contrast between the three main water plantain stalks, depicted in red, and the line-drawn ground with leaves left only in outline ringing the lower section.

Interestingly, there are no underglaze colourants on this work. However, three overglaze enamels—red, green and yellow—have been applied, with the red enamel predominant. At the time when the use of overglaze colours was still nascent, the impact of this colourful design must have been remarkably striking.

The earliest porcelain production in Japan began in the first decades of the seventeenth century in the Saga domain, Hizen province, in northwestern Kyushu. The Saga domain was controlled by the newly ennobled *daimyo*, named the Nabeshima, who were also charged with overseeing the Tokugawa-controlled international trading port of Nagasaki, and therefore intimately familiar with the China trade, including the import of porcelain.

The earliest Japanese-produced porcelain dates to the 1610s and was fired just west of Arita in the Saga domain, an area blessed with mountains, plentiful pine forests and running streams, necessary for the production of porcelain. Japanese porcelain made in the first four decades of production—that is, from about 1610 to 1640—before the advent of overglaze enamels, is generally termed *Shoki Imari* (Early Imari).[2]

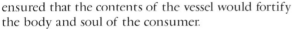

The Nabeshima administration took more active control of local porcelain production as demonstrated by major reorganizations of the kilns in the town of Arita in 1634 and again in 1637, with a consequent upgrading of the quality and quantity.[3] Significantly, an artificial island called Deshima off of Nagasaki Bay was built in 1634 to house foreign trading partners, the same year as the first reorganization of the porcelain kilns. From 1641 to 1853 the Dutch East India Company (*Verenigde Oost-indische Compagnie*, VOC) occupied Deshima and was the only official Western trading partner during that period. It would have been from this port that this flask was shipped to Europe.

International trade through Dutch and Chinese traders became an increasingly important source of revenue for the Nabeshima domain, merchants and the potters. Trade also provided a major impetus for technological and aesthetic improvement of the wares. While the early porcelain vessel forms are mostly dishes and bowls, the vocabulary of shapes such as flaring flasks, bottles and ewers rapidly developed from the later 1640s both for internal and external trade, permitted by technological advances.

The introduction of the polychrome overglaze enamel technique was one such major technological development. The traditional explanation for this overglaze technique comes from a document which records that a Chinese merchant in Nagasaki taught the technique to Sakaida Kakiemon in 1647 who then started creating overglaze enamel decorated porcelain in his kiln in the outer Arita area.[4] The technique soon spread through the Arita kiln area and the red colour caught the imagination of the Japanese potters, merchants and their customers both in Japan and abroad.

With the Nabeshima's growing involvement and oversight of the kilns, the domain created what is known as the overglaze enameller's quarters or the *aka-e machi*. The term *aka-e* literally means 'red painting' referring to overglaze enamel decorated porcelain, while *machi* translates as 'area'. From the 1650s onwards, in this *aka-e machi* area licensed workshops created the lion's share of the overglaze enamel designs on porcelain that had been previously fired in other central Arita kilns. While the potters at the *aka-e machi* created the standard export overglaze wares for both export and domestic distribution, the Kakiemon kiln, which was outside the inner area, created high-level wares for export known as Kakiemon-style porcelain, from the 1660s to the 1690s.

This early overglaze enamel decorated flask was most likely decorated in the *aka-e machi*. It would have then been sent via the port of Imari, about seven kilometres away from Arita, on to Nagasaki by ship where it would have been purchased, most likely by the Dutch VOC traders, and made its way to Europe as a fascinating, early example of the strength of the Arita porcelain designer's vision.[5]

NICOLE COOLIDGE ROUSMANIERE is a Curator in the Department of Asia, British Museum. She is also the founding Director of the Sainsbury Institute for the Study of Japanese Arts and Cultures and a Professor at University of East Anglia.

NOTES

1 Each piece of seventeenth-century Japanese porcelain differs slightly. Similar but not identical examples of this flask can be found in the Walters Art Museum (49.1989), The British Museum (Franks.1025) and the Kyushu Ceramic Museum, Arita.

2 Ôhashi Kôji, *Hizen jiki no akebono, Hyakunenan tôji ronshû, dai ichi gô* (The origins of Hizen porcelain, 100 years of ceramic research, number one)(Arita: Fukagawa Seiji kabushiki kaisha geijutsushitsu, 1988), pp. 3–9.

3 The original document, known as the Yamamoto Jineomon Shigezumi gonenpu, 1647, is located in the Taku Library in Taku, Saga prefecture. Informally it is called the Saga honpon. It was first published in the *Arita Sarayama sôgyô shirabe*, edited by Kume Kunitake in 1873, a text which also mentions the 1634 Nabeshima domain control over the Arita district. See Ôhashi Kôji, *Hizen tôji* (Hizen Ceramics) (Tokyo: Nyû saiensusha, 1989), pp. 23–27.

4 Kôji, *Hizen tôji* (Hizen Ceramics), pp. 27–28.

5 Maeyama Hiroshi, *Imariyaki ryûtsûshi no kenkyû* (Research on Imari Ware Routes) (Saga: Seibundô, 1990).

CROSS-CULTURAL TRANSLATIONS IN A TEACUP

A KAKIEMON-STYLE CUP AND SAUCER AND ITS ENGLISH TEAPOT EQUIVALENT

NICOLE COOLIDGE ROUSMANIERE

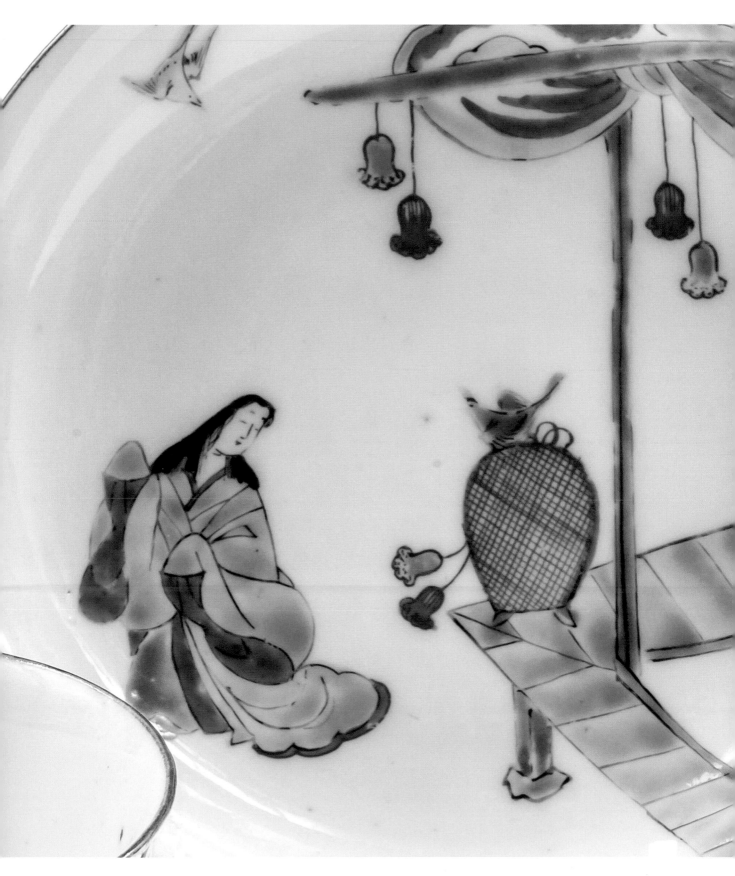

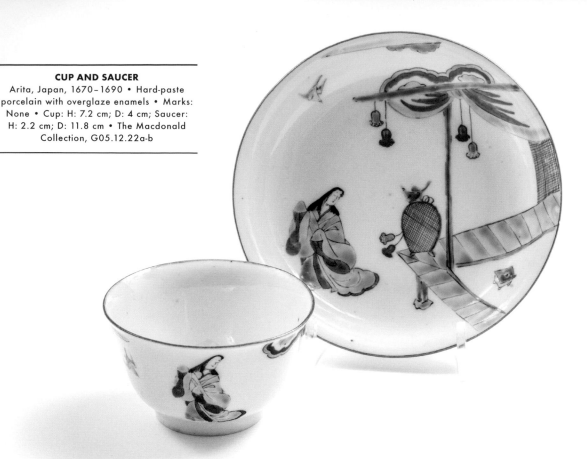

CUP AND SAUCER
Arita, Japan, 1670–1690 • Hard-paste
porcelain with overglaze enamels • Marks:
None • Cup: H: 7.2 cm; D: 4 cm; Saucer:
H: 2.2 cm; D: 11.8 cm • The Macdonald
Collection, G05.12.22a-b

46

The cross-cultural resonances that are contained in this small cup, with its accompanying saucer, and this teapot—created in different countries around 70 years apart, but with related overglaze enamel decorative schemes— are myriad. The shape, the pictorial design and the polychrome colours of both these wares combine to tell a compelling story of international translations. The delicate cup and saucer were made of porcelain in the Kakiemon style in Arita sometime between the 1670s and 1690s, while the striking teapot is made of soft-paste porcelain fired in London at the Chelsea Porcelain Manufactory in approximately 1750.[1]

The small cup and saucer combination was a newly introduced vessel form to the kilns in Arita, made originally for export to the Middle East and to Western markets. Porcelain was only fired for the first time in Japan in the Arita area kilns in the 1610s with the overglaze enamel technique introduced a few decades later, sometime between 1635 and 1640. It was during this later period that Arita fired porcelain was first exported to Southeast Asia. Trade with the Middle East and Europe followed from the late 1650s onwards.[2] This cup and saucer would have been exported to Europe in the second half of the seventeenth century.

The international porcelain trade flourished in the seventeenth and eighteenth centuries. Part of the products' continuing success was the employment of porcelain in the drinking of exotic beverages, itself a product of international trade routes. Coffee and tea enjoyed growing popularity in different measures throughout Europe, the Islamic world and Asia in the seventeenth century. Specialized wares designed for these individual beverages began to be created in Japan from the 1680s based on prototypes depending on the beverage's country of origin. Porcelain specialist Ôhashi Kôji has argued that the Ottoman Court was the first to use matching cups and saucers for the drinking of coffee in and around 1645.[3] The production of matching cups and saucers started in the Arita kilns from the early 1670s—this Kakiemon-style cup and saucer being one such early example.

When Europe began its own manufacture in the early to mid-eighteenth century, porcelain production was both less expensive and quicker to respond to changing local fashion than imported wares. This English teapot, made in the Chelsea Porcelain Manufactory, is one such example of native manufacture. The form itself, based on earlier silver European prototypes, was made of soft-paste porcelain—so named because of the lower firing

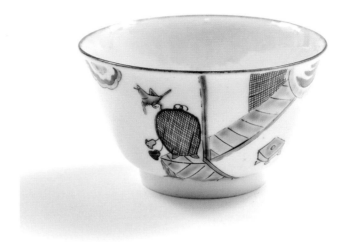

temperature that was required compared to true or hard-paste porcelain such as that fired in China and Japan. Soft-paste porcelain was developed in Europe in the 1730s and was made with white clay mixed with 'frit', a glass-like substance composed of gypsum, soda, sand, salt, alum and nitre. After firing, the ceramic body was soft to the touch and sported a thick clear glaze. The Chelsea factory, which started in 1745, created a new improved formula for its ceramic body and glaze in 1750, in which the body resembled the famed Japanese Kakiemon-style cream-coloured (*nigoshi-de*) porcelain.[4] To help launch this new style, a select number of Kakiemon-style designs were chosen to adorn some of their ceramics, such as the European termed "Hob-in-the-well" and "Old Lady" design, the latter of which is seen in this example. That the Chelsea kilns were copying Japanese designs over 70 years old reveals that the Kakiemon style still had cultural cachet.

The "Old Lady" design is perhaps the most intriguing element of this story, revealing cross-cultural misunderstandings on both shores that nevertheless resulted in a beautiful design which still has a strong visual impact today. The original Japanese design of the "Old Lady" was meant to show a Heian period (794–1185) court woman standing next to the verandah

of a palace building with an incense burner inside; a basket on the verandah (*engawa*) has one bush warbler (*uguisu*) above it and another flying towards it. The original pictorial reference possibly originates with *The Tale of Genji*, an early iconic eleventh-century novel written by Murasaki Shikibu (c. 978–1014 or 1025) about the loves and life of the Shining Prince Genji.

It is possible that this depiction is an abbreviated and adapted version of Chapter 23, entitled in Japanese "Hatsune", or "The First Song of the Bush Warbler", about the New Year's greeting between Prince Genji and the Ladies of the Rokujô Mansion.[5] Traditional depictions show Genji with the court women, a woven basket filled with New Year's delicacies and a bush warbler, with the scene often near to a verandah.[6] On the cup and saucer this has been simplified and stylized with only one court lady depicted.

The "Hatsune" chapter was one of the most popular in *The Tale of Genji* repertoire for use in Japanese decorative arts because of its auspicious symbolism of new beginnings, the most famous example being the exquisite wedding trousseau of Princess Chiyohime in the Tokugawa Art Museum, which was made of lacquer in 1623.[7] While this

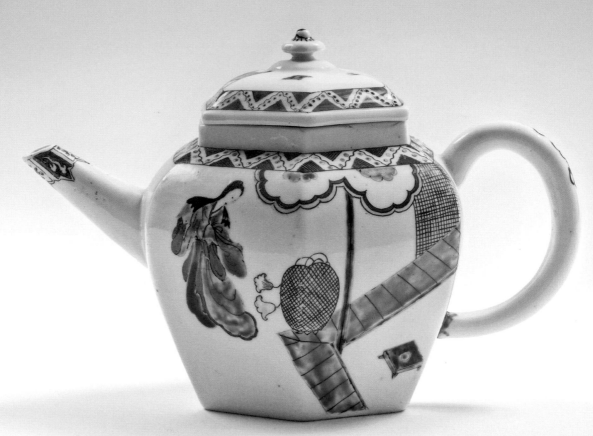

design was rare in the overall Kakiemon-style oeuvre, which mostly focused on bird and flower designs, it caught the imagination of European patrons and was copied in German, French and English ceramic factories mostly from the 1720s to the 1770s. Referred to principally as the "Old Lady" pattern, "Lady in the Verandah" or "Lady in a Pavilion", its original literary eleventh-century connotations were severed. While these designs were often faithfully copied on European porcelain, the original meaning of New Year's felicitations was simplified to that of an exotic motif of a woman in a garden.

The colours of the polychrome overglaze enamels reveal yet more about the works under discussion. In addition to the cream-coloured body on its highest end pieces, the Kakiemon style is best known for its refined and sparse decoration executed with bright enamels in a palette of orange-red, green, overglaze blue, and yellow. The original Kakiemon I, who started the Kakiemon kiln in Arita, received his name from this palette, with "Kaki" referring to persimmon, the colour of his famed orange-red enamel. Most Kakiemon-style porcelains are thought to have been produced for the international export market, particularly for

distribution through the Dutch East India Company (*Verenigde Oost-indische Compagnie*, VOC).

While very popular in Europe, Kakiemon-style pottery appears to have been particularly prized in England. In fact, Queen Mary II (1662–1694) was known to favour this style of ceramic upon her return to England in 1689.[8] Queen Mary's passion for the Kakiemon style made these wares fashionable among English society at the end of the seventeenth century, and as a lasting testimony Kakiemon-style wares can be found in many of the grand houses in Britain.[9]

From the middle to the end of the seventeenth century porcelain export from China was interrupted due to dynastic change and internal rebellion. By the early 1700s, under the new reign of the Kangxi emperor (r. 1662–1722) the Chinese kilns at Jingdezhen had been rebuilt and soon recovered the majority of the international porcelain trade. In China, new overglaze enamel styles were developed for the export market, the first being one based on a green palette, called in Chinese *su sancai* and in Europe *famille verte*. While the Chelsea teapot sports a Japanese Kakiemon-style motif, the design

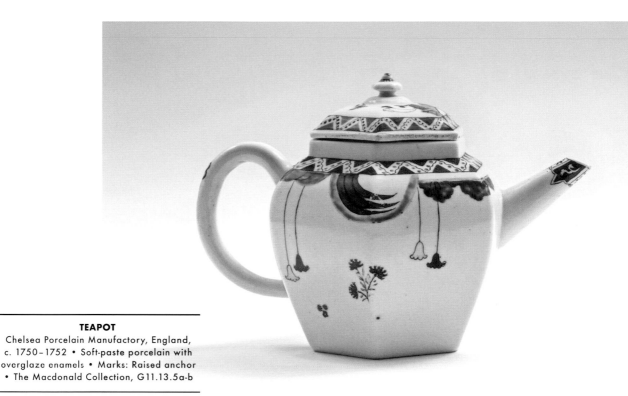

TEAPOT
Chelsea Porcelain Manufactory, England,
c. 1750–1752 • Soft-paste porcelain with
overglaze enamels • Marks: Raised anchor
• The Macdonald Collection, G11.13.5a-b

is executed with more contemporary Chinese Qing style *famille verte* influenced enamel colours. The teapot thus reflects Chinese as well as Japanese influences, though probably inadvertently.

We are provided with a small but important window to view the complexities and interconnectedness of the seventeenth- and eighteenth-century world through this delicate Japanese teacup and saucer and its robust English counterpart. Each tells its own story of the trajectory of form, function and design from Asia to Europe. ◈

NOTES

1 Other examples of the Japanese original version on cups and/or saucers can be found in Burghley House Collection, Stamford, Lincolnshire, The Metropolitan Museum of Art, New York, and the Victoria and Albert Museum, London. The Ashmolean Museum, Oxford, has a very similar saucer that was a donation in honour of the late Dr. Oliver Impey by Mr. and Mrs. William Macdonald in 1993 (1993.6). Examples of this pattern on vessels from the Chelsea Porcelain Manufactory in various forms can be found in the British Museum, London, the Victoria and Albert Museum, London, and the Metropolitan Museum, New York.

2 Nicole Rousmaniere, *Vessels of Influence, China and the Birth of Porcelain in Medieval and Early Modern Japan* (London: Bloomsbury Academic, 2012), pp. 128–143.

3 Ôhashi Kôji, "Oriental Ceramics and the Vicissitudes of the Ottoman Turkish Empire", in *Treasures from the Topkapi Palace* (Arita: Kyushu Ceramic Museum, 1995), p. 126.

4 Julie Emerson, Jennifer Chen and Mimi Gardner Gates, *Porcelain Stories from China to Europe* (Seattle: Seattle Art Museum with University of Washington Press, 2000), p. 178.

5 See Haruo Shirane, *The Bridge of Dreams: A Poetics of The Tale of Genji* (Stanford: Stanford University Press, 1987).

6 Miyeko Murase, *Iconography in the Tale of Genji: Genji Monogatari Ekotoba* (New York: Weatherhill, 1983).

7 *Meihin zuroku* (Nagoya: Tokugawa bijutsukan, Tokugawa Art Museum, 1987).

8 Patricia Ferguson, "The English Market for Kakiemon Style Porcelain and its Western Imitations, 1670–1770", in *Studies of Hizen Porcelain—On Research Issues in England and Germany* (Fukuoka: Kyushu Sangyo University 21st Century COE Program, The Kakiemon Style Ceramic Research Centre, 2008), pp. 15–27.

9 See Oliver Impey, John Ayers and J. V. C. Mallet, eds., *Porcelain for Palaces* (London: The Oriental Ceramic Society, 1990), p. 155, pp. 279–280.

PORCELAIN AS PILGRIM

THE JOURNEY OF
A BLUE-AND-WHITE FLASK

ELLEN HUANG

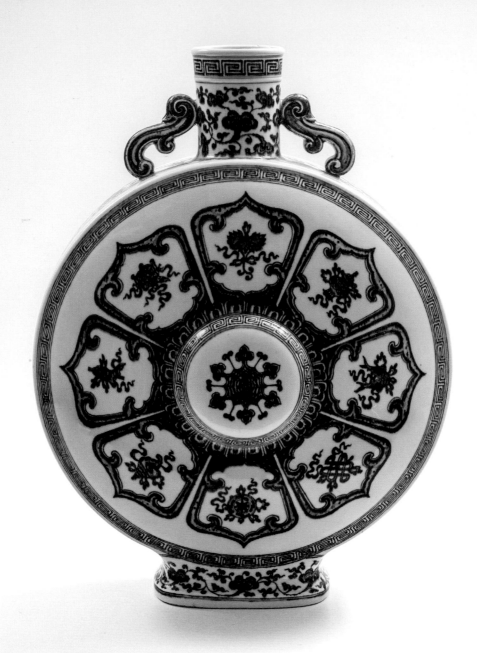

BIANHU (FLASK)

Jingdezhen, China, Qing dynasty, Qianlong period, 1736–1795 • Hard-paste porcelain with underglaze cobalt blue • Marks: "*Da Qing Qianlong nian zhi*" (Made in the Qianlong reign of the great Qing dynasty) • H: 49.8 cm; D: 37.5 cm • The Robert Murray Bell and Ann Walker Bell Collection of Chinese Blue and White Porcelain, G98.9.1

Standing sturdily with perfect balance, this blue-and-white decorated flask reflects the cosmopolitan aesthetics of eighteenth-century Qing China. Since the beginnings of its history, blue-and-white porcelain combined the techniques and tastes born out of global contact and exchange. The world's first blue-and-white ceramics may in fact have originated during the ninth century around the Tigris-Euphrates rivers, an area that encompasses parts

ELLEN HUANG

of modern-day Iraq, Syria, Iran and Turkey. An area rich and well-versed in working with cobalt oxide, skilled designers applied the blue tones of cobalt ore on to earthenware, a porous, dark-coloured ceramic made impervious to liquids, and an opaque white colour through the addition of a tin glaze on its rough surface.

During the thirteenth century, under the pan-Asian endeavours of the Mongol empire in China, otherwise known as the Yuan dynasty (1279–1368), international trade routes expanded by sea and by land, diffusing goods and ideas across diverse places and peoples throughout Eurasia, and connected China with Central Asia and Europe, in addition to such port cities along the Red Sea, Indian Ocean and Southeast Asian archipelago. Such contact between Persian merchants and Chinese goods resulted in the popularity of a new blue-and-white, one of wholly international nature: cobalt oxide mined from the Middle East used to ornament the refined white porcelains made only in Jingdezhen, China. Porcelain from Jingdezhen appealed broadly to consumers in the Middle East, and later Europe, where tin-glazed earthenwares were comparatively less white and less durable. Providing a perfectly smooth, white canvas for complex and brilliant blue designs, the materially superior Jingdezhen porcelain had arrived. Systematic production of Jingdezhen's blue-and-white porcelain in mass quantity began during the early fourteenth century. It was primarily exported through Persian traders and exhibited dense designs of mathematical precision and symmetry, a hallmark of Islamic ornament. Given such cross-border interactions, the rise of blue-and-white porcelain from Jingdezhen, a busy hinterland town located in Southeastern China in the province of Jiangxi, traverses significantly beyond the borders inferred by its commonplace namesake, "china-ware".

Blue-and-white porcelain, rather, connotes a global scope before the era of globalization. Today, Jingdezhen continues to make large quantities of porcelain for the export and domestic market, its repertoire of decorative programs far surpassing the blue-and-white schema that first ignited porcelain's global historical fame.

Both the shape and surface design of this flask are documents of transnational interactions. Its name, *bianhu*, refers to the flask's flattened circular sides. Morphing from water canteens used by

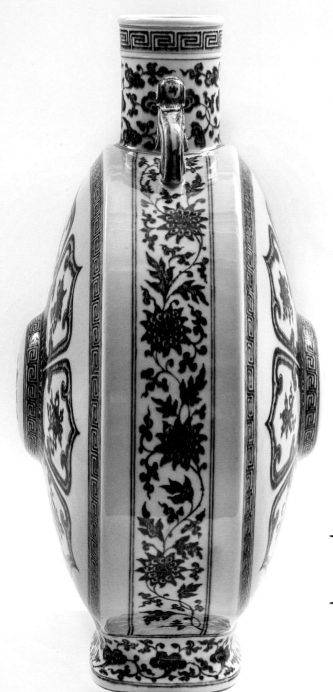

itinerant travellers and nomadic peoples travelling between the Near East and China, the flattened shape draws upon leather containers that hung from saddles of horses caravanning on trade routes along the Silk Roads. Rather than being wheel-thrown, the flask is a composite form: individual components were pressed in moulds, after which they were luted together. The shape first popularized as a form in Persian and Iranian metal and glass and later replicated by Jingdezhen potters using porcelain as the primary medium.

Each circular side is decorated in a blue pattern, with eight radiating lotus petal-shaped panels painted in underglaze blue. Each lotus panel encloses one motif of the Eight Buddhist Treasures, commonly referred to as *bajixiang*. Together, the treasures encircle a central raised boss constituting a stylized flower head divided by keyfret and leaf lappets. Botanical scrolls picturing the auspicious mushroom (*lingzhi*) decorate the long neck and relatively shorter foot, echoing the scroll handles that flank the cylindrical neck.

Introduced from Tibetan Buddhist aesthetic vocabularies into Han Chinese territory, the Eight Buddhist Treasures motif links the piece to broader

Central Asian visual systems. The eight symbols, formalized as a wheel, conch shell, umbrella, canopy, two fishes, an endless knot, lotus flower and vase, highlight the broader world of Inner Asia that preoccupied the Manchu emperors' definition of their Qing empire (1644–1911). As Patricia Berger has shown, artistic production under the Qianlong period collaged disparate visual codes—both script and symbolic—from the diverse traditions over which the Manchu Qing dynasty ruled, including the use of symbols and language from Tibet, Mongolia, Manchuria, as well as the historical territories populated by Han Chinese.[1] Qianlong's visual cosmopolitanism mirrored the empire's territorial expansion, which by the mid-Qianlong reign period (1836–1895) had successfully conquered and annexed major portions of Central Asia and Southeast Asia. Qianlong even understood his position as ruler in terms borrowed from ancient Indian Buddhist traditions, that of a *cakravartin*, meaning 'universal ruler'.

The significance of this blue-and-white porcelain to the worldly splendour of the high-Qing era of the eighteenth century is further reflected in the numerous extant pieces decorated with nearly identical blue-and-white designs. Other examples are housed in such important collections as the National Palace Museum in Taipei, Taiwan; the Palace Museum in Beijing; the Victoria and Albert Museum, London; the Idemitsu Collection in Tokyo; the Denver Art Museum; and the Harvard Art Museum, Boston.[2] In its historical trajectory, shape, design, and geographical dissemination, the Gardiner piece reiterates the significance of blue-and-white porcelain as a global art form specifically, and the universal appeal of the ceramic medium generally.

ELLEN HUANG, PhD, has held postdoctoral and teaching positions at UC Berkeley and University of San Francisco. In 2012 she curated the porcelain exhibition *Made in China*. She has published catalogue essays and academic articles, and is currently working on a book that examines china (porcelain) as China during the Qing dynasty.

NOTES

1 Patricia Berger, *Empire of Emptiness: Buddhist Art and Political Authority in Qing China* (Honolulu: University of Hawaii Press, 2003).

2 Notable examples were sold at Sotheby's Hong Kong, 8 April 2010, lot 1802, and Christie's Hong Kong, 1 December 2010, lot 2826 and 30 May 2006 lot 1239.

MORE PRECIOUS THAN GOLD

EARLY HÖROLDT MINIATURES ON MEISSEN PORCELAIN

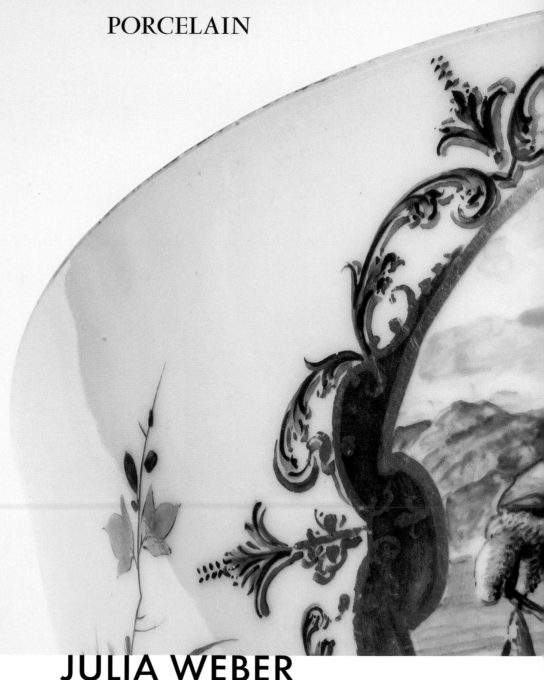

JULIA WEBER

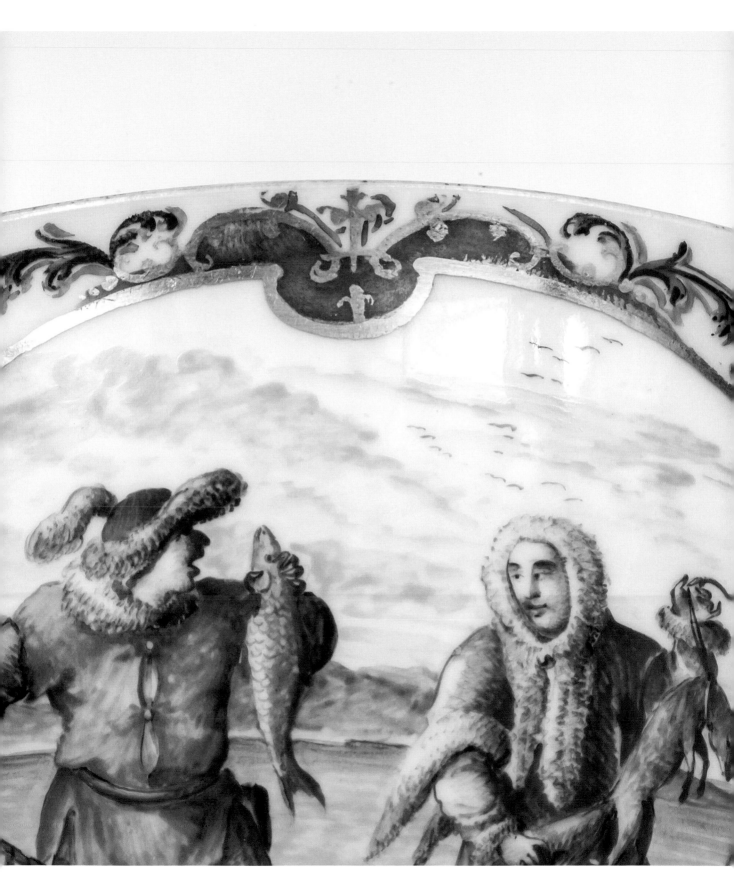

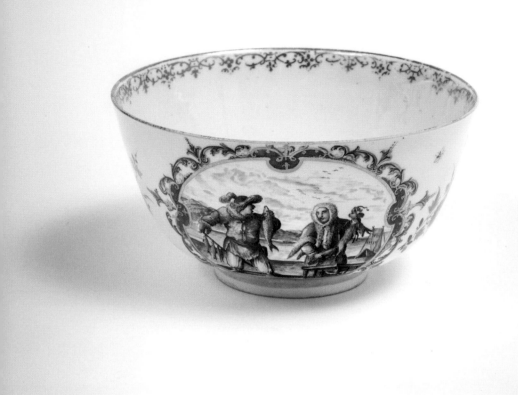

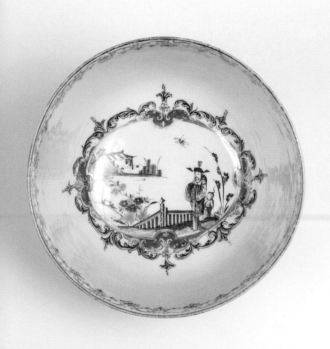

The arrival of Johann Gregorius Höroldt (1696–1775) at Meissen in 1720, ten years after the foundation of the first European porcelain manufactory there, represented a turning point in the history of the young Saxon enterprise. By this date it had gained widespread recognition for having finally seized the secret of the porcelain manufacture from the hands of the Chinese and Japanese. One crucial technology was, however, yet to be mastered: the formula for applying enamels to porcelain. In a time span of less than three years, Höroldt succeeded in developing a number of colours that were even and smooth after firing and his success was reported to the Elector of Saxony, Augustus the Strong (1670–1733), in February 1723. With his delicately rendered paintings Höroldt aroused Europe-wide curiosity for the new colourful Saxon porcelains. He and his four young assistants were, as the report continues, so admired that they were no longer able to meet their orders because of the high number of visitors to their workshop.[1]

Two early Meissen bowls in the collection of the Gardiner Museum demonstrating Höroldt's early and still restrained palette, and showing cartouches framed with very similar Baroque strapwork, can be dated to exactly this period: a teapot once belonging to the same service as the bowl with the cavorting

THE CANADA BOWL
(EXTERIOR AND INTERIOR VIEWS)
Meissen Porcelain Manufactory, Germany,
c. 1724–1725 • Decorated by Johann
Gregorius Höroldt (1696–1775) • Hard-
paste porcelain, enamel, lustre and gold •
Marks: None • H: 8.2 cm; D: 15.5 cm • Gift
of George and Helen Gardiner, G83.1.1258

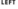

LEFT

STRAAT DAVIS EN HUDSON
Coloured engraving from Carel Allard, *Orbis habitabilis oppida et vestitus*, Amsterdam, c. 1695, plate 77 • New York Public Library, *KB+ 170-

60

dwarves bears the mark "M.P.M." in underglaze blue which we know to have been used in autumn 1722 only.[2] While the whereabouts of the teapot is today unknown, two saucers matching the two Toronto bowls have come to light. The painted scenes on both services pick up on popular motifs of the time: Augustus the Strong specifically collected engravings showing scenes which he stored grouped under the headings "dwarves" and "nations and costumes".[3] Saxon court artists drew on these thematically classified and bound prints when fulfilling commissions for their patron, for example, when designing costumes for masquerades, such as the one in which children performed dressed as dwarves for the amusement of the Elector and his guests in 1721. Masked balls with couples dressed in the typical costumes of different nations were also very popular at the Dresden court. During these carefully choreographed festivities Augustus the Strong presented himself as a sophisticated ruler presiding over an extensive knowledge of the world and all of its regions. The significance of such imagery for the magnificence of the Saxon court is mirrored by the motifs painted on Meissen porcelain. The directness of the link is evidenced by Höroldt's request to be provided with drawings of the costumes worn during the carnival festivities in 1722 to use as models for his workshop.[4]

As was common artistic practice at the time, Höroldt drew his inspiration from printed works on paper with which he had been provided. It was Meredith Chilton, founding curator of the Gardiner Museum, who discovered the actual models for the scenes depicted on the sides of the so-called *Canada Bowl*. In one of the cartouches a man and a woman bundled up in heavy clothing with furred hoods and hats stand on the shore of a lake with craggy mountains in the background. The woman has trapped a bird and holds up a fox while the man has caught fish, some of which is drying on a rack behind them. The composition is taken from an illustration in the book *Orbis habitabilis oppida et vestitus* (*Towns and costumes of the inhabited world*) published in around 1695 by Carel Allard in Amsterdam. The engraving has been given a title: *STRAAT DAVIS en HUDSON*. This locates the scene as taking place in northern Canada. In the bowl's second cartouche a woman holding a basket of fruits points to a reclining man dressed in fur and armed with a bow and arrows who is holding a dead squirrel-like animal towards her. A town on the edge of a lake is silhouetted against the blue sky in the background. Here too, the scene copies a print in Allard's book entitled *NIEU AMSTERDAM at NEW YORK*.[5] A further version of the print bears the heading *CANADA*.[6] The similarity of the costumes being worn by the figures might have

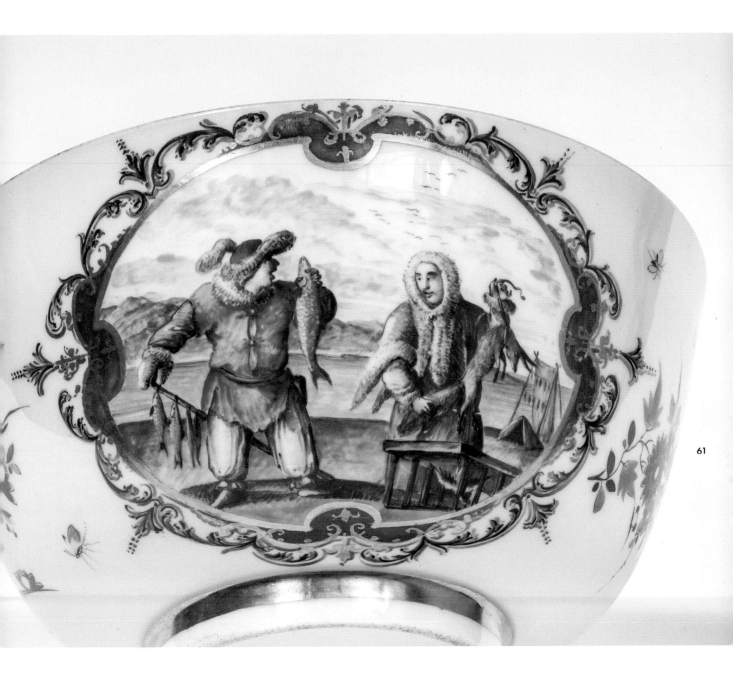

been the deciding factor which led to their combining on one bowl. The painting on a related saucer is also based on an engraving in Allard's book which shows, according to the inscription, English Quakers and tobacco planters on the Antillean island of Barbados. Another, as yet unfound, piece of this service probably depicts a couple in the dress of Goa in India, as this is the fourth scene from the *Orbis habitabilis* which can be found on a sheet with preliminary drawings from the Höroldt workshop still preserved today.[7] The preamble to Allard's book suggests that users of this collection of prints have the opportunity to circumnavigate the world and to admire the costumes and architecture of the furthest flung nations.[8] The same could be said about the one-time owner of the service of which *The Canada Bowl* was once part.[9]

The two early bowls in the Gardiner Museum are superb examples of the brilliancy of Höroldt's delicate designs which were not only praised in the aforementioned report of February 1723 but also beyond. In Dresden and Meissen Höroldt's achievements when it came to the development of porcelain colours as well as a distinct decoration scheme were held in the highest regard. A note from the same year values his work alongside gold—if not more precious than it.[10] ✍

JULIA WEBER, PhD, is curator of ceramics at the Bavarian National Museum in Munich. She recently published a catalogue about Meissen porcelain after Asian examples in the Ernst Schneider Collection in Lustheim Palace.

NOTES

1 Staatliche Porzellan-Manufaktur Meissen, Archives, AA I Aa 6, fols. 167ff.

2 Staatliche Porzellan-Manufaktur Meissen, Archives, AA I Aa 5, fols. 214, 248, 294. The teapot is illustrated in: Timothy H. Clarke, "Equestrian and Other Dwarfs on Early Meissen Porcelain", in *Keramos* 119 (1988), pp. 6–57, figs. 30, 31, 41.

3 See Claudia Schnitzer, "'in angenehmster Ordnung' Die Gründung des Dresdner Kupferstich-Kabinetts als höfische Vorlagen- und Dokumentationssammlung", in *Eine gute Figur machen. Kostüm und Fest am Dresdner Hof* (Dresden: Staatliche Kunstsammlungen, Amsterdam: Kupferstich-Kabinett, 2000), pp. 13–29.

4 See Rainer Rückert, *Biographische Daten der Meißener Manufakturisten des 18* (München: Jahrhunderts,1990), p. 159.

5 Illustrated in Meredith Chilton, "The Canada Bowl", in *Rotunda* (1995), p. 28.

6 Illustrated in Chilton, "The Canada Bowl", p. 27.

7 Illustrated in Thomas Rudi, ed., *Exotische Welten. Der Schulz-Codex und das frühe Meissener Porzellan*, (München: Grassi Museum für Angewandte Kunst Leipzig, 2010), p. 158.

8 See Carel Allard, *Orbis habitabilis oppida vestitus. Städte und Trachten der bewohnten Welt*, Raleigh Ashlin Skelton, ed. (Kassel and Basel, 1996).

9 For pieces from at least three more contemporary Meissen services bearing miniatures based on Allard's book see: Malcolm D. Gutter, "A Notable Discovery. The Earliest Depiction of Americans on European Porcelain", *Keramos 207* (2010), pp. 49–60; William W. Blackburn, "The Length of J. G. Herold's Career as an Artist, and Other Notes", *Mitteilungsblatt der Keramik-Freunde der Schweiz 39* (1957), pp. 33–37, fig. 39; Stewart Museum, Montréal, acc.no.1997.11.1.

10 See Rückert, *Biographische Daten der Meißener Manufakturisten des 18*, p. 159.

OPPOSITE

BOWL WITH FIGURES AFTER CALLOT
Meissen Porcelain Manufactory, Germany, c. 1720–1725 • Decorated by Johann Gregorius Höroldt (1696–1775) • Hard-paste porcelain, overglaze enamels and gold • Gift of George and Helen Gardiner, G83.1.656

ABOVE

SAUCER WITH ENGLISH QUAKERS OF BARBADOS
Meissen Porcelain Manufactory, Germany, c. 1723 • Decorated by Johann Gregorius Höroldt and his workshop • Hard-paste porcelain, overglaze enamels and gold • Victoria and Albert Museum, C.351A-1918 • © Victoria and Albert Museum, London

THE SCOWLING HARLEQUIN

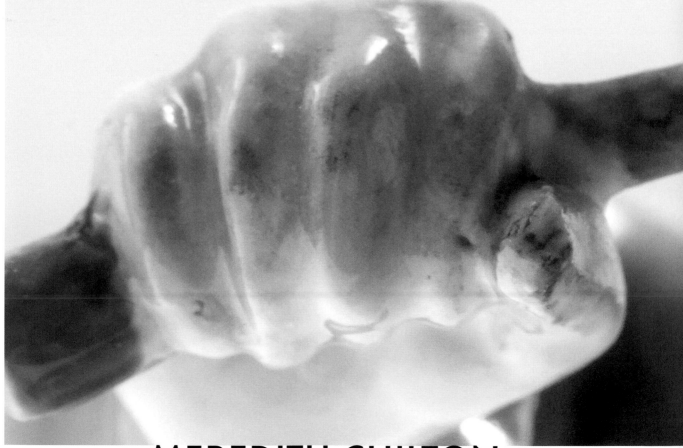

MEREDITH CHILTON

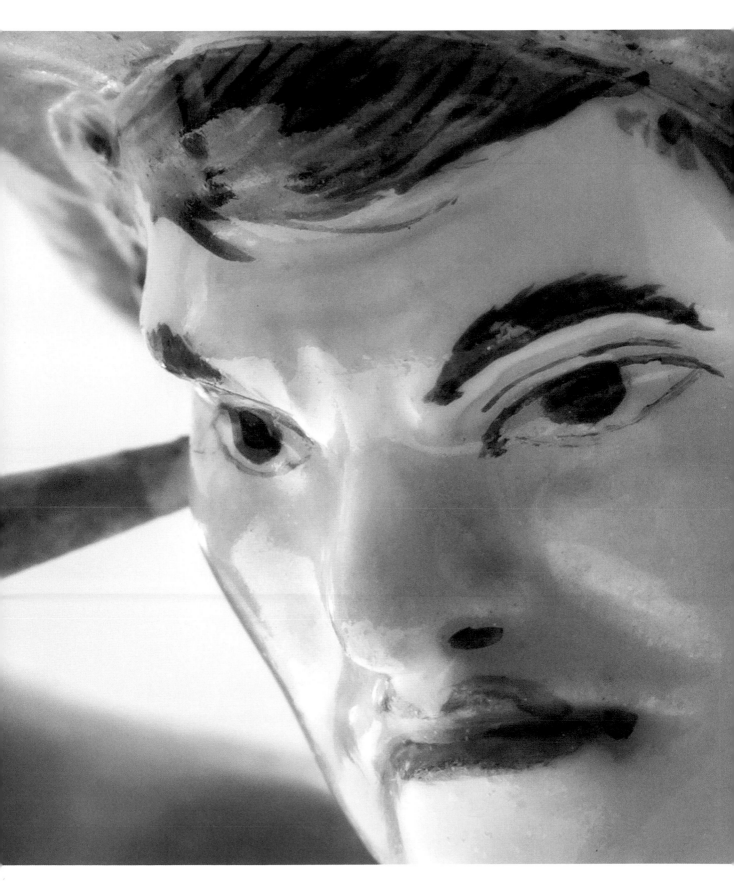

THE SCOWLING HARLEQUIN

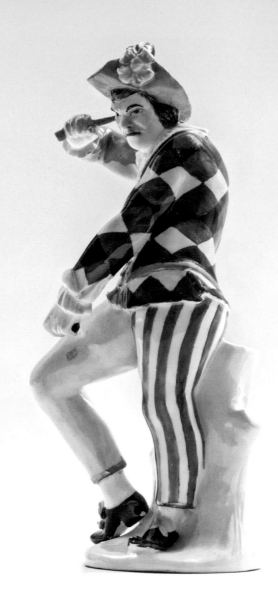

SCOWLING HARLEQUIN
Meissen Porcelain Manufactory, Germany,
c. 1738–1740 • Modelled by Johann
Joachim Kändler (1706–1775) • Hard-paste
porcelain, enamel decoration and gold •
Marks: None • H: 19.4 cm; W: 8.1 cm; D:
10 cm • Gift of George and Helen Gardiner,
G83.1.907

(Green Vaults), which housed the jewels and works of art amassed by Augustus the Strong, Elector of Saxony and King of Poland (1670–1733), and his predecessors. Clearly, Kändler's talent was recognized by the Elector himself, as on June 22, 1731, he was appointed as a sculptor at the Meissen Porcelain Manufactory, "His Most Gracious Highness having commanded that he make all kinds of figures, not only in wood but also in clay, and begin on the work of modelling."[2] Kändler began work on large-scale models of animals and birds for the Japanese Palace in Dresden along with the resident master modeller, Johann Gottlieb Kirchner. The year following Kirchner's departure from the manufactory in 1732, Kändler was appointed master modeller, a position he held until his death in 1775.

From the beginning the young sculptor enjoyed working from life, taking time to study animals in the royal menagerie at the castle of Morizburg, in the royal Bear and Lion Houses in Dresden, as well as preserved exotic animals in the royal collections.[3] It seems beyond doubt that the creative experience of these early years formed the foundation of Kändler's artistic expression. His work in the Green Vaults which exposed him to small-scale sculptures in ivory and precious metals, his knowledge of engravings and current artistic styles, as well his well-honed observations

The fashion for porcelain figures swept through Europe in the eighteenth century; they were eventually made by almost every European porcelain manufactory. These fragile creations were used to ornament rooms as well as embellish the dessert tables of the nobility and wealthy bourgeoisie. No man was more responsible for the development of small-scale porcelain sculpture in Europe than Johann Joachim Kändler (1706–1775), a brilliant and driven genius who worked at the Meissen Porcelain Manufactory.

Johann Joachim Kändler was born in Fischbach in 1706, the son of a pastor whose family had strong roots in stone masonry.[1] When he was 17 years old, the young Kändler completed his apprenticeship as a journeyman to the Saxon court sculptor Benjamin Thomae. For six years he worked in the *Grünes Gewölbe*

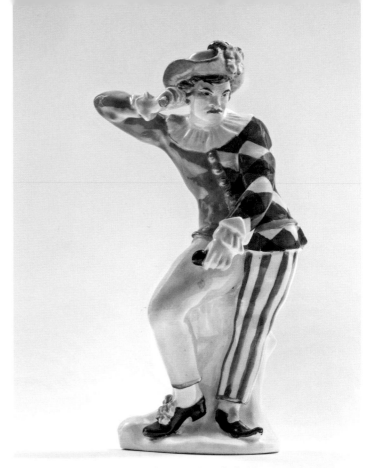

of life all influenced Kändler's radical development of small-scale figurative porcelain sculptures.

K ändler worked on his single, freestanding Harlequin figures—which are among his most celebrated creations—between 1736 and about 1744. At the same time he was producing revolutionary designs for porcelain table services, such as the famous Swan Service for Count Heinrich von Brühl, a proliferation of figurative porcelain sculptures with allegorical, religious or gallant themes, as well as small-scale animals and birds. Much, but by no means all, of his output of this period was listed in his work list, the *Arbeitsberichte*; the *Feierbendarbeit*, which accounted for models he made after hours, and in his *Taxa*, recording work done before 1740 and until 1748.[4]

Curiously, Kändler appears to have made his single Harlequin figures as individual creations, rather than as part of a series.[5] Those recorded in the lists of his output appear randomly on different dates.[6] However, these dramatic porcelain figures are usually grouped and studied together because of their common theme and similar size. The Gardiner collection includes four of Kändler's single Harlequins: the famous Greeting Harlequin, the Harlequin with a Monkey Hurdy-Gurdy, the Harlequin with a Pince-

Nez and the Scowling Harlequin.[7] Along with these individual Harlequins, there are a small number of other freestanding characters from the *commedia dell'arte* which should be considered as part of this specific oeuvre by Kändler. These include a Dancing Mezzetin, a Dancing Columbine, a figure of the Doctor, and possibly a large figure of Pantalone, which was made as a single figure as well as part of a group with a seated actress. Examples of all of these figures, with the exception of the Dancing Mezzetin, are preserved in the Gardiner collection.[8]

The Scowling Harlequin, made at Meissen between about 1738 and 1740, is a particularly powerful model showing an actor contorted with rage, holding an ear trumpet to one ear, with one leg dramatically foreshortened.[9] His bold stance and muscled appearance are reminiscent of an engraving by François Joullain after Claude Gillot, *Arlequin pleurant*, from the series *Les humeurs d'Arlequin*, but Kändler may well have been inspired from life as this figure shows such raw emotion.[10] A troupe of 14 *commedia dell'arte* actors was engaged by Augustus III, Elector of Saxony and King of Poland, to come to Dresden and Warsaw in 1738, just at the time when Kändler is thought to have created the Scowling Harlequin.[11] Harlequin was a mercurial and wily theatrical character, usually a servant and *go-between*, capable of expressing every emotion including

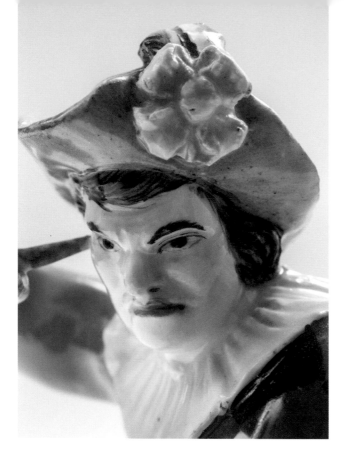

OPPOSITE FROM LEFT

HARLEQUIN WITH A PINCE-NEZ
Meissen Porcelain Manufactory, Germany,
c. 1740–1746 • Modelled by Johann
Joachim Kändler (1706–1775) • Hard-paste
porcelain, overglaze enamels and gold • Gift
of George and Helen Gardiner, G83.1.917

**HARLEQUIN WITH A MONKEY
HURDY-GURDY**
Meissen Porcelain Manufactory, Germany,
c. 1740–1741 • Modelled by Johann
Joachim Kändler (1706–1775) • Hard-paste
porcelain, overglaze enamels and gold • Gift
of George and Helen Gardiner, G83.1.914

GREETING HARLEQUIN
Meissen Porcelain Manufactory, Germany,
c. 1740 • Modelled by Johann Joachim
Kändler (1706–1775) • Hard-paste
porcelain, overglaze enamels and gold • Gift
of George and Helen Gardiner, G83.1.908

anger. He had a razor-sharp wit and always behaved inappropriately. A surviving *commedia dell'arte* scenario, perhaps similar to something Kändler might have witnessed on the Dresden stage, describes a moment of rage: after two *zanni* (a name given to servant characters such as Harlequin) were furiously scolded by the Captain for some misdemeanour, they mocked him by imitating his anger once he had left the stage.[12] It is easy to imagine the exaggerated pose and cruel gestures of the Scowling Harlequin in this context.

The enamel decoration of the Gardiner's Scowling Harlequin is boldly effective. His traditional costume included a multicoloured outfit of patched diamond shapes. Here this has become a minimal reference, but it helps us to identify the character as Harlequin. The Scowling Harlequin's costume is divided into two half sections: one side is brightly patterned, the other simply coloured. Perhaps this illustrates the duality of Harlequin's mercurial nature: a combination of an unpredictable theatrical personality with the common man. Costumes divided into half sections representing different identifiable themes were often seen in the Baroque ballet and at masquerades at this time.[13] A sophisticated audience would have recognized the symbolism of colour, pattern and accoutrements of costume and easily identified Harlequin for the opportunist he was.

A porcelain figure of Harlequin was among George Gardiner's earliest ceramic acquisitions in 1976. By the time the Gardiner Museum was opened in 1984, George and Helen Gardiner had assembled a wide collection of figures inspired by the *commedia dell'arte* from many eighteenth-century European porcelain manufactories. It continues to be one of the most beloved and distinctive collections of the Gardiner Museum. ❦

MEREDITH CHILTON is an independent art historian, who specializes in ceramics from the sixteenth to eighteenth centuries. She was the founding curator of the Gardiner Museum.

NOTES

1 For biographies of Kändler, see Helmut Gröger, *Johann Joachim Kändler, der Meister des Porzellan* (Dresden: W. Jess, 1956); and Samuel Wittwer, *The Gallery of Meissen Animals: Augustus The Strong's Menagerie for the Japanese Palace in Dresden*, John Nicholson, trans. (Munich: Hirmer, 2004).

2 Wittwer, *The Gallery of Meissen Animals: Augustus The Strong's Menagerie for the Japanese Palace in Dresden*, p. 71. Quoted

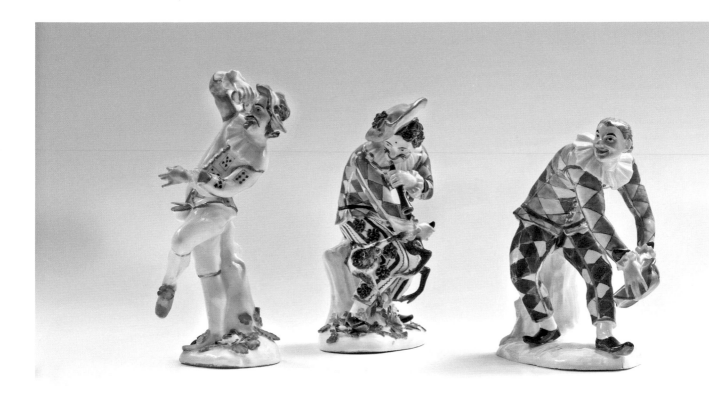

from the Betriebs-Archiv der Staatlichen Porzellan-Manufaktur Meissen GmbH: BA, Ia a.16, fols 4b–5a.

3 Gröger, *Johann Joachim Kändler, der Meister des Porzellan*, p. 33.

4 For the *Arbeitsberichte* see Ulrich Pietsch, ed., *Die Arbeitsberichte des Meissener Porzellanmodelleurs Johann Joachim Kändler 1706–1775* (Leipzig, 2002); for the *Taxa*, Ingelore Menzhausen, *In Porzellan verzaubert, Die figuren Johann Joachim Kändlers in Meißen aus der Sammlung Pauls-Eisenbeiss Basel* (Basel: Wiese, 1993); see also Ulrich Pietsch and Daniela Antonin, *Die Figurliche Meissener Porzellanplastik von Gottlieb Kirchner und Johann Joachim Kändler, Bestandskatalog Staatliche Kunstsammlung Dresden, Porzellansammlung* (Munich; Hirmer, 2006). With thanks to Quillan Rosen and Michele Beiny Inc., New York.

5 Meredith Chilton, *Harlequin Unmasked: The Commedia dell'Arte and Porcelain Sculpture* (New Haven and London: Yale University Press, 2001), p. 296.

6 The figures which appear in Kändler's various work notes include: Harlequin with a 'Passglass' and a bagpipes, c. 1736 (Chilton, *Harlequin Unmasked: The Commedia dell'Arte and Porcelain Sculpture*, p. 294); the Greeting Harlequin, c. 1740 (Chilton, *Harlequin Unmasked: The Commedia dell'Arte and Porcelain Sculpture*, p. 297); Harlequin with a Dog as a Hurdy-Gurdy, c. 1740–1741 (The Jack and Belle Linsky Collection in the Metropolitan Museum of Art (New York, 1984), 176; Harlequin with a Pince-Nez, c. 1740–1746 (Chilton, *Harlequin Unmasked: The Commedia dell'Arte and Porcelain Sculpture*,

p. 299); Dancing Columbine, c. 1740–1744 (Menzhausen, *In Porzellan verzaubert, Die figuren Johann Joachim Kändlers in Meißen aus der Sammlung Pauls-Eisenbeiss Basel*, p. 149).

7 Chilton, *Harlequin Unmasked: The Commedia dell'Arte and Porcelain Sculpture*, pp. 296–299.

8 Chilton, *Harlequin Unmasked: The Commedia dell'Arte and Porcelain Sculpture*, pp. 293, 298, 301.

9 Unfortunately, there is no reference to the creation of this model in any of Kändler's work records. Another version of the Scowling Harlequin shows the character holding a sausage in one hand and a slapstick in the other, see Reinhard Jansen, ed., *Commedia dell'Arte: Fest der Komödianten, Keramische Kostbarkeiten aus den Museen der Welt* (Stuttgart: Arnoldsche, 2001), p. 42, no. 12.

10 Chilton, *Harlequin Unmasked: The Commedia dell'Arte and Porcelain Sculpture*, pp. 189–191, fig. 308.

11 The Bertoldi troupe regularly performed in Dresden and Warsaw between 1738 and 1756. It included Giovanna Casanova, the mother of the author Giacomo Casanova, who played Rosaura, the second lady. Antonio Bertoldi played Harlequin. Menzhausen, *In Porzellan verzaubert, Die figuren Johann Joachim Kändlers in Meißen aus der Sammlung Pauls-Eisenbeiss Basel*, p. 56.

12 Mel Gordon, ed., *Lazzi: The Comic Routines of the Commedia dell'Arte* (New York: Performing Arts Journal Publications, 1983), p. 38. The original lazzi of 1622 is in the Basilio Locatelli in the Biblioteca Casanatense, Rome.

13 Chilton, *Harlequin Unmasked: The Commedia dell'Arte and Porcelain Sculpture*, pp. 39–41.

PORCELAIN DECORATION OUTSIDE THE MANUFACTORIES

HAUSMALEREI PRACTISED BY IGNAZ PREISSLER AND IGNAZ BOTTENGRUBER

MAUREEN CASSIDY-GEIGER

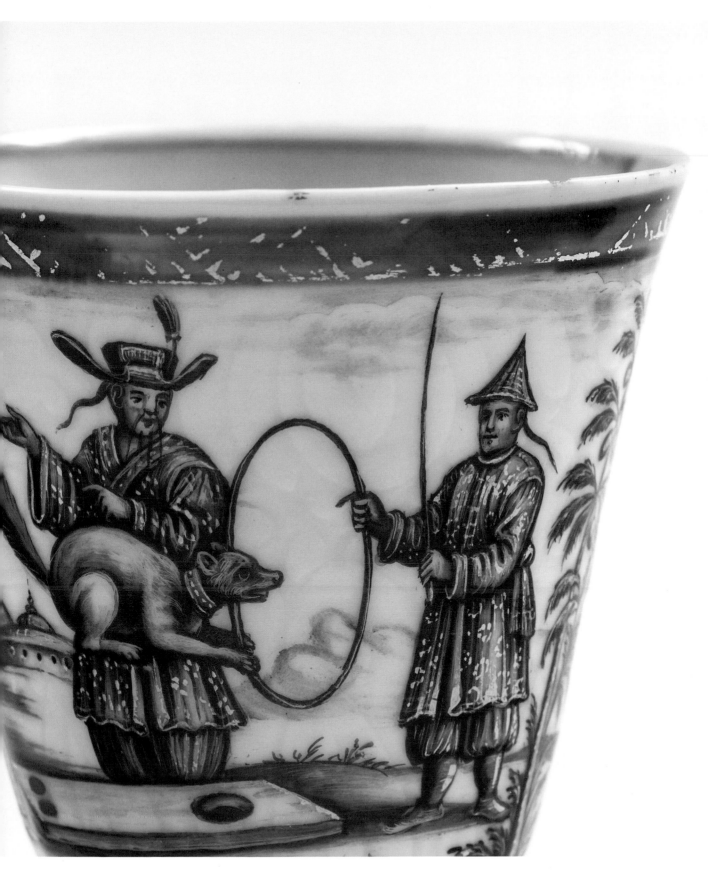

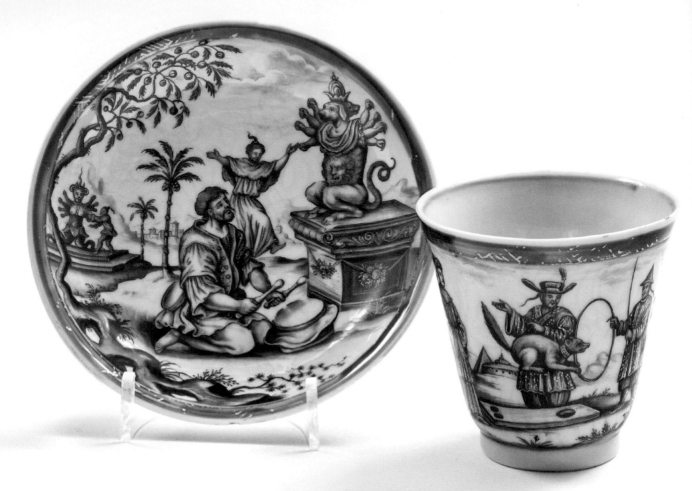

BEAKER AND SAUCER

China, c. 1700; decorated c. 1720–1725 in
Kronstadt, Bohemia, in the manner of Ignaz
Preissler (1676–1741) • Porcelain, underglaze
cobalt blue, iron-red overglaze enamel and
gold • Marks: None • Beaker: H: 7.4 cm; D:
7.6 cm; Saucer: H: 2.5 cm; D: 12.5 cm • The
Hans Syz Collection, G96.5.53a-b

A distinguishing feature of the Gardiner
Museum is its diverse collection of porcelain
painted by independent artists known
as *Hausmaler,* that is, porcelain decorators
who worked outside the confines and
controls of the European porcelain manufactories, in
a wide variety of signature styles. The scholar Gustav
Pazaurek was the first to study the independent
porcelain decorators of the German and Austrian
empires as a group and labelled them *Hausmaler*
(literally, 'painter(s) [working] at home') in his landmark
study *Deutsche Fayence- und Porzellan-Hausmaler* of
1925. Practitioners of an enamelling tradition rooted
in the faience- and glass-decorating workshops of the
seventeenth century, *Hausmalerei* on porcelain was a
short-lived phenomenon that briefly threatened the
European porcelain industry before falling victim
to it.

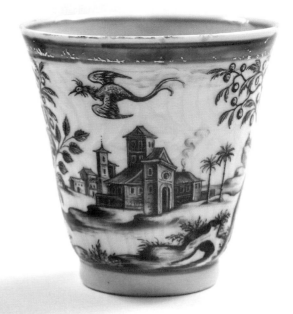

One of the more prolific and recognizable of the *Hausmaler* was the Bohemian decorator Ignaz Preissler (1676–1741), who painted this beaker and saucer with exotic imagery derived from late seventeenth-century Jesuit publications about China and Japan. The tall cup and its en suite saucer belonged to a 142-piece chinoiserie service commissioned by Franz Karl Count Liebsteinsky von Kolowrat, a member of the Austrian elite with estates in Bohemia and Preissler's chief patron from 1729 to 1731. A jug from the service is also owned by the Museum. The porcelain employed for the service, with its underglaze blue rims and markings, was actually manufactured in China and exported to Europe where it was acquired by Preissler's patron in Vienna. Some of the service was painted in iron-red monochrome and some of the pieces were painted in *Schwarzlot* (black enamel), so the 142 pieces must have comprised at least two distinct

services for drinking the fashionable hot beverages of the day: tea, coffee and chocolate. Traces of gilding on the enamelling and rims indicate the service was an expensive showpiece and collector's item that was more for display than everyday use at a time when porcelain was a luxury item for the privileged few.

Ignaz Preissler was a skilled draughtsman with a particular knack for cleverly transferring flat, rectilinear printed compositions and designs on to cylindrical vessels and circular shapes, trimming and editing as needed to fit the contours of the porcelain. On the Gardiner's beaker and saucer, the Asians in gold-flecked robes who are worshipping Asian deities and, on the beaker, training a squirrel, are lifted directly from contemporary chinoiserie engravings published in Augsburg. Preissler dropped these borrowings into his own signature

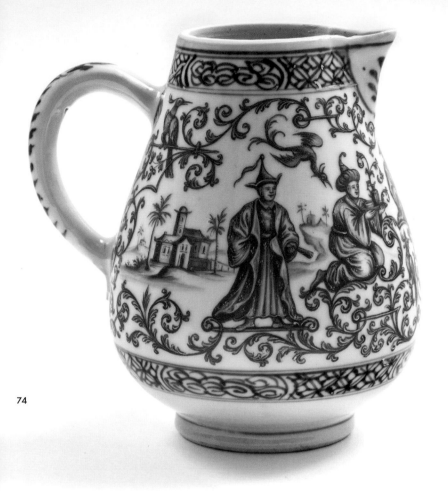

LEFT AND OPPOSITE

MILK JUG
China, c. 1700; decorated c. 1720–1725
in Kronstadt, Bohemia, in the manner of
Ignaz Preissler (1676–1741) • Hard-paste
porcelain, overglaze enamels and gold •
The Hans Syz Collection, G96.5.52

BEAKER AND SAUCER
Meissen Porcelain Manufactory, Germany,
c. 1720; decorated c. 1726 in Breslau,
Poland, by Ignaz Bottengruber (active 1720–
1736) • Hard-paste porcelain, overglaze
enamels and gold • Gift of George and
Helen Gardiner, G83.1.735.1-2

74

landscapes comprising distant lopsided hills, random villages and assertive trees used as framing devices. Dependent as he was on prints, his ornament is usually masterful while his figures can appear a bit cartoonish and stiff. Careful scrutiny shows that the artist scratched fine details into the enamel before firing, a glass-decorator's trick he practised with great confidence and flair. Doubtless he learned his craft from his father, the glass painter Daniel Preissler, with whom he worked side by side for many years. Ignaz Preissler in turn trained an assistant and the artist's own paintings on porcelain and glass are known to have inspired imitators.

Prior to relocating to Kronstadt, where this beaker and saucer were painted, Ignaz Preissler worked in Wrocław (formerly Breslau), Poland, home to the talented *Hausmaler* Ignaz Bottengruber, who is documented from 1720 to 1736. More celebrated in his lifetime than Preissler, Bottengruber spent most of his career with one patron in Breslau before decamping for Vienna. The Gardiner Museum has several examples of Bottengruber's work including a beaker and saucer of the same shape as the Preissler pieces but of Meissen porcelain. The saucer shows the earth goddess Ceres framed by agricultural attributes amid the undulating strapwork and flanked by the dragons that pull her chariot. The Roman god of wine and the grape harvest, Bacchus, is her partner on the beaker. Evidently part of a larger allegorical service with gods and goddesses representing the months of the year, other known pieces depict Neptune, Venus and Apollo. Although loosely based on French ornament prints, Bottengruber's compositions appear organic, original and alive and the overblown gilding is characteristically brassy. In contrast to Preissler, he employed a stipple technique to contour

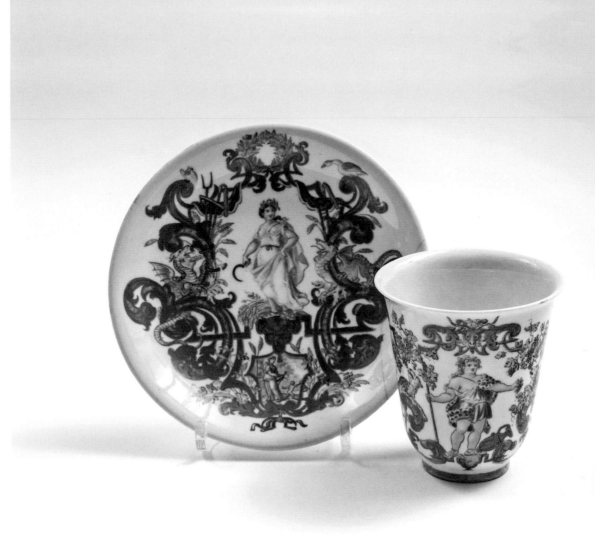

and shape his subjects and favoured a rich palette of colours.

The two Bohemian *Hausmaler*, Ignaz Preissler and Ignaz Bottengruber, worked in very different palettes and styles. Moreover, Preissler was adept at transferring pictorial subjects and ornament on to Chinese porcelain with pre-existing decoration, whereas Bottengruber favoured porcelain blanks from the European manufactories at Meissen and Vienna. Exemplary practitioners of miniature painting on porcelain, they were effectively the last of the independent decorators to work professionally before their fragile tradition evolved into an amateur occupation. ❦

MAUREEN CASSIDY-GEIGER curated Meissen exhibitions at The Bard Graduate Center and The Frick Collection from 2007 to 2008, editing and co-authoring the accompanying catalogues *Fragile Diplomacy: Meissen Porcelain for European Courts, ca. 1710–63* and *The Arnhold Collection of Meissen Porcelain, 1710–50*. She lectures and publishes extensively, and is currently working on a book about the Saxon/Polish crown prince Friedrich Christian.

WHEN DRAGONS SMILE

A BAROQUE FANTASY IN PORCELAIN

CLAUDIA LEHNER-JOBST

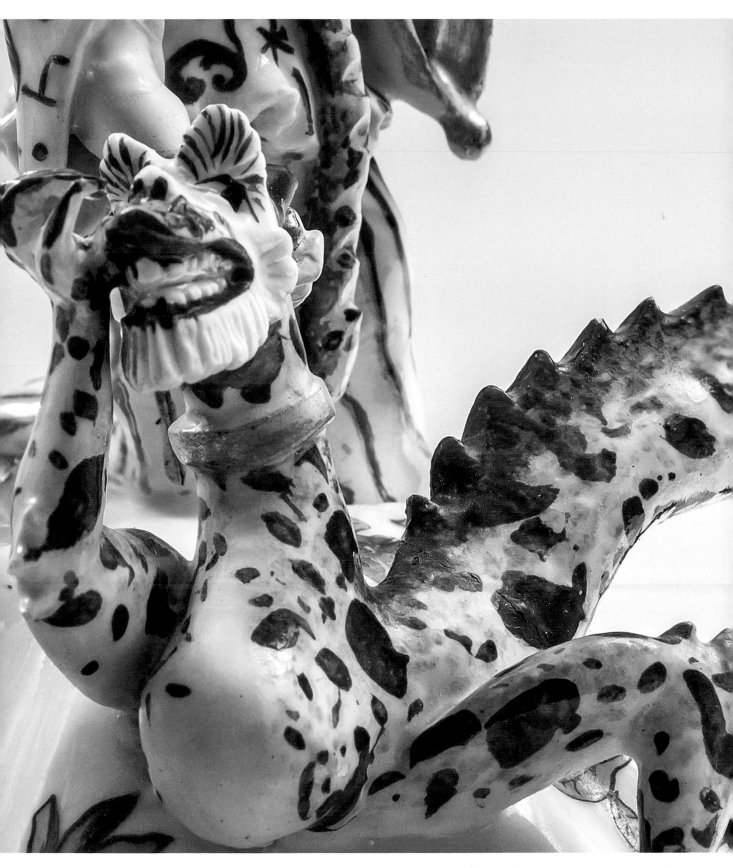

WHEN DRAGONS SMILE

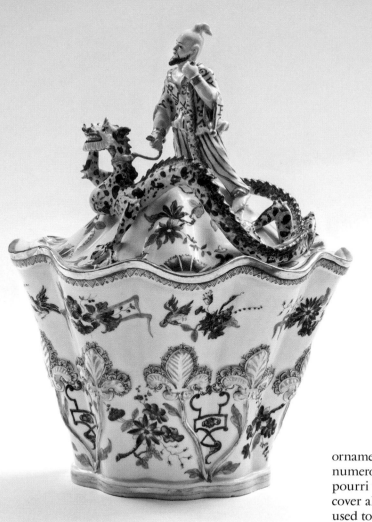

HANGING WALL VASE

Manufactory of Claudius Innocentius du Paquier, Austria, c. 1725 • Hard-paste porcelain, overglaze enamels and gold • Marks: None • H: 14 cm; W: 18 cm • Gift of George and Helen Gardiner, G83.1.1220.1-2

78

This wall vase surely counts amongst the most original and creative pieces in the Gardiner Museum's important collection of Baroque porcelain from the Du Paquier manufactory in Vienna.[1] Artistic fantasy was one of the manufactory's fundamental strengths, which brought forth a wealth of arresting and distinctive forms and décors. It was Europe's second porcelain works after Meissen and operated as a private enterprise from 1718 to 1744.

Watchfully presiding over the vessel, which was in all probability intended to grace a porcelain cabinet, is a green-speckled dragon held by a magician on a gilded leash. Its flattened back with two perforations indicates that the vase was designed to be affixed to a wall, while its plain underside suggests that it may have stood on one of the many consoles customarily mounted on the richly decorated panelling of such cabinets. When one lifts the cover, one finds that the vase has a horizontal fitting that is

ornamented with iron-red arabesques and perforated with numerous small round holes to allow the scent of a pot-pourri to flow out into the surrounding air. This inside cover also has another, larger opening, which could be used to fill the vase with floral pot-pourris, while in the warmer seasons of the year it could be filled with water and the small round holes used to hold fresh flowers. The side of the vase, which is moulded in a wave form, is painted with birds similar to the mythical Chinese *fêng-huang* and with *indianische Blumen* (Indian flowers) in colourful floral sprays made up of chrysanthemums, peonies, prunus blossoms and other Asian species. Applied to the front of the vase are pairs of heraldically shaped gilded lilies that seem to be growing out of the rim running around the bottom. Between the stems of each pair of lilies are what appear to be simplified elements of Viennese *Laub- und Bandelwerk* that are not unlike certain abstract motifs of Chinese ornamentation. Lilies were not only used as heraldic devices in France but also in the southern lands of the German-speaking world. As is usually the case with Du Paquier, lack of archival material makes it impossible to establish who originally commissioned the wall vase. In accord with the Baroque demand for symmetry as a means of ordering the world, the vase would have been complemented with at least one companion piece, as is shown by an identical vase that is

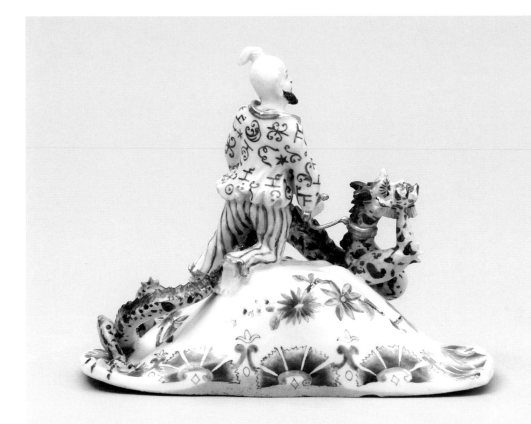

preserved without its cover in the porcelain collection of the Württembergisches Landesmuseum in the Keramikmuseum at Schloss Ludwigsburg.

On account of the Baroque fear that draughts of fresh air might contain unknown elements with unpredictable effects, windows were generally kept closed. Especially in winter, floral pot-pourris were used to freshen up the air in the stuffy rooms and give an impression of cultivation and hygiene. The pot-pourris were made according to elaborate recipes that involved petals and flowers being treated with salt and aromatic essences. Filling rooms in grand houses with the luxurious fragrance of flowers was not only done for the sake of health and hygiene but also to enhance the sensual dimension of skilfully decorated interiors and make them into even more refined settings for gatherings of small circles of guests. Before the advent of porcelain in Europe, wall vases had been made in faience; as an item, they were also familiar to Europeans from Chinese examples that were hung on sedan chairs in order to refresh the passengers inside with the sight and scent of flowers. Collecting flowers was an activity particularly highly regarded by Emperor Qianlong (1711–1799), who had such hanging vases inscribed with flower poems from his own pen.

S ince the seventeenth century the House of Habsburg had been in close communication with the Catholic missions in China and had enjoyed the good will of the Chinese imperial court. The reports sent back by the Jesuits fired the interest of Europeans, who came to regard the luxury objects imported from China as representing the height of exquisite and cosmopolitan taste.[2] As the valuable wares transported on long maritime journeys came from a land that, for the Europeans, was intimately associated with dream-like images, they soon provided inspiration for a stylization of China's strange but obviously highly civilized culture. This development culminated in what is arguably the most appealing and lovable product of the Eurocentrist view of the world: chinoiserie. In this charming genre, an invariable mood of good cheer and serenity was combined with a gently philosophical dimension to generate an effective counterbalance to the stately gesturing of Baroque society.

The ability to exploit this amusing fusion of European and East Asian imagery was one of the secrets behind the success of the first Vienna manufactory. When, in 1718, Emperor Charles VI (1685–1740) granted Claudius Innocentius du Paquier (d. 1751) a charter for the production of porcelain, the wording of the "Privilege" specified the intentions

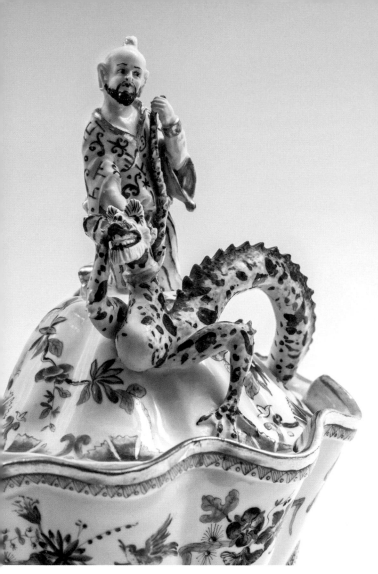

OPPOSITE LEFT

A 'CHINESE' DRAGON-TAMER
Detail from the wall panelling of the "Indian Cabinet" at Schloss Eckartsau (Lower Austria), c. 1730 • Photo: Archive of the author

that were to govern the new project. Among other things, Du Paquier's wares were to surpass the well-known porcelain of East Asia, "with far more beautiful colours, décors, and forms".[3]

Especially noteworthy in this context is the dragon on the cover of the present vase. As one of the four miraculous beasts that helped Pangu, creator of the world in the Chinese tradition, the dragon symbolizes power and strength. With their magical abilities, dragon deities had to be appeased, as their influence extended to the weather, among other things, and thus to the harvest and prosperity in general. The appearance of the dragon is influenced by no fewer than nine different real animals; it has the winding body of a snake, for example, and the claws of an eagle. Although the modeller at the Vienna manufactory would certainly have been familiar with images of Chinese dragons,

he gave his own interpretation of the conventional iconography, so that the traditionally fear-inspiring bared teeth are rendered as a smile and the threatening raised claw as a friendly wave. As magic forms are an integral part of the Chinese tradition, it is not surprising to find that the Vienna dragon is the pet of a 'Chinese' magician with a robe painted with pseudo-alchemistic signs. The Chinese dragons that the Europeans found so exotic and visually appealing also appeared in other branches of the decorative arts. At Schloss Eckartsau (Lower Austria), which was redecorated between 1720 and 1732 for Count Franz Ferdinand Kinsky, for example, the painted panelling of the "Indian Cabinet" in the ladies' tract features wonderfully fierce dragons being looked after or subdued by fearless Chinese-style animal-tamers.

Preserved in The Melinda and Paul Sullivan Collection is an unpainted pair of covers, similar in form to the present example but sadly bereft of their vases, that bear 'frisky' dragons ridden by chinoiserie boys,[4] while further examples with boldly sculpted dragons are a clock case dated 1725 preserved at the Museo Civico in Turin,[5] and a series of four dragon vases at the Metropolitan Museum of Art.[6]

As one of the choice group of objects selected to mark the Gardiner Museum's 30th anniversary,

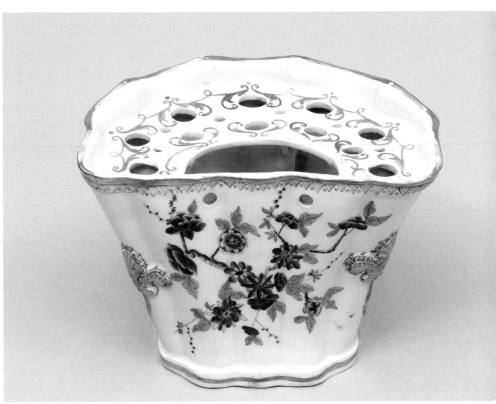

may this prize example of Baroque Vienna's artistic creativity be a source of truly dragon-like strength and spirit in future years.

Translated by John Nicholson.

CLAUDIA LEHNER-JOBST, PhD, lives and works as an independent art historian in Vienna. She was co-editor of *Fired by Passion*, 2009, and has curated several porcelain exhibitions at the Liechtenstein Museum, Vienna. Her recent achievements include the permanent installation of the Strasser Collection of glass for the Kunsthistorisches Museum, Vienna, at Schloss Ambras, Innsbruck.

NOTES

1 See J. P. Palmer and Meredith Chilton, *Treasures of the George R. Gardiner Museum of Ceramic Art* (Toronto: George R. Gardiner Museum of Ceramic Art, 1984), p. 37; Meredith Chilton, "Du Paquier Porcelain", *The Antique Collector* 59/2 (1988), p. 62; Elisabeth Sturm-Bednarczyk, ed., *Claudius Innocentius du Paquier. Wiener Porzellan der Frühzeit. 1718–1744* (Vienna: Edition Brandstätter, 1994), p. 120, cat.138, illus. p. 121; Meredith Chilton, Patricia Ferguson and Susan Jefferies, *A Collection of*

Collections: The Gardiner Museum of Ceramic Art* (Toronto: Gardiner Museum of Ceramic Art, 2002), p. 39; Meredith Chilton, and Claudia Lehner-Jobst, eds., *Fired by Passion. Vienna Baroque Porcelain of Claudius Innocentius du Paquier* (Melinda and Paul Sullivan Foundation for the Decorative Arts, Stuttgart: Arnoldsche Art Publishers, 2009), vol. 3, p. 1322, cat. 419.

2 From 1715 onwards the trading ships of Emperor Charles VI plied the route to Canton flying the imperial double-headed eagle; in 1722 the Emperor founded an East India Company of his own, which was closed down in 1731 under pressure from competing countries, principally Holland and England. See Claudia Lehner-Jobst, "Claudius Innocentius du Paquier and the History of the First Vienna Porcelain Manufactory", in *Fired by Passion*, vol. 1, p. 152.

3 From the imperial privilege granted to Claudius Innocentius du Paquier for the foundation of the porcelain manufactory in Vienna: Privilegium, (27 May 1718) (copy), OeStA, FHKA, NHK, Bancale Akten NÖ 620, fol. 1r.

4 Melinda and Paul Sullivan Collection, Hartford, Connecticut, inv. nos. P 23a, 23b. See Chilton and Lehner-Jobst, *Fired by Passion*, vol. 3, p. 1322, cat. 420.

5 Museo Civico d'Arte Antica, Palazzo Madama, Turin, inv. no. 2674/C. Chilton and Lehner-Jobst, *Fired by Passion*, vol. 3, p. 1328, cat. 445.

6 The Metropolitan Museum of Art, New York, inv. nos. 1995-268.276-1995.268.279, h,g,e,f. Chilton and Lehner-Jobst, *Fired by Passion*, vol. 3, p. 1323, cat. 425 (further dragon vase variants under cat. 422 and 423).

HAVING ARRIVED AT A VERY HIGH LEVEL OF PERFECTION

AN EARLY VASE FROM THE SAINT-CLOUD MANUFACTORY

DONNA CORBIN

HAVING ARRIVED AT A VERY HIGH LEVEL OF PERFECTION

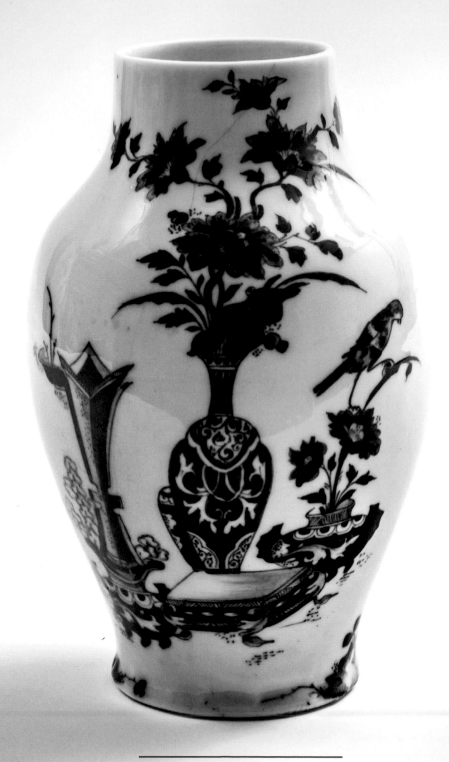

VASE
Saint-Cloud Porcelain Manufactory, France,
c. 1695–1700 • Soft-paste porcelain with
underglaze blue • Marks: None • H: 18 cm;
D: 11 cm • Purchased with funds raised by
the Twelve Trees of Christmas Gala, G97.4.1

DONNA CORBIN

In the account of his visit to the Saint-Cloud porcelain manufactory in 1698, the eminent English scientist Martin Lister wrote, "I saw the Potterie of the St. Clod, with which I was marvelously well pleased, for I confess I could not distinguish betwixt the Pots made there, and the finest China Ware I ever saw."[1] As the first factory in Europe to manufacture porcelain on a commercial scale, Saint-Cloud had a pioneering role in the history of porcelain production. Since Asian porcelain made its first appearance on the continent, Europeans had marvelled at the beauty of this mysterious material, and more than a few had attempted its manufacture. These early enterprises, including one famously financed by Francesco Maria de'Medici (1541–1587) that operated in Florence between 1576 and 1587, lacked the scientific know-how necessary to determine the composition of the porcelain body, and most relied instead, with limited success, on established ceramic materials and methods.[2]

A factory to produce tin-glazed earthenware (faience) was established at Saint-Cloud on the banks of the Seine to the west of Paris by Claude Révérend in 1666. In 1674, the manufactory was leased to Barbe Coudray and her husband Pierre Chicaneau I, a faience painter. Chicaneau experimented with porcelain production, and the experiments were continued after

his death in 1677 by Coudray, the Chicaneau children and her second husband Henri Trou I, who purchased the factory outright in 1683. In an effort to protect the success of their endeavours, Coudray and her children petitioned for, and were granted in 1702, *lettres patentes* for the manufacture of porcelain "in imitation of that of China and the Indes"; the petition included the claim that the secret of porcelain was discovered by them in 1693 after some 16 years of experimentation. In spite of this, a porcelain factory at Saint-Cloud was not officially established until 1697.[3]

In the early years, every aspect of the production was safely guarded and even in 1704 a porcelain factory was little in evidence.[4] In part because of the factory's success in maintaining secrecy around their activities, from its founding until 1730 when a manufactory was established with the backing of Louis-Henri de Bourbon, Prince de Condé (1692–1740) at Chantilly, Saint-Cloud enjoyed a virtual monopoly on porcelain production in France.[5] In a period when the distinction between porcelain and tin-glazed earthenware was not always made, the *Mercure de France* of December 1700 declared that Saint-Cloud had "no parallel in all of Europe".[6] The *lettres patentes* granted to Saint-Cloud were subsequently renewed

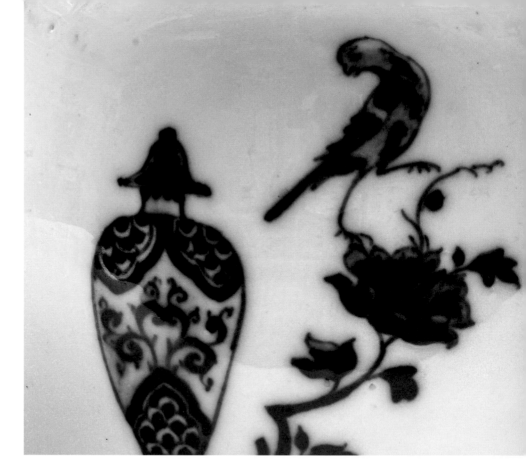

in 1713, 1722, and 1742, and the factory remained in existence under the ownership of descendants of the Chicaneau and Trou families until 1766 when competition from the royal manufactory at Sèvres along with other factors forced its closure.[7]

The Museum's remarkable vase dates from around the time the factory was established, making it among the earliest pieces of porcelain made at Saint-Cloud.[8] It belongs to an extraordinary group of mostly vases with underglaze blue decoration—a technique that was perfected shortly after the mastery of the porcelain body and the first of several Asian styles copied at Saint-Cloud—that is dated to the late 1690s and that in the past was attributed to the Rouen manufactory.[9]

In both shape and decoration, the Museum's vase is derived from a Chinese model, possibly one in the possession of Louis XIV's brother, Philippe, duc d'Orléans (1640–1701). During his lifetime, the Duke, who directly or indirectly may have extended support to the nascent Saint-Cloud factory, amassed a large collection of Chinese and Japanese porcelain, some of which was housed in his château at Saint-Cloud. The Duke's collection of Asian porcelains would have been known to Henri Trou who is recorded in contemporary documents as both an usher (*hussier du duc d'Orléans*) and an officer in the Duke's household, and from 1684 until his death, as an occasional painter at the Duke's château.[10]

The decoration on the Museum's vase, comprising of two vases, an incense burner and a low table, was known in China, where it was employed on a range of decorative objects including porcelain and lacquer in the early Qing period (1644–1911), as the "Hundred Antiquities", or *bai gu*.[11] In China, the "Hundred Antiquities" represent the attributes of a cultured life and symbolize the material success that, according to Confucian belief, will come with study and diligence. However, without a context for deciphering its meaning, the significance of the decoration was most likely lost on Saint-Cloud's otherwise sophisticated French clientele that even at this early date included elite members of society and the royal family.[12]

Similar groupings of antiquities appear on two other pieces of Saint-Cloud porcelain from the same period: a vase in the collection of the Metropolitan Museum of Art on which the Chinese symbols are combined in a rather unconventional way with human and animal forms taken from the engravings of Jacques Androuet Du Cerceau (c. 1515–1585)[13] and a vase in a private collection that bears an unusual pseudo-Chinese mark.[14]

DONNA CORBIN

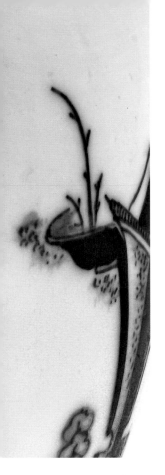

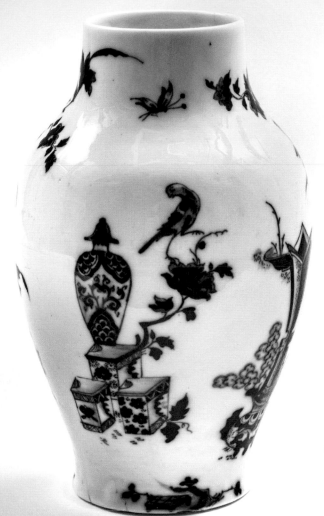

Like the decoration, the shape of the Museum's vase is modelled on a Chinese prototype, examples of which can be seen among the Asian-export porcelains and lacquers in a late seventeenth-century Netherlandish depiction of a shop.[15] Judging from contemporary sources and extant examples, it would seem that ornamental wares including vases represented a substantial portion of the factory's output at the end of the seventeenth century; some 204, divided between the manufactory and its retail outlet on the rue Coquillière in Paris, were included in the 1700 estate inventory of Henri Trou.[16] Interestingly, despite the European demand for vases that would increase as the eighteenth century progressed, for whatever reason, they ceased to be part of Saint-Cloud's production after the early years of the century.

Among the objects listed in Trou's estate inventory are vases described variously as *urnes* (covered jars), *cornets* (beakers), *calebasses* (gourds), and *rouleaux* (cylindrical-shaped vases); the inventory suggests the vases were intended to "serve for garnitures of chimneypieces". Further indication of possible methods of display of both Saint-Cloud vases and the Asian ones from which they took inspiration is provided by the 1689 inventory of the collection of Chinese porcelain belonging to the Grand Dauphin (1661–1711), son of Louis XIV. At the Dauphin's château at Meudon, vases were displayed on tops or stretchers of tables, on carved and gilded wall brackets, and on the cornices of rooms in a fashion similar to that depicted in the engraved interiors views of Daniel Marot (c. 1663–1752).[17]

While it is impossible to know who the original owner of this wonderful vase was it certainly would have been a proud possession. Today it serves as an excellent reminder of the astonishing innovation and creativity that was achieved by the Saint-Cloud manufactory at the dawn of the eighteenth century.

DONNA CORBIN is the Chairman of the American Ceramic Circle, and the Louis C. Madeira IV Associate Curator of European Decorative Arts at the Philadelphia Museum of Art, a position she has held since 2004.

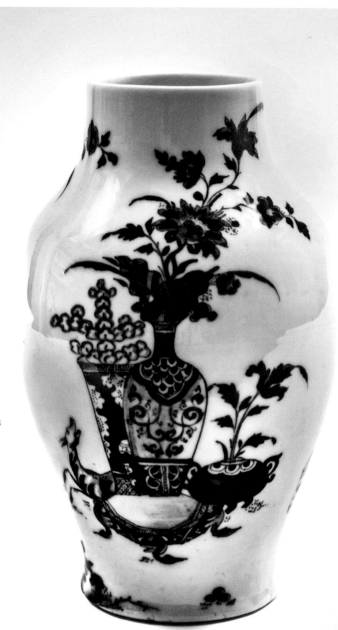

NOTES

1 Martin Lister, *A Journey to Paris in the Year 1698* (facsimile of the third edition of 1699) (Urbana: University of Illinois Press, 1967), p. 139.

2 The porcelain produced at Saint-Cloud, referred to as "artificial" or soft-paste (*pâte tendre*), consisted of a special composition called "frit". With a few exceptions, soft-paste, which was fired at a lower temperature than the "true" or hard-paste (*pâte dure*) porcelain of China and Japan that the Europeans were striving to imitate, was produced in Europe prior to the discovery of hard-paste porcelain at Meissen in 1709. In France, soft-paste continued to be made until after kaolin, one of two primary ingredients in hard-paste, was discovered near Limoges in the late 1760s.

3 Under Louis XIV (r. 1643–1715), the system of *lettres patentes* (formal letters to the parliaments from the king), which in part exempted entrepreneurs like the Chicaneau family from various established legal obligations, were intended to provide a favourable environment for the production of goods, in particular, luxury goods, limit competition and encourage the development of new technologies. A previous *lettre patente* had been granted to Claude Révérend in 1664, the same year in which Louis XIV's minister, Jean-Baptiste Colbert, founded the French Compagnie des Indes in an effort to increase France's involvement in the lucrative trade with Asia.

4 G. Le Duc and R. de Plinval de Guillebon, "Contribution à l'étude de la manufacture de faïence et de porcelaine de Saint-Cloud pendant ses cinquante premières années", *Keramik-Freunde der Schweiz Mitteilungsblatt* Nr. 105, (March 1991), p. 8.

DONNA CORBIN

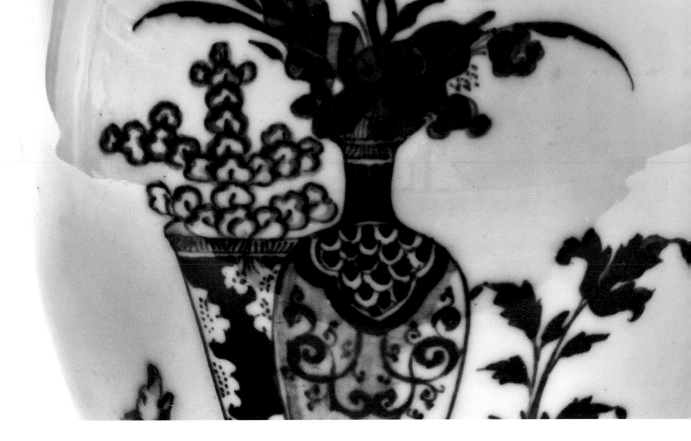

5 Before the establishment of the Chantilly manufactory, Saint-Cloud's only real competitors were the Rouen factories of Edme and Louis Poterat. The Poterat factories however were largely producers of faience, porcelain being a less important and less successful part of their business. Several smaller enterprises were also in operation in Paris in the early eighteenth century. Of those known today, several were offshoots of Saint-Cloud owned by members of the Chicaneau family, such as Pierre II, and at least two, those founded by Pierre Pélissié and Jean-Baptiste Bellevaux, were operated by workers from Saint-Cloud who had defected with some knowledge of the secret.

6 Bertrand Rondot, ed., *Discovering the Secrets of Soft-Paste Porcelain at the Saint-Cloud Manufactory c. 1690–1766* (New Haven: Yale University Press, 1999), p. 17.

7 For the history of the Saint-Cloud manufactory see Le Duc and de Plinval de Guillebon, "Contribution à l'étude de la manufacture de faïence et de porcelaine de Saint-Cloud pendant ses cinquante premières années", and Rondot, *Discovering the Secrets of Soft-Paste Porcelain at the Saint-Cloud Manufactory c. 1690–1766.*

8 The vase likely originally had a cover.

9 See Rondot, *Discovering the Secrets of Soft-Paste Porcelain at the Saint-Cloud Manufactory c. 1690–1766*, p. 264.

10 Le Duc and de Plinval de Guillebon, "Contribution à l'étude de la manufacture de faïence et de porcelaine de Saint-Cloud pendant ses cinquante premières années", p. 49.

11 *The World's Great Collections: Oriental Ceramics*, Vol. 7. Musée Guimet, Paris (Tokyo and New York: Kodansha International, 1981), pp. 171–172, no. 82, fig. 82. The Hundred Antiquities decoration also appeared on pieces of French faience and Dutch delft, see Christine Lahaussois, *Faïences de Delft* (Paris: Réunion des musées nationaux, 1994), p. 86, no. 74.

12 "C'est ainsi qu'ils pourront écrire en 1700 que depuis plusieurs années ils fournissent le Roi et toute la maison royale 'en tasses, soucoupes et autres vases de porcelaine qui servent à prendre le thé, le café, le chocolat et les autres liqueurs bouillantes qui est ce qu'il y a de plus périlleux à l'égard de la porcelain fine et transparente.'" Le Duc and de Plinval de Guillebon, "Contribution à l'étude de la manufacture de faïence et de porcelaine de Saint-Cloud pendant ses cinquante premières années", p. 15.

13 Metropolitan Museum of Art, New York (17.190.1911).

14 Rondot, *Discovering the Secrets of Soft-Paste Porcelain at the Saint-Cloud Manufactory c. 1690–1766*, p. 73, figs. 6-1, 6-2.

15 Victoria and Albert Museum, London, Interior of a Chinese Shop, possibly The Netherlands, 1680–1700, gouache on paper mounted on a wood panel, P.35-1926.

16 Le Duc and de Plinval de Guillebon, "Contribution à l'étude de la manufacture de faïence et de porcelaine de Saint-Cloud pendant ses cinquante premières années", p. 18.

17 Sir Francis Watson and John Whitehead, "An Inventory dated 1689 of the Chinese porcelain in the collection of the Grand Dauphin, son of Louis XIV, at Versailles", *Journal of the History of Collections*, Vol. 3, (1991), p. 17.

POT-POURRI POMPADOUR

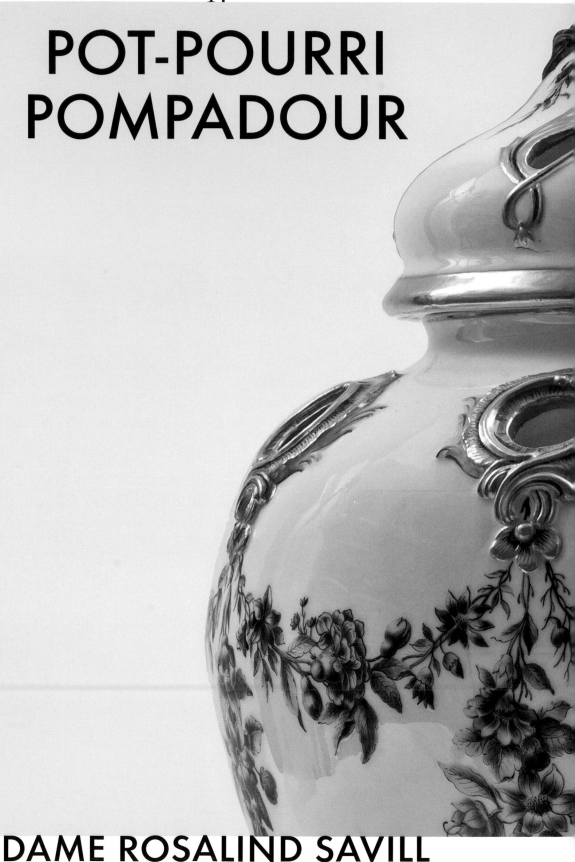

DAME ROSALIND SAVILL

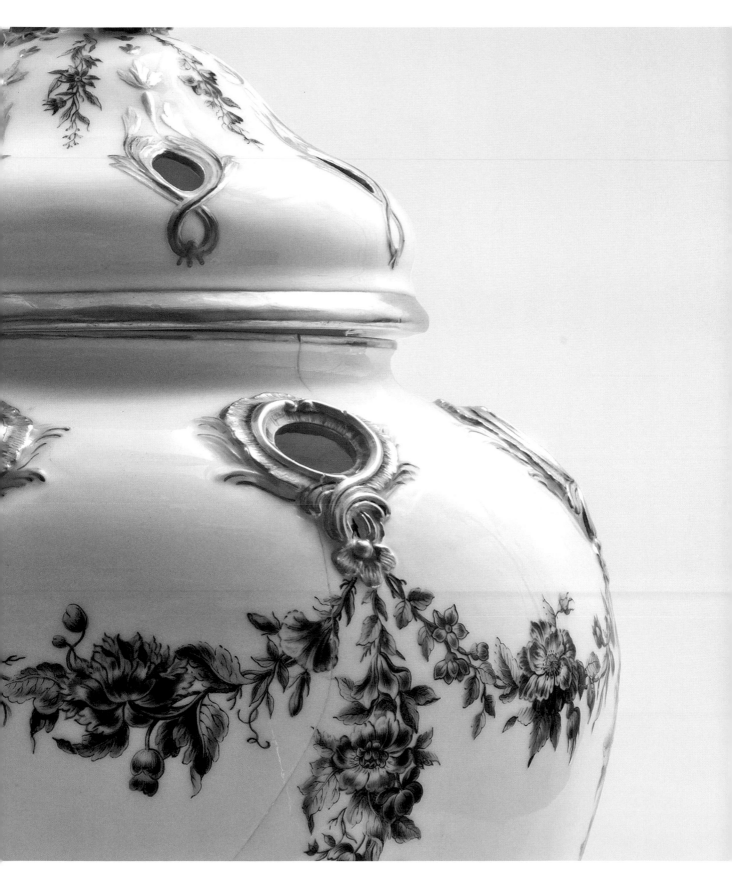

POT-POURRI POMPADOUR

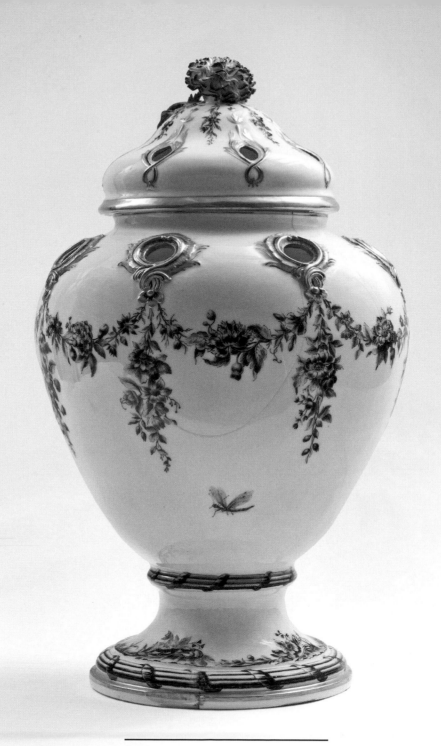

POT-POURRI VASE
(POT-POURRI POMPADOUR)

Vincennes Porcelain Manufactory, France,
c. 1752 • Modelled by Jean-Claude Duplessis
(c. 1695–1774) • Soft-paste porcelain,
enamel and gold • Marks: Interlaced "L's"
in blue enamel and three dots • H: 31.5
cm; D: 25.5 cm • Gift of George and Helen
Gardiner, G83.1.1095.1-2

DAME ROSALIND SAVILL

One of the great joys of ceramics is savouring a single object that is both tinglingly tactile and redolent with the history of its time. This pot-pourri vase, made at Vincennes c. 1752, at the height of the Rococo period, reflects in its shape and decoration the bold curves, sculptural scrolls, rocky elements and watery wave patterns typical of this most naturalistic of styles. But, above all, in its decoration and function, it exudes the richness of flowers, modelled, painted and contained within, as it exemplifies the quintessential mid-eighteenth-century French desire to bring the garden indoors. It loudly proclaims that it could only have been made at this moment in the history of porcelain.

The French Royal factory of Vincennes, founded in 1740 and moved to Sèvres in 1756, attracted from Paris the greatest chemists, sculptors and painters of its day. But one man, the sculptor/goldsmith to Louis XV, Jean-Claude Duplessis (c. 1695–1774), was best able to design models that celebrated this new naturalism while also understanding the volatile nature of soft-paste porcelain. This glorious, translucent, creamy-white material was all too easily damaged by the punishing effects of many firings in the manufacturing process, but Duplessis' ingenious rounded forms often masked sagging, cracking and other firing imperfections.

He also perfected the art of elegant, sturdy and practical designs for the fashionable uses of his time. His drawing for this pot-pourri vase, still surviving in the Archives at Sèvres, shows how he intended it to be well-grounded so that it would not be easily knocked over, and with large openings to emit the perfume from inside, but his eight holes on the shoulder were later reduced to six, presumably to avoid weakening the vase at its widest, most vulnerable curve. The model was in production in 1751 and was made in four sizes; the two smallest were made in greater numbers, the larger sizes being much rarer: apparently only five examples of the first size and two of the second size are known to survive, the Gardiner vase being of the second size. Such gigantic vases were particularly difficult to manufacture and so seem to have been made for only a short time in the early 1750s.

The relief details and painted decoration echo each other beautifully. The perfume holes are framed by wave-patterned cartouches which, on the vase, emerge from a single flower in relief, and on the cover tail off into a *fleur-de-lis*. The life-size, fully three-dimensional carnation on the knop of the cover is an exquisite reminder of the

hundreds of individually modelled and naturalistically painted Vincennes flowers which were mounted on metal stems and set in a variety of Duplessis' flower vases. They were sometimes mixed with real garden flowers, or even perfumed with the right scent to trick the eye and delight the nose, and to last longer and beyond the flowering season of real flowers. The painted decoration continues the garden imagery, with fountain-like rockwork on the foot and grand swags of flowers emerging from the relief flowers below each hole, and introduces some wildlife in the form of a fly and an insect crawling across the vast white body of the vase. The purplish-pink tonality of the flower garlands and rockwork is typical of early Vincennes, as is the unusual banding in crimson and purple around the foot and base of the body of the vase, and also echoed in blue and pink round each hole. Unlike other decorative arts, the colours on ceramics never fade, so these pinks and blues are a true reflection of the palette of the interiors of their time.

The model was named after Louis XV's mistress, the then 30-year-old Jeanne, Madame de Pompadour (1721–1764), whose infectious enthusiasm for the factory was increasingly shared by the King. She was always among the first buyers of Duplessis' new models, cleverly created to serve innovative and practical needs within the home, from dinner, tea and *toilette* wares, to useful and ornamental vases, decorative sculpture, snuff-box plaques and even dog bowls. Her earliest passion was for the Vincennes porcelain flowers mounted on metal stems, buying vast quantities of them from 1747, if not before. At this time the idea of the pot-pourri vase was emerging at Vincennes, soon to be followed by the shrewd tactic of occasionally naming models after valued patrons, resulting in Madame de Pompadour being honoured by this vase *Pot-Pourri Pompadour* of 1751. It cleverly recognized her passion for flowers, and was to lead to a range of increasingly complicated pot-pourri vases, including some shaped as ships or fountains, that she was to buy over the next ten years. She obviously delighted in bringing fragrance into her rooms and this model was to prove a great success, with her buying a minimum of 12 specified examples between 1751 and 1753 for her châteaux at Bellevue, Marly and Saint-Ouen, and for the Hôtel Pompadour in Paris, and probably many more which are generically listed as Vincennes pot-pourri vases.

This vase would have been filled with an intoxicating mixture of dried flowers, herbs and spices. A recipe published by Madame Menjaud c. 1750 lists

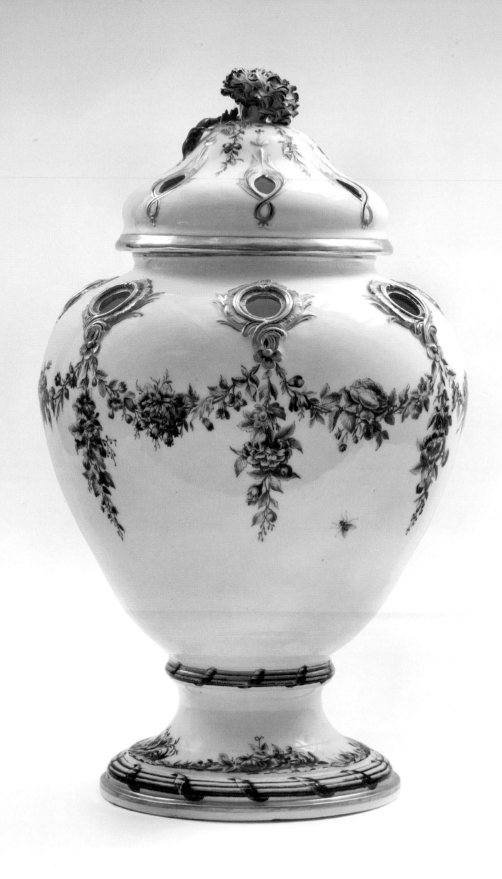

POT-POURRI POMPADOUR

a vast variety of ingredients, including flowers (single red roses, musk roses, orange flowers, single crimson pinks, sweet clover, violets, lavender, iris, balsam and hyssop), trees (myrtle, French bay, benzoin [gum Benjamin tree], cyprus and cedar), fruits (lemon and orange rind), herbs (basil, rosemary, sage, thyme and marjoram), and spices (cinnamon, cloves, white pepper and nutmeg), mixed with such aromatic waters as rosewater and "Queen of Hungary" water (a precursor to *eau-de-Cologne*, with rosemary steeped in brandy, but also including bergamot, jasmine, marjoram, orange blossom, lemon and amber). Myrtle leaves and orange-flower water were also used to revive the mixture when it became too dry. Pot-pourri vases filled with such exotic delicacies would scent the room and conceal the inevitable odours in the days of meagre hygiene and poor sanitation.

Pot-pourri vases were displayed in both formal and intimate rooms, but it is likely that one as large as this would have been on show for all to admire. It could have been placed on a chimneypiece, on a table in the centre of a room, or on a console table between the windows; Madame de Pompadour had a Vincennes example on a chimneypiece in her Hermitage at Fontainebleau.

She also used pairs of smaller examples to perfume bathrooms and *garde-robes*, and it is possible that sometimes such vases were decorated to match the painted schemes of the bathroom.

This rare Vincennes vase is too early for it to have the marks to show who painted or gilded it and when, or to identify who bought it in the factory's sales records, but it needs no such enhancement. Any museum would be proud to own such a sumptuously beautiful, yet intrinsically useful piece which also tells us about ceramic production and aspects of court life in eighteenth-century France. It is, quite simply, a masterpiece of its time. ⑤

DAME ROSALIND SAVILL DBE, FBA, FSA, is a former Director of the Wallace Collection in London (she published *The Wallace Collection Catalogue of Sèvres Porcelain*, 3 Vols., 1988) and is President of the international French Porcelain Society.

POT-POURRI POMPADOUR

A TEAPOT
CALCULATED RATHER FOR ORNAMENT
THAN FOR USE

SIMON SPERO

A TEAPOT

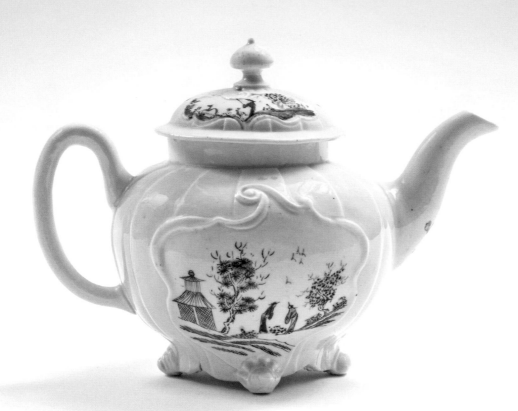

The Worcester factory, established in 1751, was the first of its kind outside the metropolis. London was by far the largest population centre in England at that time, a social and economic hub and an artistic and cultural centre. Its porcelain industry had been established at Chelsea, Bow and more briefly, at Limehouse, since the 1740s and this initial provincial venture was therefore a *terra incognita*.

The decline of the Levant Trade and the reciprocal Worcester broadcloth exports was a severe blow to the economy of the city and the setting up of a porcelain factory was intended to provide alternative economic growth, employment and prestige for a regional capital which had in the opinion of one local newspaper, become famous for "entertaining company in the most agreeable gentle manner".[1] Both the population of Worcester and the neighbouring areas accommodated landed gentry, wealthy aristocrats and prosperous tradesmen of the kind who might support a new luxury industry. But the initial nature of the proposed porcelain would be crucial to the new venture's success.

The Chelsea factory concentrated exclusively on a luxury production intended for "The Quality and Gentry", persons of taste and refinement. The far larger Bow company, a multitiered enterprise, sought to compete directly with the importations of The Honorable East India Company. By contrast, the short-lived Limehouse factory directed their output of blue-and-white wares at those aspects of production neglected in the Chinese importations.

The bankruptcy papers of Richard Holdship, one of the original partners of the Worcester factory, reveal the objectives of the production as a "porcelain manufactory in imitation of Dresden ware".[2] Yet, whereas at Chelsea the Meissen taste was emulated and only slightly adapted, at Worcester the designers selected one distinct style, the *indianische Blumen* of the 1720s, and used it as a basis to create an innovative and highly individual idiom, integrating it with Japanese Kakiemon motifs, Chinese *famille verte* and *famille rose* and even an influence drawn from the Staffordshire salt-glazed stoneware tradition. The decorative idiom resulting from this amalgam of diverse influences, Chinese, Japanese, Meissen and Staffordshire, was of delightful chinoiserie landscapes incorporating floral and figural designs, stork-like birds and scholar's rocks, all painted with a delicacy and freshness of palette and an expressive vitality, which set it apart from any previous class of porcelain. Furthermore, these innovative

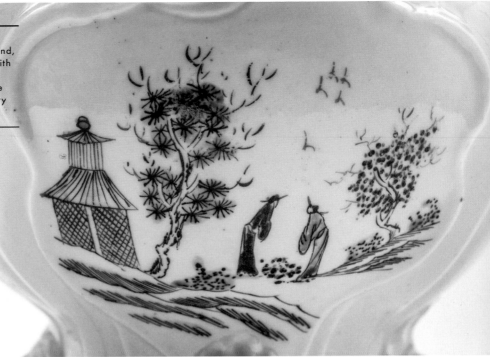

TEAPOT WITH STAGHUNT PATTERN
Worcester Porcelain Manufactory, England,
c. 1752–1753 • Soft-paste porcelain with
overglaze enamels • Marks: None •
H: 14 cm; W: 11 cm; D: 18.5 cm • The
Radlett Collection of Eighteenth-Century
English Porcelain, G13.12.8a-b

designs were displayed upon a range of equally
inventive shapes, some derived from silver models.
Sauceboats, creamboats, creamjugs, tankards, beer
jugs and teapots furnished a diversity of models,
strongly related to corresponding silver, yet most
often resourcefully designed adaptations rather than
close imitations. The employment of sophisticated
moulded ornamentation, especially on sauceboats
and teapots, added a further element of finesse to
this most imaginative idiom, presented for the first
time in 1752.

The tradition of porcelain collecting began
in England with the accession of Queen Mary, wife
of William III, in 1688. She was a passionate collector,
principally of Japanese porcelain, and her example
was instrumental in what became a widespread
pursuit amongst the wealthier classes. By the middle
of the eighteenth century, with the establishment of
the first English porcelain factories, not only was
Japanese porcelain no longer available for importation,
but The Honorable East India Company was
discouraging the private importation of the finer
and more desirable *famille verte* wares. This provided
the commercial window of opportunity for the
newly established Worcester factory. Their array of
silver-inflected models decorated in an entirely fresh

and beguiling chinoiserie style appealed to the
connoisseur collectors in Worcester and the
surrounding counties. The sheer novelty of
intricately shaped lobed creamjugs, quatrefoil lobed
cups, 12-sided teabowls and saucers, small vases and
octagonal tewares all decorated in a sophisticated
but completely unfamiliar chinoiserie idiom,
presented an astute marketing coup. Many of these
graceful and rhythmically designed models were
theoretically functional, including sauceboats,
tankards and perhaps even some creamboats. Yet
the majority was, in the words of *The Gentleman's
Magazine*, itself owned by publisher Edward
Cave (1691–1754) who was a partner in the factory,
"calculated rather for ornament than for use".[3]

The remarkable early Worcester teapot, 1752,
was surely intended for a collector's china
cabinet rather than for domestic use. One
of only three such examples recorded, its
complex yet rhythmic contours display
the influence of Rococo silver and convey a sense
of restless energy most unusual in early English
porcelain. In its asymmetrical, moulded cartouches
and splayed scroll feet, it echoes the exuberant
fluidity associated with the Huguenot silversmith

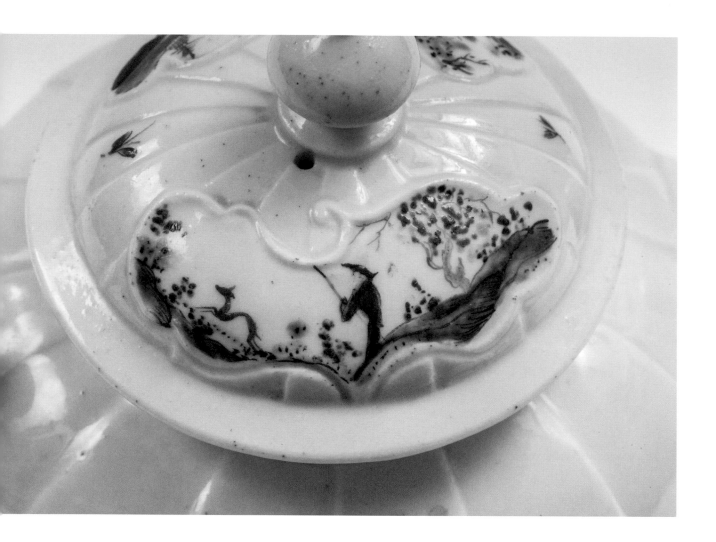

Paul de Lamerie (1688–1751) and in particular, his innovative style of the 1730s which may have been inspired by the series of Augsberg engravings circulating throughout Europe at this period. The unusual feature of splayed feet, known also on several contemporary Worcester jugs and two beaker-shaped cups,[4] also occurs on the Chelsea strawberry leaf moulded coffee pots from the triangle period.[5]

The "Staghunt" pattern, derived from Chinese porcelain, occurs on English and Dutch decorated oriental wares and was employed at several English factories. At Worcester it appears throughout the First Period, from 1752 onwards and was re-introduced some 40 years later by Chamberlain as the "Hunting Pattern in Compartments" pattern No 9. It appears to be the only Worcester chinoiserie design at

Worcester from the earliest period to survive into the nineteenth century.

As at Chelsea, Bow and Vauxhall for example, many of the most ambitious Worcester models date from the earliest years of the factory at a time when the subsidized continental industry in Germany, France and elsewhere, was still a template for its English counterpart. Only from about 1754 onwards did the realization dawn that its commercial priorities lay with utilitarian wares directed towards a primarily middle-class market rather than a niche market for the connoisseur collector.

For all its allusive sophistication and beguiling design, the underside of this teapot displays its firing faults, some of the problems encountered in moulding, potting and firing so complex a cast shape. This necessitated the filling in

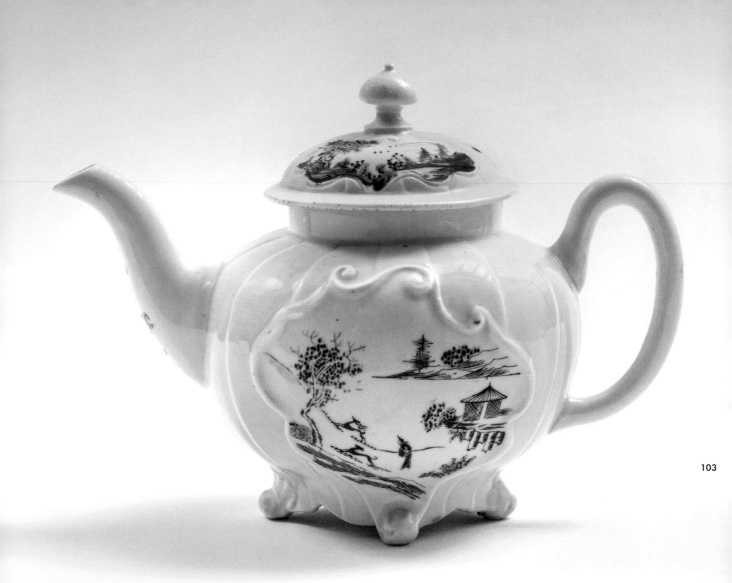

of the fissures with crushed flint or 'frit' in order
to reinforce the splayed feet.

It was a supreme achievement of the
Worcester factory in its formative years, exemplified
in this remarkable teapot, to create a truly original
style fulfilling an elusive alchemy whereby influence
is converted into innovation.❧

SIMON SPERO is an author, lecturer and antiques dealer specializing in
early English porcelain. He has written five reference books and over 30
exhibition catalogues, and lectured in the UK, Australia and North America.

NOTES

1 Simon Spero, *Lund's Bristol and Early Worcester Porcelain*
(London: C and J Smith, 2006), p. 27.

2 Simon Spero and John Sandon, *Worcester Porcelain, 1751–
1790: The Zorensky Collection* (Woodbridge, Suffolk: Antique
Collectors' Club, 1996), p. 44.

3 *Gentlemen's Magazine*, Volume XXXIII, (1763), p. 191.

4 Simon Spero, *Lund's Bristol and Early Worcester Porcelain*, nos.
45 and 130.

5 John Austin, *Chelsea Porcelain at Williamsburg* (VA: Colonial
Williamsburg Foundation, 1976), no. 21.

SCENTS AND SENSIBILITIES

MIMI HELLMAN

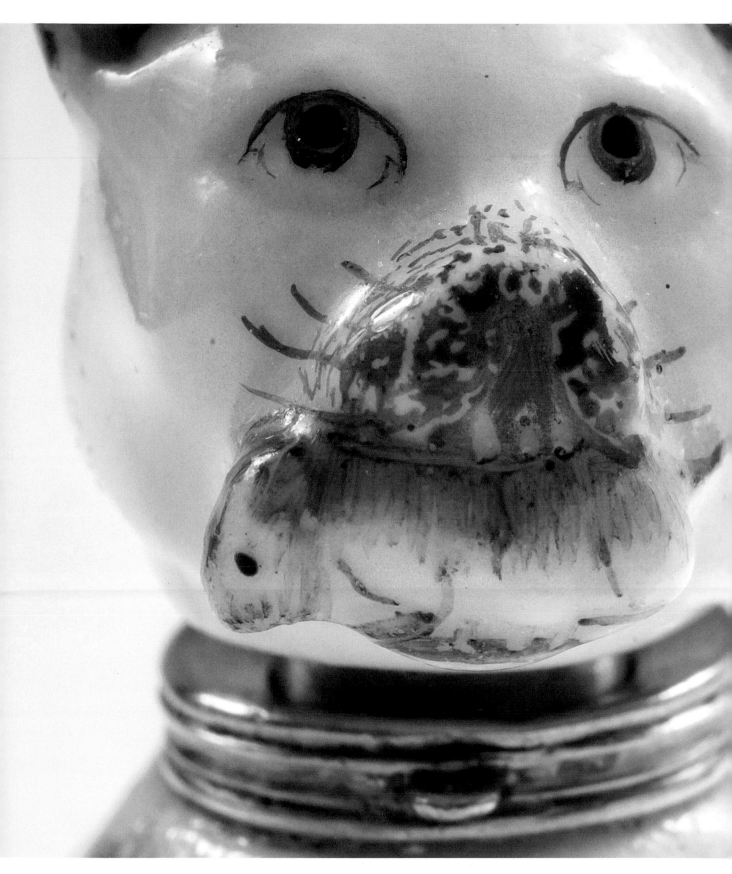

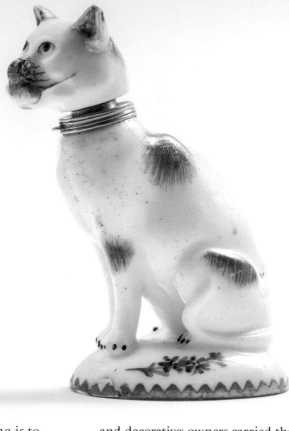

SCENT BOTTLE IN THE FORM OF A CAT
Chelsea Porcelain Manufactory, England,
c. 1755 • Soft-paste porcelain, frit, enamel
and gold • Marks: None • H: 6.6 cm;
D: 5.1 cm • Gift of George and Helen
Gardiner, G83.1.971.1-2

"To toy with something is to manipulate it, to try it out within sets of contexts, none of which is determinative."[1] This porcelain figurine is sure to charm modern cat lovers. Diminutive, wide-eyed, and grasping a mouse in its mouth, it invites the bemusement that many people feel when a pet shows off its prey. The appeal doubles when we realize that it is also a scent bottle, the head serving as a stopper once attached by a chain, and we might imagine that it once contained a seductive fragrance. But what did it mean to own something like this in eighteenth-century England? In the spirit of my opening quotation and the feline propensity to play with a good catch, I would like to explore some historical attitudes that render this object more complex than it seems at first glance.

Scent bottles were produced in various materials and styles during the eighteenth century, including many in the relatively new medium of porcelain.[2] In England, they were often called smelling bottles and figured among a host of fashionable accessories that also included letter seals and boxes for snuff, sweets or beauty patches. Marketed as toys and avidly sought by a growing elite population, these items were both functional and decorative: owners carried them in pockets and small bags, kept them handy in desk and dressing table drawers, and displayed them in elegant interiors.[3]

During this period, perceptions of scent were bound up with conceptions of status. Elites associated foul smells with the allegedly uncivilized nature of the lower class and non-Caucasian races. They expressed social superiority by masking body odour and claiming sensitivity to the air of stuffy rooms and refuse-strewn streets. Since daily bathing was considered unhealthy, pleasurable fragrances provided an important means of signalling refinement and countering environmental offences.[4] Merchants promoted a range of fragrances, from traditional musk to more flowery or citrusy scents like lavender, jasmine or bergamot. Despite social criticism that associated perfume with the vanity of women and foppish men, it was widely appreciated by consumers of both genders.[5]

Use of scent also addressed the idea that privileged individuals were fragile, prone to illness, and easily overcome by physical or emotional exertion. To fortify themselves they inhaled the fumes of concoctions dominated by vinegar, hartshorn (an ammoniac substance), asafetida, or pungent herbs like rosemary. A newspaper advertisement of 1756 touted one version that treated heartburn, "lowness

of Spirits", and ringing in the ears; relieved "Hysterick Fits, Hypochondraical or Nervous Disorders"; and prevented smallpox.[6] Such claims were compelling at a time when modern understandings of mental illness and contagious disease were not yet established. Women were supposedly more delicate than men, and hence more in need of smelling bottles, but aromatherapy also contributed to the definition of class.[7] Tellingly, the 1756 advertisement did not pitch its potion to ladies, but rather claimed that the upper echelons of society "constantly carry it in their pockets".

Whether a scent was sweet or sharp, the container mattered just as much as the contents. Especially when employed in a social setting—while receiving visitors at one's morning toilette, for instance, or amid the swirl of a ball—an artful bottle enhanced self-presentation and interaction. A novel design signalled personal taste and stimulated conversation. Showing a tiny trinket to others created a sense of intimacy, and holding it encouraged graceful hand gestures. Many examples, including the Gardiner cat, had flowers painted on the underside of the base, a detail that invoked olfactory delight and became visible when the object was handled.

But the cat was an unusual subject for porcelain design. Most scent bottles depicted flirtatious encounters, popular theatrical characters, exotic places or luscious flowers or fruits. There were numerous birds and quite a few dogs, but cats—especially hunting cats —seemingly found less favour.[8] This may have been due to ambivalent cultural attitudes. Most cats were kept to hunt vermin, not as cherished pets. Torturing them was tolerated and may have constituted an outlet for social tensions. And while a longstanding association with witchcraft had faded, it was still possible in 1718 for a woman to be accused of consorting with the devil by shape-shifting into a cat.[9]

At the same time, people increasingly cultivated affective relationships with cats, criticized animal cruelty as a threat to civil society, and even commemorated favourite felines in elegies.[10] A wry tribute to Hodge, companion of the author Samuel Johnson, contrasted the animal's virtues with human foibles. Hodge "never thought, nor uttered ill", never drank, stole, cheated or consorted with prostitutes.[11] But cat-friendly perspectives were hardly ubiquitous. A natural history of the 1790s praised the loyal obedience of dogs and dismissed cats as antisocial exterminators. Many visual and literary representations of fashionable domesticity cast lapdogs, birds and monkeys as the most desirable pets.[12]

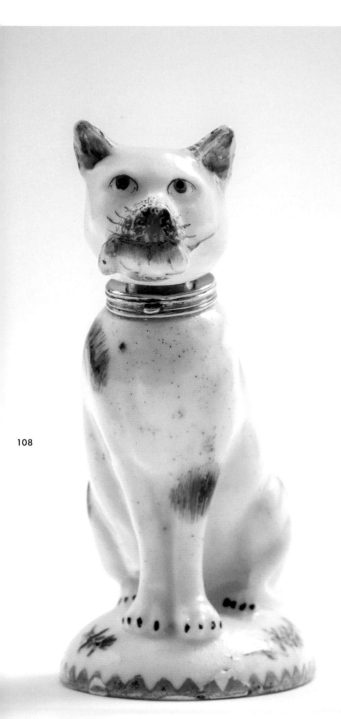

coquettish wife who leaped out of bed at night to capture mice.[13] And a mock-heroic poem about a pet who drowned while attempting to catch goldfish cautioned ladies with "wand'ring eyes/ And heedless hearts" to resist the temptations of "all that glisters".[14] In a society devoted to wit and suspicious of female power, a pert porcelain hunter may have sparked banter about wily women who chased both baubles and men.

A quite different vein of thought linked hunting with social mobility. In a well-known folk tale, a poor orphan named Richard Whittington staked his accomplished mouser in an overseas trading venture. The mission yielded none of the promised profit but the cat solved the rodent problem of an African king. Whittington received a handsome reward, married his employer's daughter, and became a philanthropist and mayor of London.[15] If associated with the scent bottle, this story redefined a luxury commodity as an emblem of good fortune, useful skill and civic-minded prosperity.

Yet Whittington's cat was a worker, not a companion. Celebrating cats as pets required a more qualified treatment of predation. One tribute described a tabby who "drove sad Thoughts away" with her playfulness and purring but also protected the pantry from invasion: "in the Mint of her projecting Mind,

What, then, was the appeal of a mouse-toting cat? One possibility was its potential for innuendo based on derogatory gender associations. 'Cat house' was a term for brothel; 'pussy' had the same double meaning as today. An old fable circulating in several forms recounted how metamorphosis turned a man's cat into a sharp-eyed,

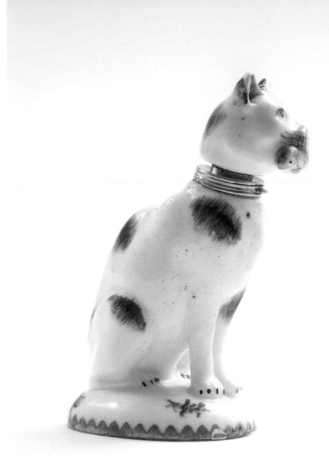

Against the Mice, deep Stratagems are coin'd".[16] The notion of feline calculation elevated instinct to a human-like exercise of reason in the service of domestic order. Other authors invoked hunting only to displace it. In another poem, a girl departing for boarding school bid farewell to a cat who had shared her food and bed, who "licked my hands/ With velvet tongue ne'er stained by mouse's blood." This account banished rapacity from the home, setting innocent pet love against an outside world that "Glowed with ambition, business, and vice."[17]

The design rhetoric of the scent bottle takes a similarly equivocal approach by simultaneously alluding to and underplaying the act of pursuit. An intact, sketchily rendered mouse hangs innocuously from a mouth with no visible teeth. The cat's upright pose and outward gaze deny any creaturely fascination with the catch. Its compact shape and sleek surface invite stroking. All miniature objects confer symbolic domination on their viewers, but this aestheticized body does so in an especially suggestive way. Grasping the little figurine and pulling off its head to dispense scent transfers domination from animal to human, turning the porcelain predator into a kind of prey.

Once upon a time, this 'toy' amused, valourized and empowered fashionable consumers in a society that held equivocal views of both scents and cats. Now, poised forever in the Gardiner Museum it still releases a heady whiff of the past.

MIMI HELLMAN teaches art history at Skidmore College in Saratoga Springs, New York. Her scholarship explores the roles of visual and material culture in the social formation of eighteenth-century French elites.

NOTES

1 Susan Stewart, *On Longing: Narratives of the Miniature, the Gigantic, the Souvenir, the Collection* (Durham and London: Duke University Press, 1993), p. 56.
2 Kate Foster, *Scent Bottles* (London: The Connoisseur and Michael Joseph, 1966); Edmund Launert, *Scent and Scent Bottles* (London: Barrie & Jenkins, 1974); Meredith Chilton, "Passion, Perfume and Porcelain: English Scent Bottles from the Gardiner Collection", *Potpourri*, (Winter 2000), pp. 4–5. The first major European experiments in porcelain manufacture took place between the 1690s and 1710s; English production began in the 1740s. Elizabeth Adams, *Chelsea Porcelain* (London: The British Museum Press, 1987); Hilary Young, *English Porcelain 1745–95:*

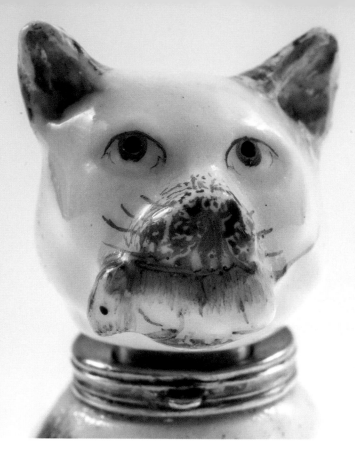

Its Makers, Design, Marketing and Consumption (London: V&A Publishing, 1999); Sarah Richards, *Eighteenth-Century Ceramics: Products of a Civilised Society* (Manchester and New York: Manchester University Press, 1999).

3 G. E. Bryant, *The Chelsea Porcelain Toys* (London and Boston: The Medici Society, 1925); Yvonne Hackenbroch, *Chelsea and Other English Porcelain, Pottery and Enamel in the Irwin Untermyer Collection* (Cambridge, Massachusetts: Harvard University Press, 1957), pp. 101–162.

4 Bathing was problematic because of a belief that water could permeate the body and disrupt physiological, mental and emotional functions. Propriety was achieved through measures such as wiping the face and hands, applying cosmetics, and wearing white collars and cuffs. See Georges Vigarello, *Concepts of Cleanliness: Changing Attitudes in France Since the Middle Ages*, Jean Birrell, trans. (Cambridge: Cambridge University Press, 1988). See also Mark S. R. Jenner, "Civilization and Deodorization? Smell in Early Modern English Culture", in *Civil Histories: Essays Presented to Sir Keith Thomas*, Peter Burke, Brian Harrison and Paul Slack, eds. (Oxford: Oxford University Press, 2000), pp. 127–144; Clare Bryant, "Fume and Perfume: Some Eighteenth-Century Uses of Smell", *Journal of British Studies* 43 (October 2004), pp. 444–463.

5 Perfumers' broadsides listed dozens of fragrances; see, for example, Arthur Rothwell, *Perfumer, at the Civet-Cat and Rose. In New Bond-street* (London, 1745). For critiques of perfume, see Bryant, "Fume and Perfume", pp. 448, 459.

6 *Harrop's Manchester Mercury (and General Advertiser)* 203, (3 February 1756); original orthography preserved. Many other advertisements make similar claims.

7 For the understanding of disease, see Dorothy Porter and Roy Porter, *Patient's Progress: Doctors and Doctoring in Eighteenth-Century England* (Stanford: Stanford University Press, 1989). For the afflictions known as hysteria, hypochondria and the vapours, see Glenn Coburn, ed., *The English Malady: Enabling and Disabling Fictions* (Newcastle: Cambridge Scholars Publishing, 2008).

8 This assessment is based on the dozens of bottles reproduced in Bryant, *The Chelsea Porcelain Toys* and Hackenbroch, *Chelsea and Other English Porcelain*. I am aware of only one other model for a Chelsea bottle shaped like a hunting cat; it grasps a mouse in one paw. See Bryant, plate 4; Hackenbroch, plate 79; and Adams, *Chelsea Porcelain*, p. 137. For a French mouser, see J. P. Palmer and Meredith Chilton, *Treasures of The George R. Gardiner Museum of Ceramic Art* (Toronto: The George R. Gardiner Museum of Ceramic Art, 1984), p. 60. Among the small cat population in eighteenth-century European porcelain more generally, most curl up benignly or serve as companions for humans.

9 Robert Darnton, "Workers Revolt: The Great Cat Massacre of the Rue Saint-Séverin", in *The Great Cat Massacre and Other Episodes in French Cultural History* (New York: Vintage Books, 1985), pp. 75–104; Phyllis Guskin, "The Context of Witchcraft: The Case of Jane Wenham", in *Articles on Witchcraft, Magic and Demonology*, Brian P. Levack, ed., 12 vols. (New York: Garland, 1992), Vol.

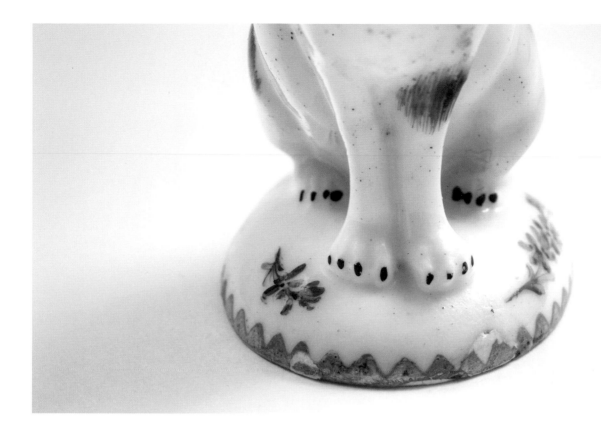

6, pp. 94–119; Ronald Paulson, "Hogarth's Cats", *Raritan* 12, (Spring 1993), pp. 1–25; Karen Raber, "How to do Things with Animals: Thoughts on/with the Early Modern Cat", in *Early Modern Ecostudies: From the Florentine Codex to Shakespeare*, Thomas Hallock, Ivo Kamps and Karen L. Raber, eds. (New York: Palgrave Macmillan, 2008), pp. 93–113.

10 John D. Blaisdell, "A Most Convenient Relationship: The Rise of the Cat as a Valued Companion Animal", *Between the Species* 9 (Fall 1993), pp. 217–230; Ingrid H. Tague, "Dead Pets: Satire and Sentiment in British Elegies and Epitaphs", *Eighteenth-Century Studies* 41, (Spring 2008), pp. 289–306; Ingrid H. Tague, "Companions, Servants, or Slaves?: Considering Animals in Eighteenth-Century Britain", *Studies in Eighteenth-Century Culture* 39 (2010), pp. 111–130.

11 Percival Stockdale, "An Elegy on the Death of Dr. Johnson's Favourite Cat" [c. 1764], in *The Poetical Works of Percival Stockdale*, 2 vols. (London: Longman, 1810), Vol. 2, pp. 255–257.

12 Ralph Beilby, *A General History of Quadrupeds* (Newcastle Upon Tyne: S. Hodgson et al., 1792), pp. 208–211, 296–336. On trends in pet keeping, see Laura Brown, "Immoderate Love: The Lady and the Lapdog", in *Homeless Dogs and Melancholy Apes: Humans and Other Animals in the Modern Literary Imagination* (Ithaca, New York and London: Cornell University Press, 2010), pp. 65–89; Kimberly Chrisman-Campbell, "Beauty and the Beast: Animals in the Visual and Material Culture of the Toilette", *Studies in Eighteenth-Century Culture* 42 (2013), pp. 147–170.

13 Christopher Pitt, "The Fable of the Young Man and His Cat", in *Poems and Translations* (London: Bernard Lintot et al., 1727), pp. 167–171. The tale also appeared in editions of fables by Aesop and Jean de La Fontaine.

14 Thomas Gray, "On the Death of a Favourite Cat, Drowned in a Tub of Gold Fishes" [1747], in *Horace Walpole's Cat*, Christopher Frayling, ed. (New York: Thames & Hudson, 2009), p. 26.

15 The tale of Richard (Dick) Whittington, a highly fictionalized account of the life of a mayor of London at the turn of the fifteenth century, began circulating in print during the seventeenth century and is still popular in Great Britain today. See Henry B. Wheatley, ed., *The History of Sir Richard Whittington* (London: The Villon Society, 1885).

16 Henry Needler, "An Elegy on the Death of a Tabby-Cat", in *The Works of Mr. Henry Needler* (London: J. Watts, 1724), pp. 19–20.

17 James Thomson, "Lisy's Parting with Her Cat" [c. 1725], *The Annotated Edition of the English Poets*, Robert Bell, ed. (London: John W. Parker and Son, 1855), pp. 39–41.

AS BIG AS LIFE

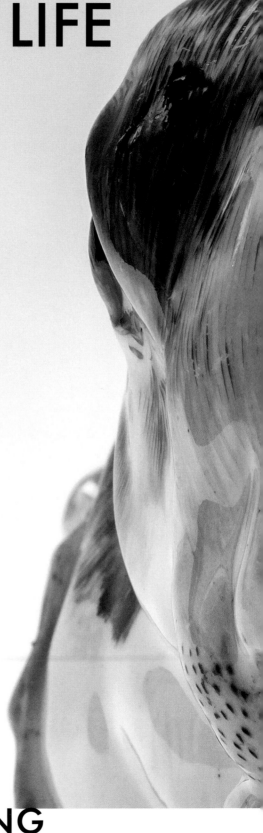

HILARY YOUNG

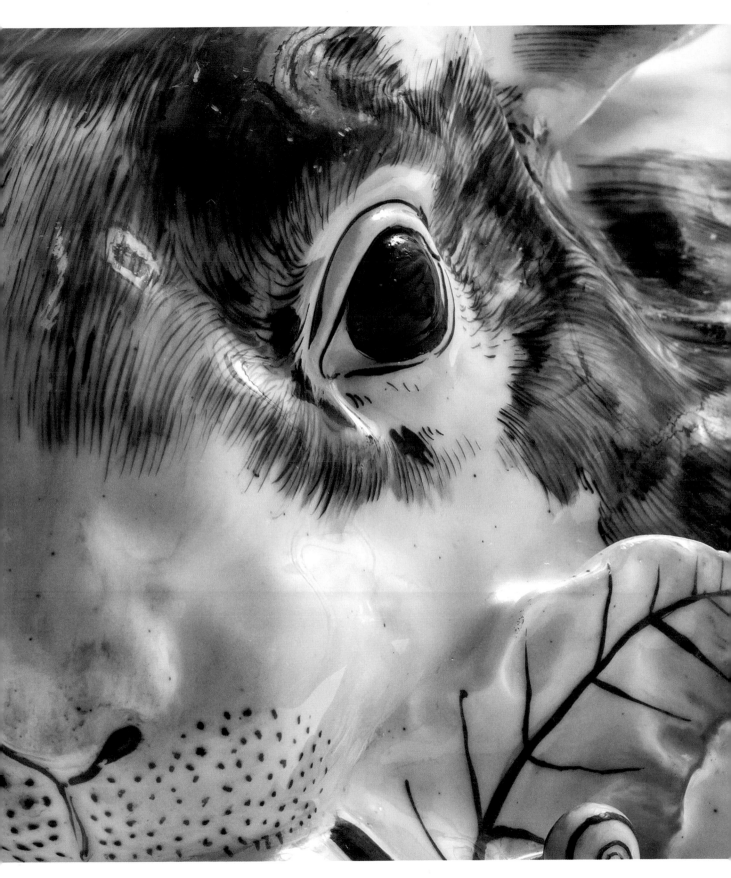

AS BIG AS LIFE

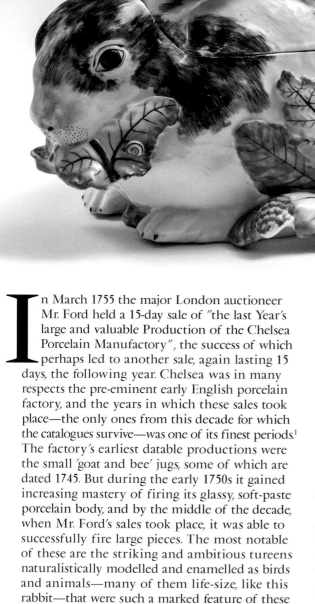

In March 1755 the major London auctioneer Mr. Ford held a 15-day sale of "the last Year's large and valuable Production of the Chelsea Porcelain Manufactory", the success of which perhaps led to another sale, again lasting 15 days, the following year. Chelsea was in many respects the pre-eminent early English porcelain factory, and the years in which these sales took place—the only ones from this decade for which the catalogues survive—was one of its finest periods.[1] The factory's earliest datable productions were the small 'goat and bee' jugs, some of which are dated 1745. But during the early 1750s it gained increasing mastery of firing its glassy, soft-paste porcelain body, and by the middle of the decade, when Mr. Ford's sales took place, it was able to successfully fire large pieces. The most notable of these are the striking and ambitious tureens naturalistically modelled and enamelled as birds and animals—many of them life-size, like this rabbit—that were such a marked feature of these two sales. It is clear that today's high estimation of these productions was shared by Mr. Ford's cataloguer, who drew attention to the finest lots with beguiling descriptions embellished with italics, and, in the case of exceptional pieces, with

capitals also: he described this model, eight examples of which were included in the sales, as "A beautiful TUREEN in the form of a RABBIT as large as life, and a fine dish to ditto".[2]

Other tureens of this type made around 1755-1756, and bearing the factory mark of a red anchor,[3] were modelled as artichokes, asparagus, cauliflowers, melons, plaice, carp, eels, ducks, pigeons, partridges, chickens, boars' heads, and even swans; and while it is clear that their inspiration came from Meissen, Chelsea took to the idea with greater enthusiasm than the Saxon factory ever had. Evidence for this derivation lies in a remarkable sequence of letters dated 1751 from Sir Charles Hanbury Williams (1708-1759), the British Envoy to the Saxon court of Augustus III at Dresden (1696-1763).[4] In these Sir Charles states that he had received a request for examples of Meissen porcelain (which could not then be legally imported into Britain for commercial sale) "to furnish the Undertakers" of the Chelsea works "with good designs". He replied that it "would be better & Cheaper for the Manufacturers... to take away any of my China... [in London] and to copy what they like". That they did so is confirmed by several Chelsea dessert table figures closely based on Meissen porcelain owned by Sir Charles. Three

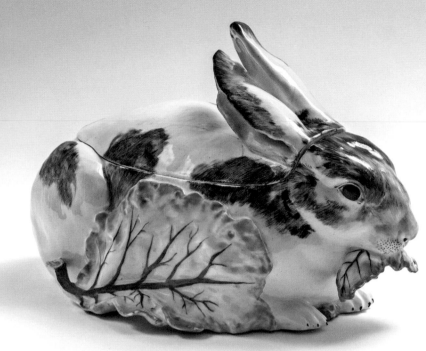

COVERED TUREEN IN THE FORM OF A RABBIT
Chelsea Porcelain Manufactory, England, c. 1755–1756 • Soft-paste porcelain, overglaze enamels • Marks: Factory mark of an anchor painted in red enamel on cover, and "20" painted in red on both parts • H: 22.9 cm; W: 33.7 cm; D: 17.8 cm • Purchased with a gift from Dr. Walter S. Bloom and Carol Bloom Koffler in memory of their mother, Adele S. Bloom, a collector and connoisseur of English porcelain; with a grant from the Government of Canada, Ministry of Communications under the terms of the Cultural Property Export and Import Act and with the assistance of the Telecote Foundation, G94.2.1.1-2

lists of the components of the Meissen dessert service intended for Hanbury Williams also survive, and among the pieces itemized are "12 Compotiers [dessert tureens] in form of an artichoke" and a further 12 dessert tureens shaped as "Sun Flowers with handles" with matching dishes, the latter of which were certainly copied at Chelsea. It is highly likely therefore that Hanbury Williams' loans prompted Chelsea's creation of such naturalistic vegetable and zoomorphic serving vessels as this rabbit tureen. The fashion soon spread to other English porcelain factories in the 1750s, notably Bow, Worcester and Longton Hall, and it resurfaced in Wedgwood's pineapple and cauliflower tearwares of the following decade. On the continent it enjoyed a long life, making an early appearance at the Strasbourg and Sceaux tin-glazed pottery factories and lasting well into the nineteenth century in earthenware production.

It is far from clear how the Gardiner Museum's rabbit tureen would have been used. *Trompe l'œil* table decoration and naturalistic serving vessels had been a feature of grand dining since at least the Renaissance. During the eighteenth century such decoration was particularly associated with the dessert course, though it appears also on silver soup tureens and other vessels used for savoury foods. We know from Mr. Ford's sale catalogues, and from a letter from Benjamin Franklin (1706–1790) to his wife,[5] that some of Chelsea's smaller tureens shaped as vegetables were intended for stewed fruit or creams served during the dessert, and the same is true of a much smaller version of this rabbit.[6] The exterior form of Chelsea's naturalistic pieces cannot therefore be taken as indicating the general nature of their contents, and indeed any contrast between their zoomorphic shape and what they contained must have been deliberate and intended to delight and surprise. Some of the larger animal tureens, like this rabbit, do appear to have been made for serving savoury foods. Certainly, they are simply called "tureens" in the catalogues and not identified as "for the desart". In the case of the boar's head tureen, the sword and other hunting accoutrements adorning its under-dish strongly suggest that it was intended for boar, or at least game.[7] However, as all the large zoomorphic pieces lack internal liners and have irregularly shaped flat-bottomed interiors, they can never have been practical vessels for serving soups, ragouts and olios, the normal contents of large tureens used during the savoury courses. Perhaps this impracticality contributed to the short life of *trompe l'œil* forms at Chelsea. All were originally equipped

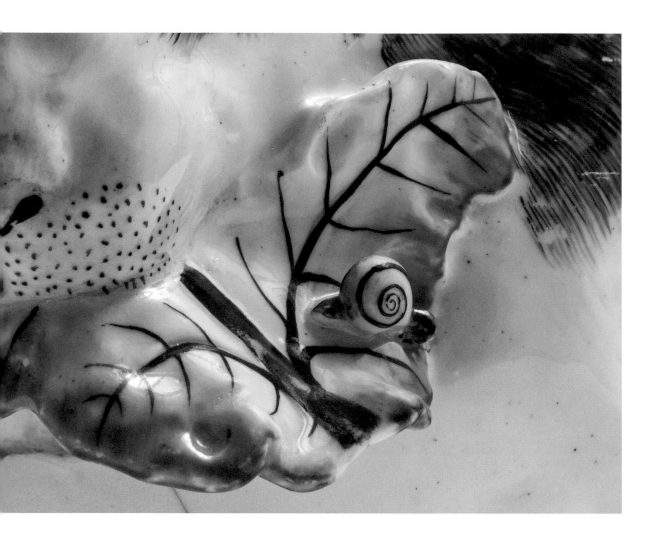

with under-dishes, often decorated with "proper ornaments", but being large and flat these were easily broken and very few survive.

The chief modeller at the factory was the Fleming Joseph Willems (1710–1766), and it is possible that he created the rabbit and other naturalistic wares. More certainly, they would have been made under the direct supervision of Nicholas Sprimont (1716–1771), the owner and chief 'undertaker' of the Chelsea works, who was born in Liège in Flanders and is usually said to be a Huguenot, though there is little evidence to support this.[8] Sprimont was a fascinating individual, not least because he was a highly talented designer who first appears in England working as a silversmith for the highest levels of society. It is of interest, in this context, that some of the distinctive Rococo tablewares he made as a silversmith featured sculptural naturalism.[9] The fact that he abandoned this promising career to embark on experimental soft-paste porcelain production in the earliest days of the English industry tells us much about the allure of this exciting new material. Soon after this rabbit tureen was made, he steered the factory in a new artistic direction, responding to contemporary developments in Rococo design at Sèvres. In doing so, he turned his back on the simplicity and restraint of this fine tureen, and other mid-1750s productions, in favour of the greater elaboration and rich gilding that characterize Chelsea's output between about 1758 and his sale of the factory 11 years later. ❧

HILARY YOUNG is a Senior Curator at the Victoria and Albert Museum, London. He is the author of *English Porcelain, 1745–95*, 1999, and has published extensively on ceramics, silver and design.

NOTES

1 For the 1755 catalogue see John C. Austin, *Chelsea Porcelain at Williamsburg* (Williamsburg, VA: Colonial Williamsburg Foundation, 1977); for the 1756 catalogue see R. W. Rhead, *A Reprint of the Original Catalogue of One Year's Curious Production of the Chelsea Porcelain Factory...* (Salisbury: Benett Brothers, 1880).

2 1755 sale: second day, lot 88, fourth day, lot 90, eighth day, lot 41, twelfth day, lot 43; 1756 sale: second day, lot 35, fifth day, lot 35, 52 and 58.

3 Production at Chelsea is often divided into periods according to the factory mark. The 'red anchor' period runs from about 1753–1758, and the subsequent 'gold anchor' period dates from the adoption of extensive gilding around 1758. For the limitations of this terminology, see J. V. G. Mallet, "An Old Collection of Chelsea on Loan to the Ashmolean", *The Ashmolean*, No. 28 (spring/summer 1995), pp. 15–17.

4 For the documents and Chelsea copies see T. H. Clarke, "Sir Charles Hanbury Williams and the Chelsea Factory", *English Ceramic Circle Transactions*, Vol. 13, Part 2 (1988), pp. 110–123, and Meredith Chilton, "Dogs and Diplomats: Meissen Porcelain in England" in *Fragile Diplomacy: Meissen Porcelain for European Courts ca. 1710–63*, Maureen Cassidy-Geiger, ed. (New Haven and London: Yale University Press, 2007), pp. 279–290 and figs. 12–25.

5 Letter written from London in 1755 quoted in Austin, *Chelsea Porcelain at Williamsburg*, p. 12.

6 Lot 18 on the second day of the 1755 sale was described as "Two small fine cabbage-leaves, and 4 rabbits, for desart". For an example of this smaller rabbit tureen see Robin Emmerson, "Design for Dessert", in *British Ceramic Design, 1600–2002*, Tom Walford and Hilary Young, eds. (Beckenham, Kent: English Ceramic Circle, 2003), fig. 10.

7 Elizabeth Adams, *Chelsea Porcelain* (London: British Museum Press, 2001), fig. 8–11. An example of this model, possibly old stock, was mentioned in an advertisement in *The Dublin Journal* for the factory's sale in that city in July 1758 (Mallet, "An Old Collection of Chelsea on Loan to the Ashmolean", p. 16).

8 Hilary Young, "Anti-gallicanism at Chelsea: Protestantism, protectionism and porcelain", *Apollo*, Vol. 147, No. 436 (June 1998), pp. 35–41.

9 Michael Snodin, ed., *Rococo: Art and Design in Hogarth's England* (London: V&A Publishing, 1984), cat. G17-19 and O7.

A GENERAL
ON A JUG

SIMON SPERO

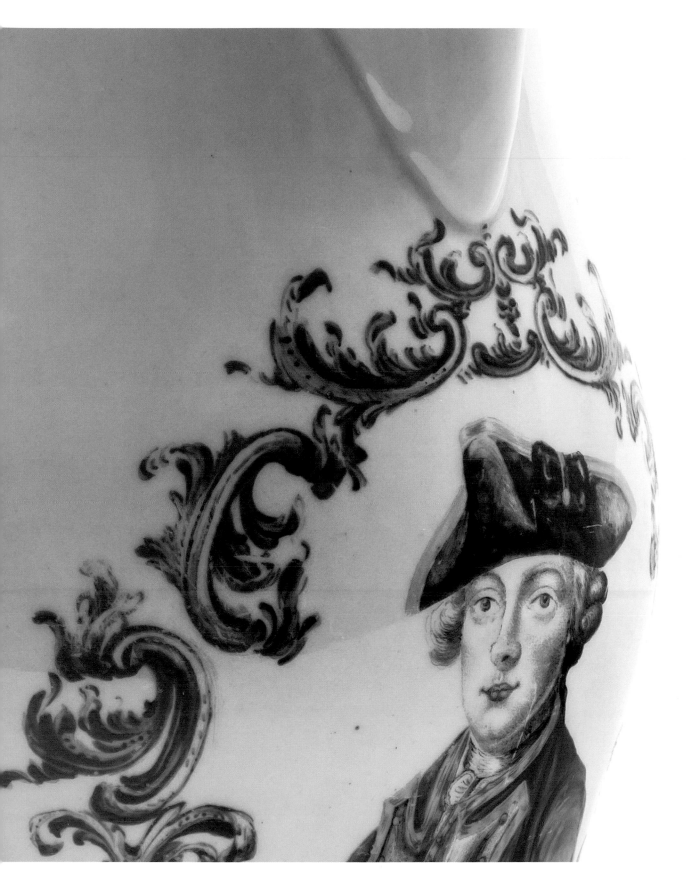

A GENERAL ON A JUG

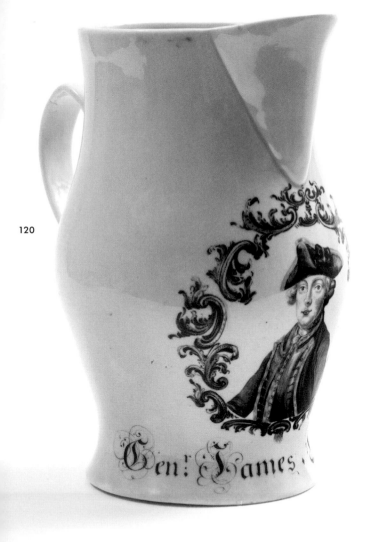

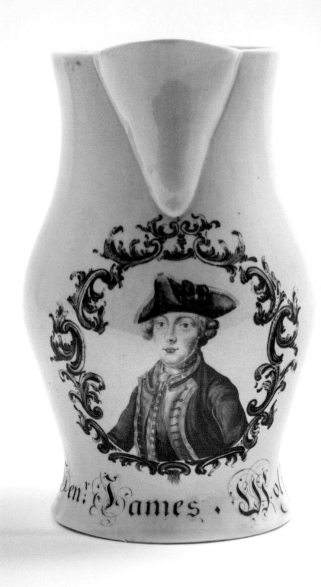

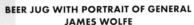

BEER JUG WITH PORTRAIT OF GENERAL JAMES WOLFE

Richard Chaffers and Co., England, c. 1760 • Soft-paste (bone ash) porcelain with overglaze enamels • Marks: Inscribed "Gen.r. James. Wolfe" • H: 18 cm; W: 11.5 cm; D: 16.5 cm • The Radlett Collection of Eighteenth-Century English Porcelain, G05.18.5

1759 was a crucial turning point in The Seven Years' War (1756–1763), the first truly global conflict, stretching from the Ohio River on the outer boundaries of the American frontier, to the Ganges in India, from the lakes and impenetrable wildernesses of Canada to the rich sugar islands of the Caribbean and from the plains of Central Europe to the Spanish strongholds in the Philippines. In a war essentially rooted in colonial rivalry, Britain and her European ally Prussia were ranged against the armies of France, Austria, Russia and Sweden.

The momentous events of this conflict, and most particularly the triumphs of 1759, led to a huge upsurge of patriotism, national pride and greatly enhanced prestige, both for the British monarchy and its government as a whole. The victories of Robert Clive (1725–1774) in India, Admirals Edward Boscawen (1711–1761) and Edward Hawke (1705–1781) and of Frederick II of Prussia (1712–1786), led to an eventual triumph which laid the foundations of the British Empire for the following 200 years.

The achievements of these military and naval heroes were commemorated on contemporary ceramics and it was no coincidence that these were primarily tankards, punch bowls and beer jugs, vessels befitting the toasting and celebration of the attainments

of national heroes. And none of these were more courageous, more youthful or more tragic than General James Wolfe (1727-1759).

Wolfe was borne in 1727, entering the army at 14 years old, seeing action with his regiment at the Battle of Dettingen in 1743, and three years later, at Culloden as one of the duke of Cumberland's staff officers in Scotland. At around this time in his career, he appears in William Makepeace Thackeray's novel, *The Virginians: A Tale of the Last Century* (1857-1859), described as "the youngest lieutenant-colonel in the army". Ambitious, single, even ruthless, he was plagued by persistent ill health and seldom sought popularity with his fellow officers. Yet his courage and enterprise caught the eye of William Pitt the Elder (1708-1778), the British Secretary of State. He had taken on the overall strategy of the War and considered the conquest of Canada to be a crucial objective. Following the capture of the great Fortress of Louisbourg in 1758, during which Wolfe played a prominent role, Pitt overlooked many more senior officers and selected the 32-year-old Wolfe to command the amphibious expedition against Quebec.

The elderly King George II (1683-1760), on being informed by the Duke of Newcastle (1693-1768) that Wolfe was too young, too eccentric and "mad", is said to have observed, "Mad is he? Then I hope he will bite some of my other generals."[1]

Co-operating amicably with Admiral Saunders (c. 1717-1775), the naval commander, Wolfe spent the summer of 1759 in a series of fruitless attempts to attack Quebec, located on the heights overlooking the St. Lawrence River and garrisoned by a notional army of 16,000 commanded by General Louis-Joseph Marquis de Montcalm (1712-1759). As the season drew on, Wolfe, suffering from recurring bouts of illness, in open hostility with his three equally youthful brigadiers, was facing failure. Autumn would bring an end to the campaigning season as the St. Lawrence River would freeze and the British army would be obliged either to withdraw to the open sea or to be trapped by the bitter Canadian winter.

Quebec was almost impregnable to a frontal onslaught but in a daring manoeuvre on the night of 12 September, with Admiral Saunders' ships creating a successful diversion, Wolfe led 4,800 troops, scaling

A GENERAL ON A JUG

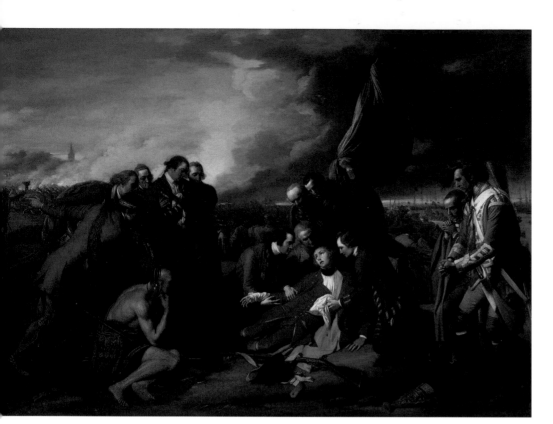

ABOVE

BENJAMIN WEST (1738–1820),
THE DEATH OF GENERAL WOLFE, 1770
National Gallery of Canada, Ottawa •
Transfer from the Canadian War Memorials,
1921 • Gift of the Second Duke of
Westminster, England, 1918 • Photo ©
National Gallery of Canada

the precipitous bluffs on to a plateau above the city. Ironically, amongst the soldiers who scrambled up the rock- and scrub-strewn cliffs were men from two recently formed Highland regiments, some of whom would have fought against Wolfe at Culloden 13 years earlier. By daybreak the little British army was deployed in line of battle, awaiting the French response. Taken off guard and outflanked, the Marquis de Montcalm had little choice but to attack with his weakened mixed force of regulars and militia, and with his Native American allies sniping at the British flanks. Wolfe had trained his men personally and they lay prone so as not to present easy targets until the French had advanced to within about 91 metres. As the range narrowed, the British fired the first of three devastating volleys, advancing a short distance between each of them. This virtually decided the engagement and within 15 minutes the French were in flight, abandoning the city. Wolfe, wounded three times as he led the advance, died on the battlefield in the moment of victory, as did his gallant opponent, the Marquis de Montcalm. Quebec surrendered five days later and with the capture of Montreal by General Amherst (1717–1797) the following year, the French power in Canada ended. The campaign of the summer of 1759, brought to a victorious conclusion by Wolfe's persistence and resourcefulness in the face of huge logistical difficulties, weakening morale and personal ill health, was the culmination of the long struggle for the mastery of North America. The event won for Wolfe a place in

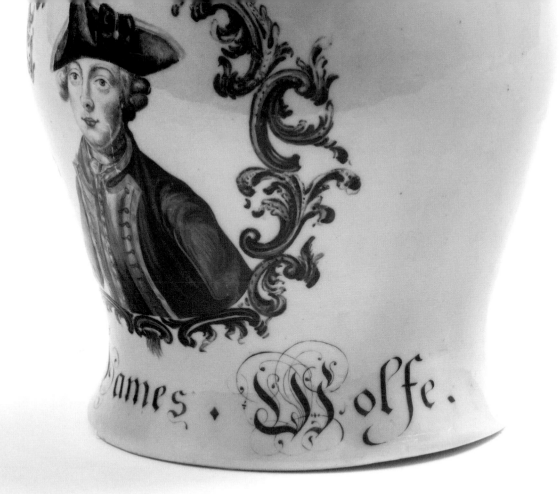

James · Wolfe.

history which he so desired, personified in Benjamin West's (1738–1820) celebrated painting of 1771, *The Death of General Wolfe*, and popularized five years later by William Woollet's (1735–1785) engraving, which was reproduced on English tableware.

A more immediate commemoration was on the fine quart beer jug from the Liverpool factory of Richard Chaffers. Dating from about 1760, it was possibly painted by the miniature painter William Jackson who was also responsible for a similar jug commemorating Britain's heavily subsidized continental ally, Frederick II, King of Prussia (1712–1786). The contours of the large jug, its flattened strap handle and slightly upturned lip are characteristic of the soapstone porcelain made by Richard Chaffers between 1756 and 1765, at his Liverpool factory at Shaw's Brow. He made a specialty of these finely shaped beer jugs, both in polychrome and underglaze blue. As with Liverpool porcelain, no factory mark was used.

Hand-painted tankards and beer jugs commemorating prominent personalities of The Seven Years' War are extremely scarce. Yet the process of transfer-printing over the glaze, invented in about 1753–1754, was employed at such centres as Bow, Longton Hall, Worcester and several Liverpool factories and commemorated figures including George II, William Pitt, Admiral Boscawen, the Marquis of Granby, Britain's continental allies Frederick II of Prussia and Ferdinand, Duke of Brunswick and also General James Wolfe.

Wolfe's victory at the Battle of the Plains of Abraham was the turning point in Britain's struggle to wrest control of the New World from France, a supreme element in William Pitt's global strategy and a vital contribution to Britain's ultimate triumph in 1763.

NOTES

1 Frank McLynn, *1759. The Year Britain became Master of the World* (London: Jonathan Cape, 2004), p. 204.

CREAMWARE

DOCUMENTING FORM AND FUNCTION
IN THE AGE OF ENLIGHTENMENT

PETER KAELLGREN

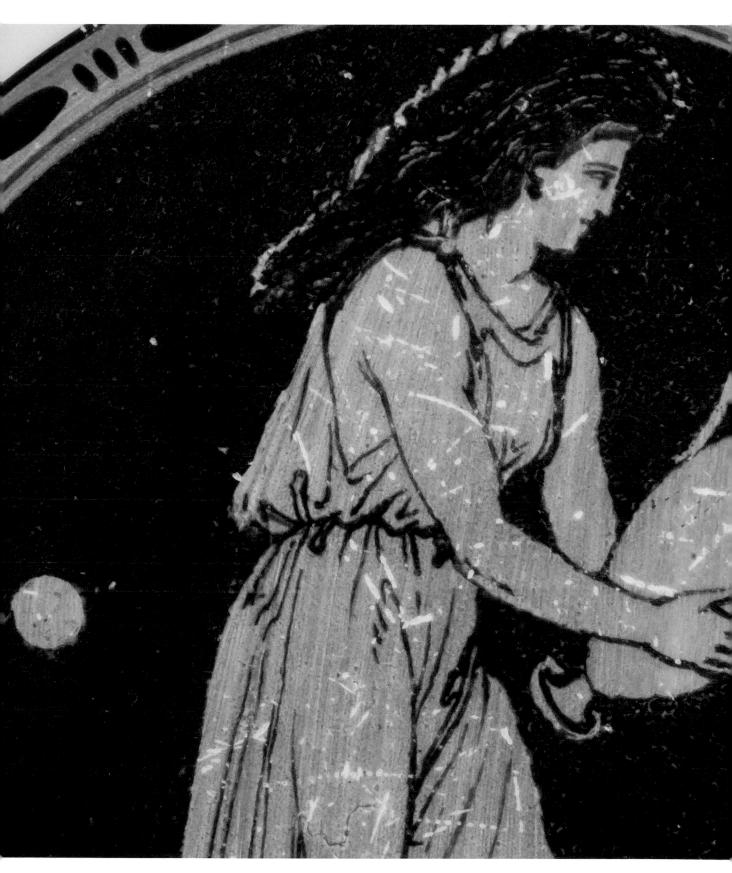

CREAMWARE

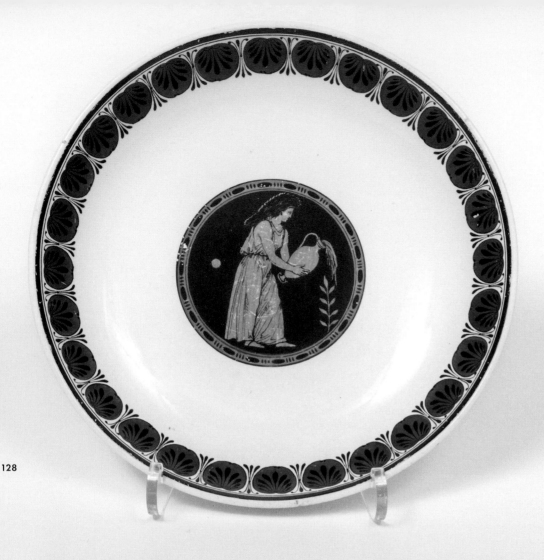

In 2008, Jean and Kenneth Laundy presented the Gardiner Museum with 63 pieces of creamware and pearlware. Inspired by her studies as a docent at the Gardiner Museum, Jean and her husband began to collect examples of these functional English earthenwares. The Laundy Collection is one of the most representative in Canada. It focuses on mainly plain, undecorated examples which document the range of elegant forms inspired by the Neoclassical or "Adam" style.

Creamware, a fine, thin, lightweight and durable white earthenware with yellowish lead glaze, was invented in Staffordshire. In the early 1760s, Josiah Wedgwood I (1730-1795) perfected the formula, range of fashionable forms and quality of production. After receiving a complimentary letter from Queen Charlotte in 1765, Wedgwood requested permission to call his improved creamware "Queen's ware".[1] This enhanced his market share and inspired imitators. Beginning in 1773, Wedgwood and his partner Thomas

Bentley (1730-1780) published illustrated catalogues in French, German and Dutch to market Queen's ware to a wider audience. The quality of production improved with a glaze formula that included traces of cobalt blue which made the ware appear whiter, introduced around 1780. A full range of tablewares, tea- and coffeewares, and useful pieces like large bowls for dairies, jelly moulds and other kitchen wares, and items for nurseries and sickrooms were made in creamware and pearlware. Line engravings in catalogues from Wedgwood and producers like the Castleford Pottery help to identify and date examples.

Josiah Wedgwood I was forever seeking new sources of design and inspiration as well as artists and decorators who could provide work that would appeal to the public. His business activities are documented in surviving letters to his partner Bentley, who was a businessman with experience in the Continental European market. In 1769, with the help of money from his wife's inheritance, he opened

DISH WITH HELLENISTIC DESIGN
Wedgwood, England, 1790 • Creamware
(lead-glazed white earthenware), transfer-
printed and enamels • Marks: None • H:
4.5 cm; D: 20 cm • Gift of Jean and Kenneth
Laundy, G08.2.18

the model factory of Etruria in Staffordshire. At that time, ancient Greece and Rome were highly regarded. Much of what was then known about their art came from excavations of tombs in southern Italy and the ruins of Pompeii and Herculaneum. These tombs yielded black pottery and red figured vases from the period c. 530–c. 400 BCE, which were both imports from Greece and products of local potteries. The tombs were thought to relate to the Etruscans, the early inhabitants of Italy. Painted decoration on the vases was highly regarded as a rare survival of the art of the ancients. By the 1760s, thousands of wealthy Britons were travelling on the Grand Tour in Europe with Italy, its art and ancient ruins, as the ultimate destination. Collectors brought home art, ancient sculpture, Etruscan and Greek vases and other antiquities as souvenirs to adorn elegant interiors.

The most prominent collector of ancient vases was Sir William Hamilton (1731–1803), Envoy Extraordinary to the Kingdom of the Two Sicilies (British Ambassador to the court of Naples) from 1764 to 1800. Selected vases from his original collection were documented by P. F. Hugues d'Hancarville in *Antiquités Etrusques, Grecques et Romaines, tirées du Cabinet de M. William Hamilton*, published in four folio volumes between 1766 and 1776 with engraved plates of the designs printed in red and black. So celebrated were the Hamilton antiquities that The British Museum purchased his first collection for £8,400 in 1772.

Josiah Wedgwood befriended Sir William and was able to study his vases.[2] The initial production of Etruria included six large "First Day" urns in black stoneware painted with red slip (liquid clay) using patterns taken from the Hamilton vases. Wedgwood called his decoration imitating these ancient vases "encaustic". Originally this term referred to ancient paintings on wood done with bee's wax pigments, but the scholarly name worked well for marketing. Wedgwood's plain black stoneware was inspired by everyday ancient ceramics and referred to as "basalt", a name derived from hard stone that was used by the ancient Egyptians for carving sculpture. It was used to produce vases, busts, medallions and tea- and coffeewares.

In 1769, Wedgwood established a showroom and decorating studio in Chelsea, London, supervised by Bentley. The finest encaustic decoration was painted by skilled artists in this studio who often copied engravings of the Hamilton vases. The demand for such wares continued through the late 1700s.

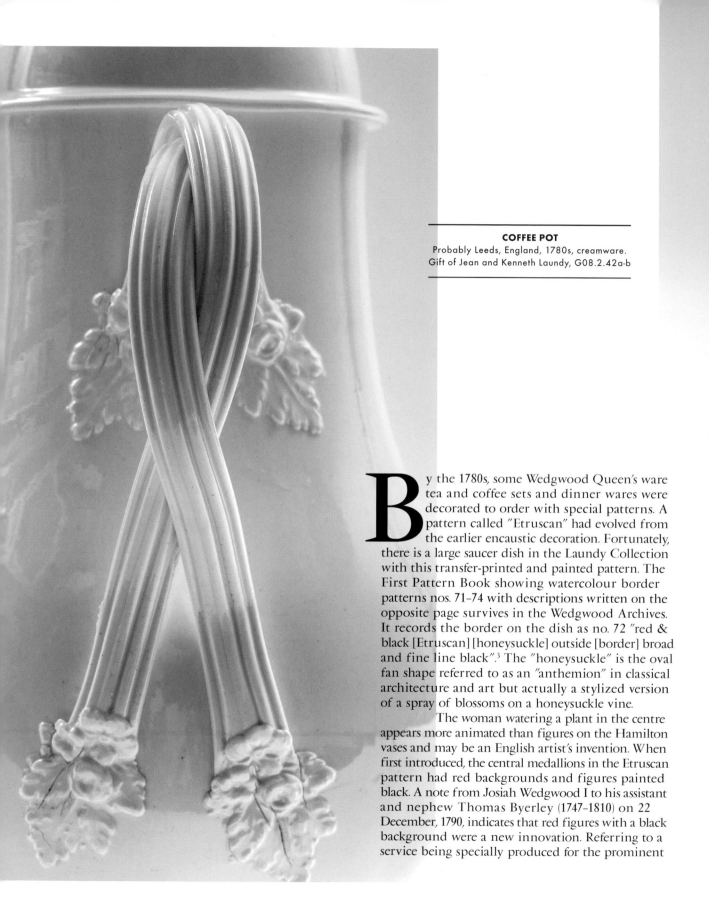

COFFEE POT
Probably Leeds, England, 1780s, creamware.
Gift of Jean and Kenneth Laundy, G08.2.42a-b

By the 1780s, some Wedgwood Queen's ware tea and coffee sets and dinner wares were decorated to order with special patterns. A pattern called "Etruscan" had evolved from the earlier encaustic decoration. Fortunately, there is a large saucer dish in the Laundy Collection with this transfer-printed and painted pattern. The First Pattern Book showing watercolour border patterns nos. 71–74 with descriptions written on the opposite page survives in the Wedgwood Archives. It records the border on the dish as no. 72 "red & black [Etruscan] [honeysuckle] outside [border] broad and fine line black".[3] The "honeysuckle" is the oval fan shape referred to as an "anthemion" in classical architecture and art but actually a stylized version of a spray of blossoms on a honeysuckle vine.

The woman watering a plant in the centre appears more animated than figures on the Hamilton vases and may be an English artist's invention. When first introduced, the central medallions in the Etruscan pattern had red backgrounds and figures painted black. A note from Josiah Wedgwood I to his assistant and nephew Thomas Byerley (1747–1810) on 22 December, 1790, indicates that red figures with a black background were a new innovation. Referring to a service being specially produced for the prominent

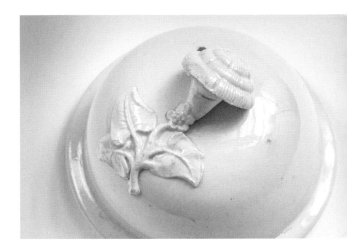

Scots-Dutch banker and collector Thomas Hope (1769–1831), Wedgwood attributes a delay in its completion to "the difficulty of making the red upon black instead of black upon red as we used to do".[4] Wedgwood's Etruscan patterns proved popular on the Continent, especially in Paris, which would have given satisfaction to Josiah I who had helped to negotiate an improved trade treaty with France in 1786.[5]

 The Laundy Collection is extremely useful for documenting popular consumer taste between 1760 and 1800. The large saucer dish offers additional insights: its decoration reflects the contemporary interest in Classical Antiquity and how it inspired Wedgwood's early production. ❧

PETER KAELLGREN completed a PhD in Art History at the University of Delaware in 1987, and is now Curator Emeritus at the Royal Ontario Museum, having developed the Museum's collection, curated specialist exhibitions and lectured variously, including annually from 1991 to 2008 at the Museum's Decorative Arts Symposium. From 2011 to 2012 he served as Chief Curator at the Gardiner Museum.

NOTES

1 Robin Reilly, *Wedgwood: The New Illustrated Dictionary* (Woodbridge, Suffolk: Antique Collector's Club, 1995). For cream-coloured ware, see pp. 122–123; for encaustic, pp. 149–150; pearlware, pp. 327–328; and Queen's ware, pp. 358–359.

2 See Ian Jenkins and Kim Sloan, *Vases & Volcanoes: Sir William Hamilton and His Collection* (London: The British Museum, 1996), pp. 49, 60, 182–185, 188.

3 Robin Reilly, *Wedgwood* (London: MacMillan London Limited, 1989). Plate C54, borders reproduced in colour with original period captions quoted exactly.

4 Reilly, *Wedgwood*, p. 306. Caption for Plate 375, and Plate 376, where a dessert plate of similar pattern with a black ground in the central medallion is illustrated, diameter 20.5 cm (8 1/8 inches). Reilly quotes Wedgwood's comments found in Ms96-1722 22 December 1790. An Etruscan dinner plate is shown in colour on Plate C57. Information on Thomas Hope as a leader in the ancient style can be found in a number of sources, in particular David Watkin, *Thomas Hope 1769–1831 and the Neo-Classical Idea* (London: John Murray, 1968).

5 Reilly, *Wedgwood: The New Illustrated Dictionary*, p. 153.

GOING JAPANESE

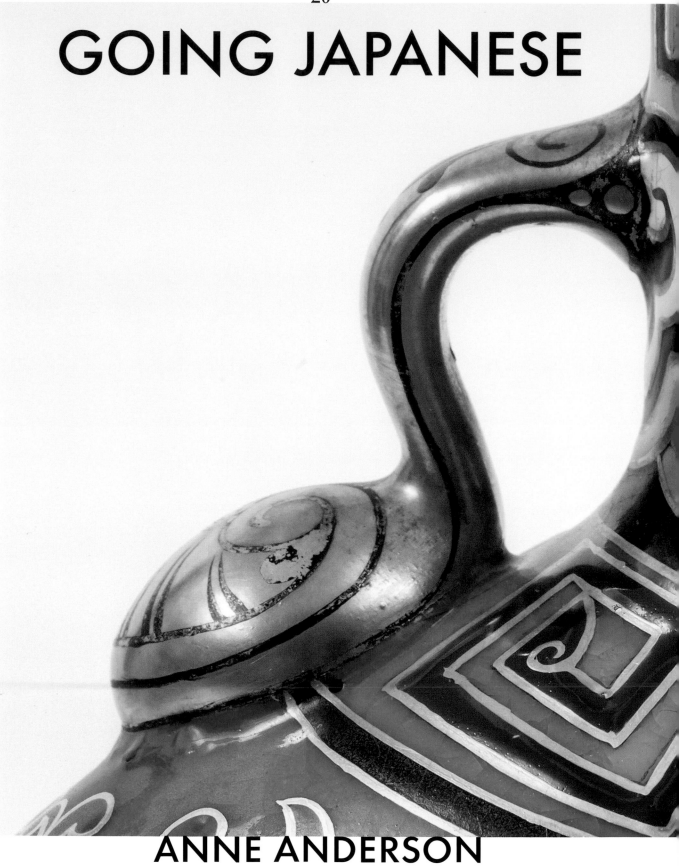

ANNE ANDERSON

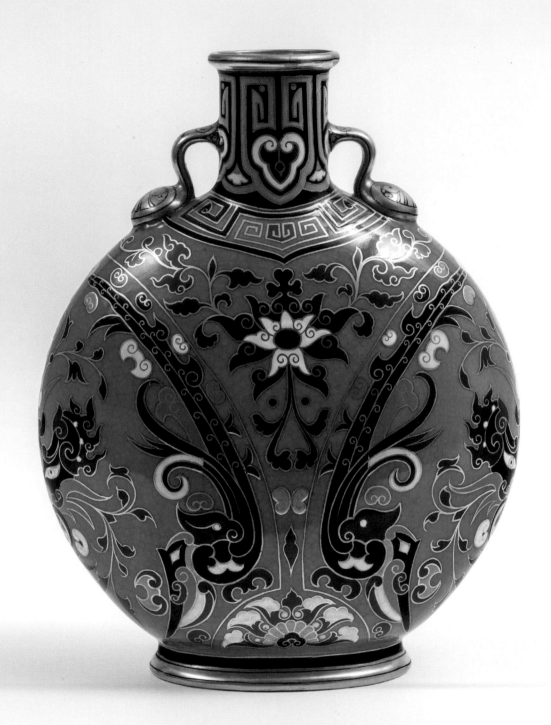

MOON FLASK VASE

Minton, England, 1860s • Designed by
Christopher Dresser (1834–1904) • Bone
china, overglaze enamel and gold • Marks:
None • H: 26.5 cm; W: 21 cm; D: 10.6 cm •
Gift of N. Robert Cumming, G98.1.28

ANNE ANDERSON

The sources for this Minton moon flask vase, designed by Christopher Dresser (1834-1904), appear to be Chinese, reflecting the factory's long tradition of freely using Oriental prototypes. The form was modelled after a Ming pilgrim flask, its flattened globular form offering an ideal decorative surface. Its *cloisonné* decoration similarly appears to derive from China; Minton's version of *cloisonné* made no attempt to replicate the technique of filling metal compartments or cells (*cloisons* in French), normally attached to a copper base, with enamel paste. Instead the effect was imitated by painting in coloured enamels on a turquoise ground with gilding to simulate the wires. This new technology, thought to have been developed by the factory's art director Léon Arnoux (1816-1902), was first presented at the Paris Exposition Universelle of 1867.

Minton had to keep pace with their rivals in a fiercely competitive market; the public eagerly responded to technical innovations and fashion trends. Colin Minton Campbell (1827-1887) was acutely aware of the need to maintain momentum. Dr. Christopher Dresser, botanist, designer and theorist, was just the man Minton needed to keep them one step ahead. Working freelance, he sold his first designs in 1858; Minton initially sought his expertise for their contribution to the London International Exhibition of 1862.[1] Dresser's studio would have been a hive of activity leading up to Paris 1867; as well as contending with European advances he had to vie with the newly awakened interest in all things Japanese, a vogue known as *Japonisme*.

Following a protracted isolation, Japan had been opened to the West by a United States Squadron under the command of Commodore Matthew C. Perry (1794-1858) in 1854. Initially Europe reaped the benefits; artists Félix Bracquemond (1833-1914) and James McNeill Whistler (1834-1903) were captivated by Japanese prints. Paris became the centre of the new trade; *La Porte Chinoise*, which sold various Japanese goods, opened on the rue de Rivoli, one of the most fashionable shopping streets in Paris, in 1862. Japanese *cloisonné*, which did not emerge as a major art form until the late Edo period (1800-1868), debuted at the 1867 Exposition Universelle; recognizing the importance of this new commodity the South Kensington Museum (latterly the Victoria and Albert Museum) purchased its first specimens. Dresser greatly admired both Chinese and Japanese *cloisonné* enamels, which were being skillfully copied by the French firms Barbédienne and Christofle.

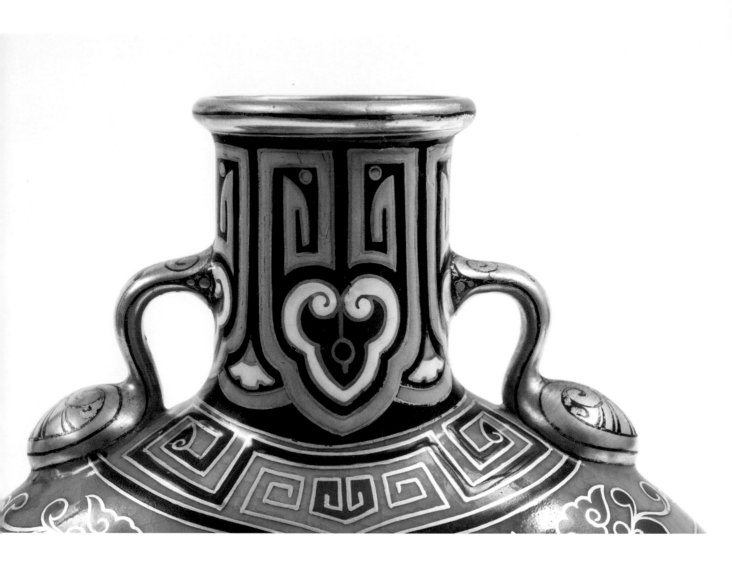

D resser had been fascinated by Japanese design since the mid-1850s; the public's imagination was awakened at the 1862 London International Exhibition, at which Sir Rutherford Alcock's collection was displayed. Dresser gained permission to draw some 80 specimens; at the close of the exhibition he bought a "fair selection" of them.[2] Dresser was confident that Japanese goods would reform English taste, later commenting, "I firmly believe that the introduction of the works of Japanese handicraftsmen into England has done as much to improve our national taste as even our schools of art and public museums... for these Japanese objects have got into our homes, and among them we live."[3] Dresser became one of the few designers to visit Japan (in 1876 as a guest of the Japanese nation) and he consistently promoted Japanese art throughout his long career. European response to Japan was already evident at Paris 1867; Félix Bracquemond exhibited his *Service Rousseau*, its decoration inspired by motifs taken from Japanese woodcuts. Consequently Minton's *cloisonné* moon flask can be situated within the so-called "Cult of Japan", illustrating how the factory responded to this new design ethos. However, it must be remembered that many artists failed to distinguish between Chinese and Japanese sources; Claude Monet (1840–1926) referred to *Terrace at Sainte-Adresse*, 1867, as his "Chinese painting with flags" even though his debt to Japanese prints is manifest in the work's high viewpoint and horizontal banding.[4] Dresser openly acknowledged China as the source for Minton's *cloisonné*, writing "Minton's vases are copies of the *cloisonné* enamels of China, or of old Persian works."[5]

ANNE ANDERSON

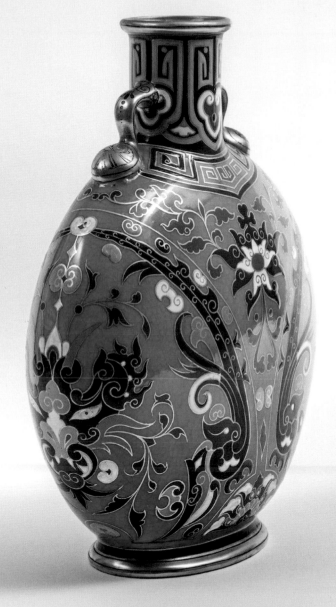

D resser sought to understand Japanese design principles and to adapt them to Western needs, 'reforming' commodities from teapots to toast racks. Following the 1851 Great Exhibition of the Works of Industry of all Nations, British design and taste were hotly debated; designs were criticized for being too ornate, impractical and ignoring the qualities of the materials used. Henry Cole (1808–1882), the moving force behind the Great Exhibition, was the self-appointed leader of the design reform movement. His aim was to improve the standards of industrial design in the face of competition from France and Germany; to this end Cole was instrumental in securing the £186,000 surplus from the Great Exhibition for enhancing science and art education. Cole assumed the directorship of the South Kensington Museum constructing a programmatic collection of antique and modern works of art that were to inform British artisans and improve the public's taste. Dresser was a protégé of the South Kensington system, attending the Government School of Design, Somerset House, from the age of 13. His path to success lay in achieving Cole's goal, forging an alliance between art and industry and creating innovative designs for textiles, metalwork, glass and ceramics.

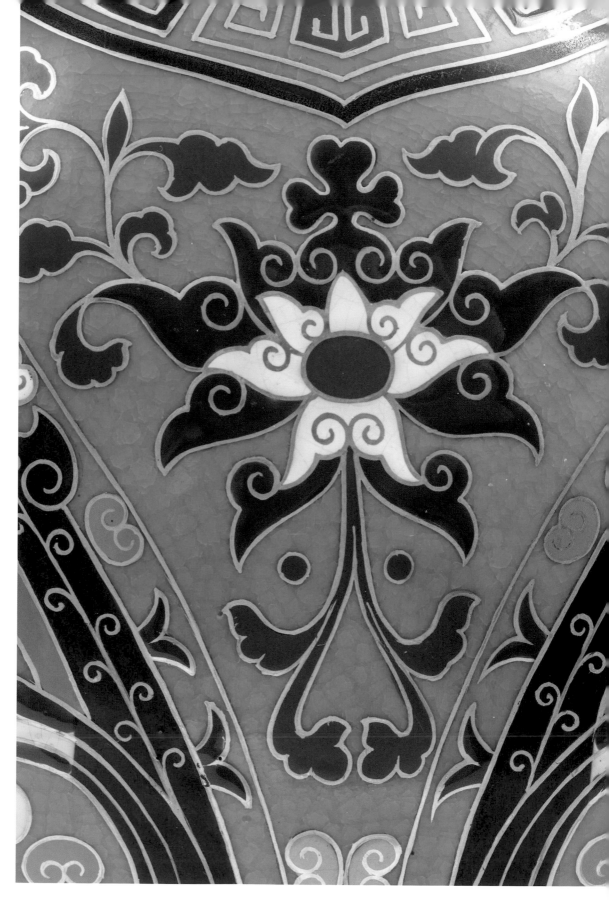

resser was not content to imitate, nor was he striving for archaeologically accurate 'reproductions'; his conceptions are imaginative and unique: "We may borrow what is good from all peoples; but we must distil all that we borrow through our own minds."[6] He favoured geometric forms, including inverted cones, U-shaped tubes and straight-sided cylinders, sometimes grouped together. He preferred angular rather than rounded shapes, noting "another merit of Japanese drawing is its crispness of touch, or angularity... [which] gives vigour and life".[7] His surface decoration followed similar principles being abstract and flat rather than representational or three-dimensional; Owen Jones' *Chinese Ornament*, 1867, provided prototypes. Minton's moon flask is undoubtedly a product of the 1860s; an 'art manufacture' that allied imaginative design with advanced technology in order to satisfy an increasingly sophisticated consumer. ❧

ANNE ANDERSON, PhD, was a senior lecturer in the History of Art and Design at Southampton Solent University for 14 years; she held the Cumming Ceramic Research Fellowship in 2007 and 2010 for projects on 'chinamania'; and she is currently Hon Research Fellow at Exeter University. Her most recent publication is "'The China Painter': Amateur Celebrities and Professional Stars at Howell and James's 'Royal Academy of China Painting'", in *Crafting the Woman Professional in the Long Nineteenth Century: Artistry and Industry in Britain*, 2013.

NOTES

1 Joan Jones, *Minton: The First Two Hundred Years of Design and Production* (Shrewsbury: Swan Hill Press, 1993), p. 56.

2 Charlotte Gere and Michael Whiteway, "Dr. Christopher Dresser: His Life and Career", in *Shock of the Old: Christopher Dresser's Design Revolution*, Michael Whiteway, ed. (London: V&A Publishing, 2004), p. 35.

3 Jones, *Minton The First Two Hundred Years*, p. 89.

4 Paul Smith, *Impressionism Beneath the Surface* (London: Weidenfeld and Nicolson, 1995), p. 31.

5 Christopher Dresser, "Eastern Art and its Influence of European Manufactures and Taste", *Journal of the Society of Arts 6* (February 1874), pp. 211–219, quoted in Judy Rudoe "Dresser and his Sources on Inspiration", in *Shock of the Old: Christopher Dresser's Design Revolution*, Whiteway ed., p. 85.

6 Christopher Dresser, *Japan, its Architecture, Art and Art Manufactures* (London: Longmans, Green and Co., 1882), p. 319.

7 Dresser, *Japan, its Architecture, Art and Art Manufactures*, p. 286.

MARC CHAGALL'S CLAY WORK

SUSAN JEFFERIES

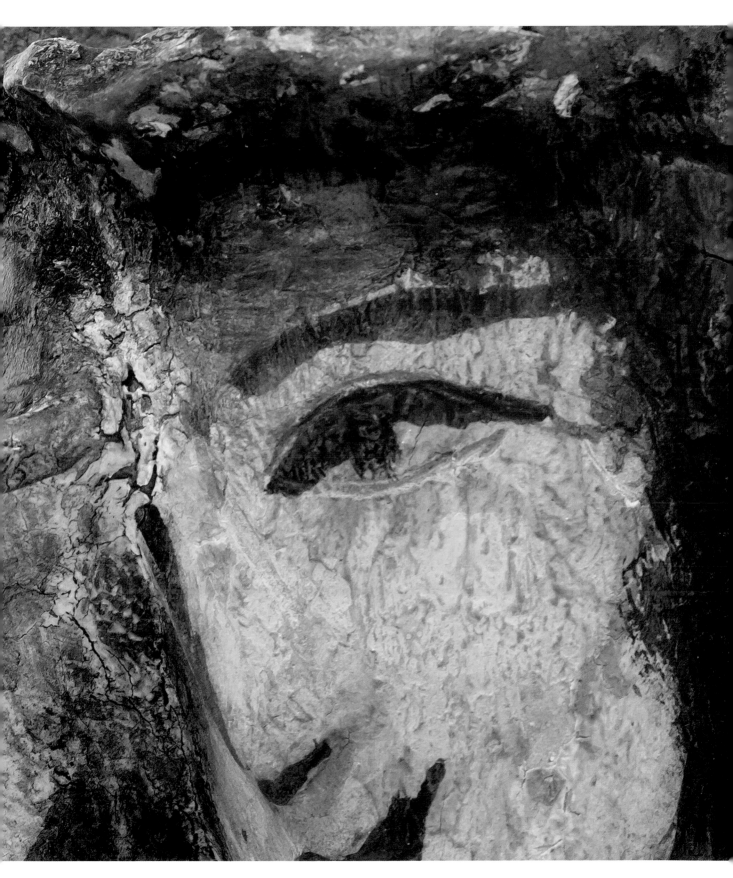

MARC CHAGALL'S CLAY WORK

142

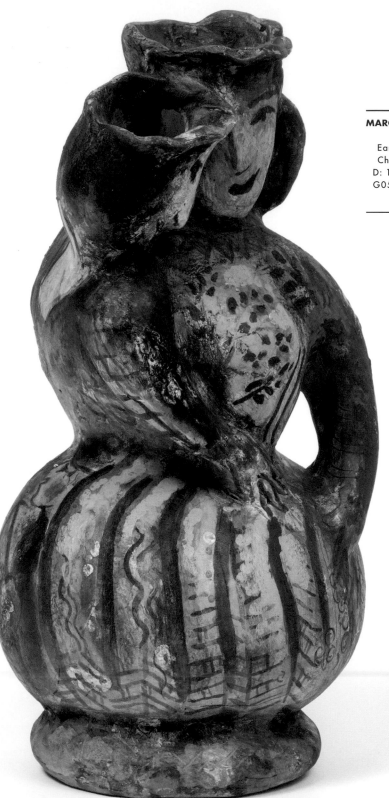

MARC CHAGALL (BELORUSSIAN, 1817–1985)
LOVERS, 1957
Earthenware with glazes • Mark: "Marc Chagall 1957" • H: 32 cm; W: 16.5 cm; D: 15 cm • Gift of Bram and Bluma Appel, G05.19.1 • © SODRAC 2013 and ADAGP 2013, Chagall ®

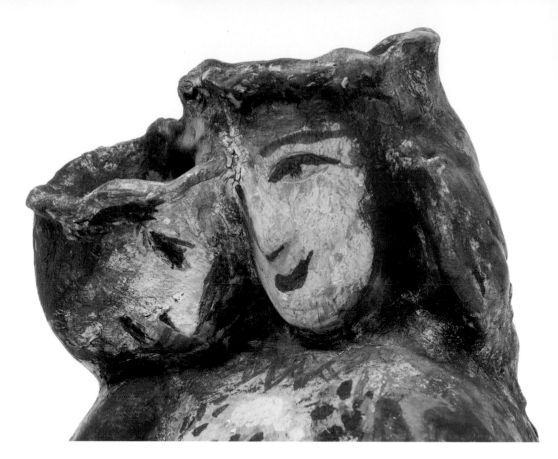

*"*I work in whatever medium likes me at the moment." With this simple statement, Marc Chagall defends his right to work with clay or any other medium and by implication deflates the controversy surrounding visual artists working with ceramics.[1] It is feared by some that these "visitors to clay" may be merely dabbling and compromising their talents.[2] However, this piece by Chagall and two landmark ceramic exhibitions at the Gardiner Museum, *Miró: Playing with Fire* (2000) and *Picasso and Ceramics* (2004–2005),[3] have confounded these views.[4]

After the Second World War, the Côte d'Azur became a magnet for visual artists wishing to escape the aftermath of war and live in a light-filled environment. Marc Chagall, Pablo Picasso and Henri Matisse were among the notable artists living in the area who gravitated to clay. All three had stints at the famous Madoura Pottery run by Georges and Suzanne Ramié.[5] Local potters were employed to throw plates, cups and vases on the potter's wheel.[6] Substituting glazes for paint, the artists decorated the wares, the vessels effectively becoming canvases for their ideas. Some artists, including Chagall (and Picasso), could not resist the allure of working more actively with the clay itself. Jug and vase forms morphed into human and animal forms, blurring the line between domestic wares and sculpture.

Chagall began working in clay in 1949. Over the course of the next 13 years he worked at the Madoura Pottery and with Serge Ramel at Madame Bonneau's atelier in Vence. In 1972 he worked briefly with Michel Muraour at St. Paul de Vence. In total, he made over 220 unique pieces, including an extensive dinner service of over 70 pieces for his daughter Ida's marriage in 1951. Each piece was painted with individual scenes including lovers, circus performers and animals. In the same year the Gardiner piece was made, he installed a commissioned, 90-tiled wall panel entitled *Traversée de la mer rouge* (*Crossing of the Red Sea*), at Notre-Dame-de-Toute-Grâce in Assy. In 1969–1970, 92 of his ceramic pieces were included in a retrospective, *Hommage à Chagall*, at the Grand Palais in Paris. Unlike Picasso, Chagall did not make any editions of his ceramic work: each piece was unique. The eminent Galerie Maeght in St. Paul de Vence exhibited and sold his work, including the clay pieces, throughout this period.

"Art is not created through theory—paintings and ceramics are created using one's hands and heart."[7] Marc Chagall's ceramic portrayal of two lovers in the Gardiner Museum collection illustrates the "hand and heart" approach. This superb piece is made with tenderness and devotion to detail. Chagall has manipulated the clay to create a young woman in a

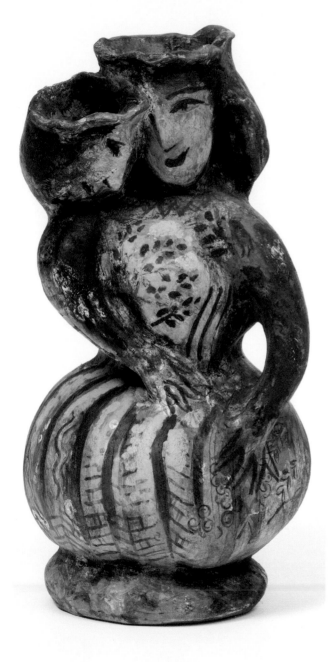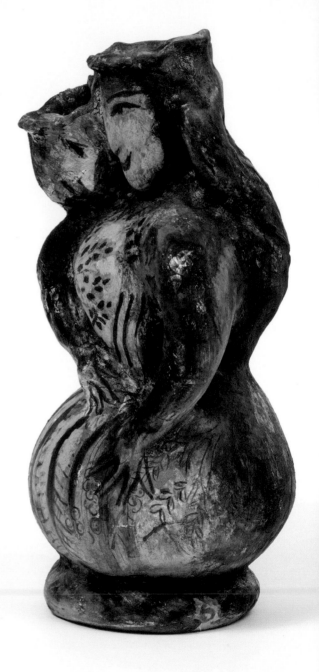

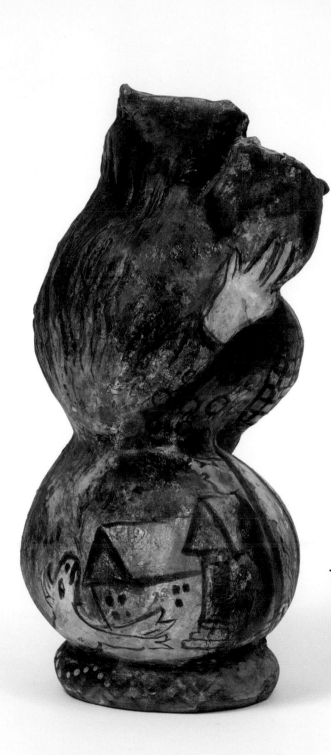

striped billowing skirt with a floral bodice and long hair cascading down her back. The young suitor is devoted, languishing with his head on the woman's shoulder. Touches of blush pink, black and yellow highlight the faces, clothes and background. Jewel-like blue dots zigzag along the generous base. The narrative continues on the back with drawings of two houses, an upside-down animal and a figure with a hat. A second glance reveals that this sculptural piece is actually a functioning jug: the woman's graceful arm is its handle and the man's doting head its spout.

What is immediately striking about this piece is the way in which the artist manages to replicate the luminescent blue colour we see in his paintings.[8] Chagall associated luminosity with the earth and the earth with clay: "The very earth on which I walk is so luminous. It looks at me tenderly as if it were calling me. I had the sudden feeling that this bright earth was calling awake the deaf earth of my far-off home town."[9] Ceramic glazes are notoriously difficult to make and control, yet here is a piece with a lively surface in tune with Chagall's output in other media. The sensitive rendering of colour validates Picasso's statement: "When Matisse dies, Chagall will be the only painter left who understands what colour really is."[10]

Chagall's work is unusual in that it reflects aspects of his own personal life, a complex world of memories: growing up in the Russian Pale (an area of Russia where Jews were required to live), his years with his first wife Bella, and exile from Russia and France. Artistically, he translated these memories into narrative and figurative work, paintings, ceramics, stained glass, stage design, tapestries, lithographs and etchings.

The forceful reiteration of certain motifs evident in much of Chagall's work is seen in the Gardiner's ceramic piece: the log huts of Vitebsk, his birthplace, lovers with flowers (often not in scale with their surroundings) and upside-down animals. His work is based on his own personal inner reality, dream-like perhaps, but not fantasy or myth as is sometimes claimed. In his paintings and on the back of this piece, he re-orders the earth and sky. With the universe spatially transformed, the people, animals and houses are set free: anything and everything is possible.

This sculptural jug, a gift from Bram and Bluma Appel, is an outstanding example of Chagall's ceramic work and a welcome addition to the Gardiner Museum's collection.[11]

SUSAN JEFFERIES is a freelance curator and educator who established the modern and contemporary gallery at the Gardiner Museum and served as its Curator for ten years. She has curated travelling exhibitions to Asia and Europe and served as a juror on the Taiwan Ceramics Biennale in 2008.

NOTES

1 His work in stained glass, book illustration, stage and costume sets, tapestries and lithography is well documented.

2 The list of eminent visual artists working in clay is surprisingly long. It includes: Pierre Alechinsky, Karel Appel, Arman, Miquel Barceló, Vanessa Bell, Pierre Bonnard, Georges Braque, Mary Cassatt, Eduardo Chillida, André Derain, Kees van Dongen, Raoul Dufy, Lucio Fontana, Paul Gauguin, Duncan Grant, Asger Jorn, Wifredo Lam, Ferdinand Léger, Aristide Maillol, Kazimir Malevich, Gerhard Marcks, André Masson, Henri Matisse, Roberto Matta, Ben Nicholson, Mimmo Paladino, Pablo Picasso, Auguste Renoir, Jean-Paul Riopelle, Georges Rouault, Cindy Sherman, Antoni Tàpies and Édouard Vuillard.

3 Curated by Anne McPherson with accompanying catalogue.

4 Curated by Paul Bourassa and Léopold L. Foulem with accompanying catalogue.

5 More recent innovations in the artist/potter synthesis have been realized in the ceramic studio of Hans Spinner in Grasse, France. It was here that Miró made his 'death' masks that were featured in the Gardiner exhibition in 2000. Spinner's

work with artists Anthony Caro, Pierre Alechinsky, Eduardo Chillida and Antoni Tàpies was equally productive. Spanish painter Miquel Barceló poked, prodded and dove through a large wall of clay and was sprayed with liquid clay as part of a performance entitled, *Paso Doble*, seen in Brooklyn in 2007 and Avignon in 2010. A later work by Barceló, a chapel made exclusively of clay, Capella del Santíssim in the cathedral in Palma illustrates clay's sensual power to heighten spiritual emotions. See the documentary *Mar de fang: Miquel Barceló, a la SEU de Mallorca*, 2008.

6 Interestingly Picasso reserved his praise for ceramic artist Gilbert Portanier, who makes his functional and free-form pieces from start to finish, never employing a local craftsman to fabricate his work. Picasso said of Portanier: "Each of his pieces belongs in a museum." See Gilbert Portanier, *Œuvres 2000–2009* (Arnoldsche Press, 2009), p. 33.

7 Roland Doschka, ed., *Marc Chagall: Ceramic Masterpieces* (Munich: Prestel, 2003), p. 23.

8 The colour blue is associated with the sea or sky. In Chagall's work the sky often includes floating objects, people and animals. Chagall paraphrases visually, artist Yves Klein's comment, "What is blue? Blue is the invisible becoming visible". See Hannah Weitemeier, *Klein* (Taschen, 2001).

9 Philippe Forest, *Marc Chagall, la céramique est si lumineuse* (Paris: Gallimard, 2007), p. 21.

10 Jackie Wullschlager, *Chagall: A Biography* (London: Knopf, 2008), p. 456.

11 Bluma Appel in conversation with Susan Jefferies, 2004. Bluma and Bram Appel purchased this piece and a tile from Suzanne Ramié, Chagall's dealer at the Madoura Pottery in Vallauris. In the early 1960s, Mrs. Appel sat next to Marc Chagall aboard the SS *France*, conversing with him in French and Hebrew. They exchanged addresses and a year later when the Appels were in Antibes they contacted the artist and were invited to his villa, La Colline (The Hill) in Vence. They brought along photographs of their pieces, hoping to have them signed. Chagall became visibly upset when they made their request and ran to the cabinet in the front hall where his favourite ceramic pieces were kept. Finding them gone, he shouted for his wife Vava and began arguing with her. The Appels beat a hasty retreat.

MARILYN LEVINE
CHEMISTRY IN CLAY

SANDRA ALFOLDY

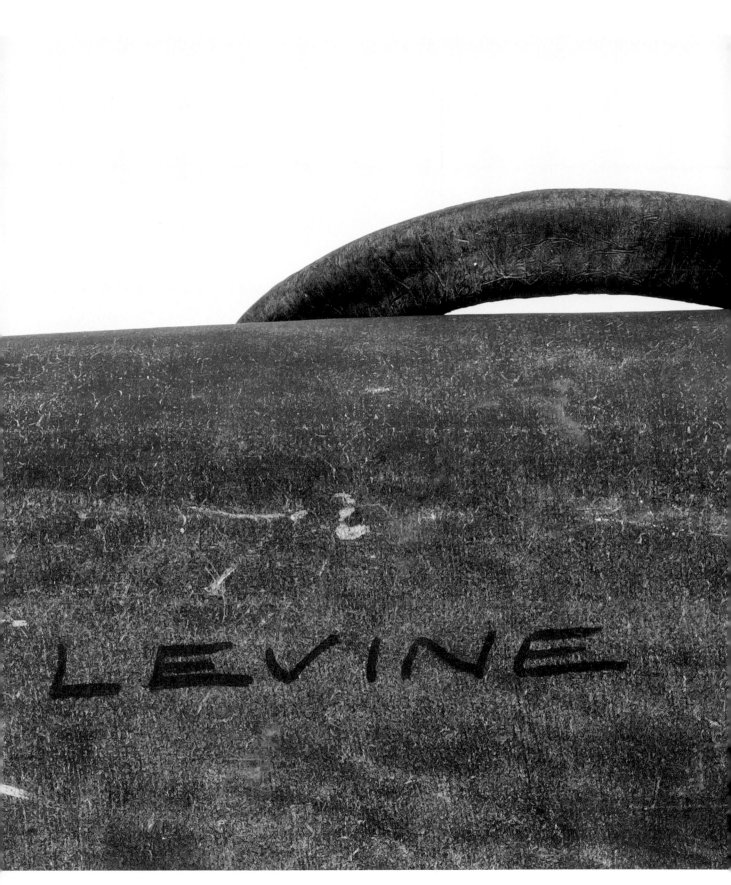

MARILYN LEVINE

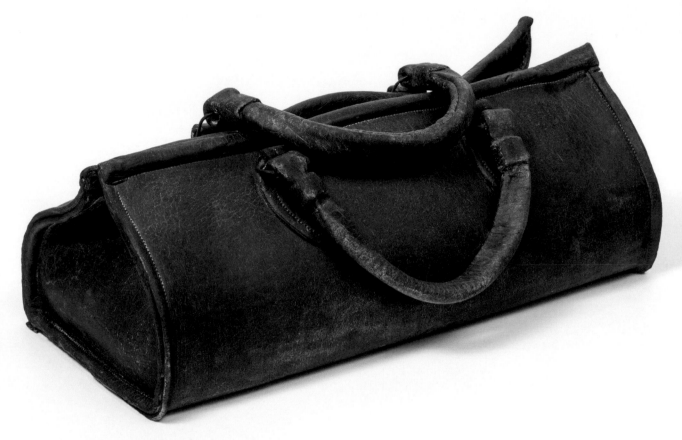

The *Doctor's Bag* rests heavily, handles folded softly from use, one end slightly open and unable to close from all the wear and tear. It can certainly fool the eye, but its surface and details nag at the viewer, with hints of clay peeking through the leather trickery. It is a vastly different aesthetic in relation to its counterpart, the *Suitcase with One Strap*, whose hyper-realism shocks, a piece that demands repeated glances, and curious investigations to marvel over the latches, the strap, the handle, the bolts. *The Doctor's Bag* was completed in 1970, the *Suitcase with One Strap* in 1979, a decade that was miles apart in terms of the artistic trajectory of Marilyn Levine, from unknown pottery student to darling of the California Funk ceramics world; echoing a decade that saw ceramics expanding and pushing beyond its previous boundaries.

The 1970 *Doctor's Bag* is a remarkable piece. Completed before Levine finished her MFA at the University of California, Berkeley in 1971, it attests to her breakthrough into the male-dominated world of sculptural ceramics. Not bad for a feisty prairie girl who started her career as an analytic inorganic chemist.[1] Born in 1935 and raised in Medicine Hat, Alberta, Levine graduated with an MSc in Chemistry from the University of Alberta in 1959. It was this chemistry background that allowed Levine to develop her later ceramic bodies that worked so well reproducing the leathery look she favoured. She was very scientific when discussing her clay, stressing "I developed a stoneware body that incorporated between one-and-a-half percent to two percent chopped nylon fibre. Early on I guessed that a non-silicate fibre might be superior, in that it wouldn't bond to the clay. So in

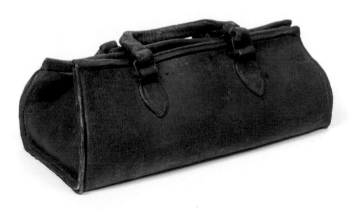

MARILYN LEVINE (CANADIAN, 1935–1956)
THE DOCTOR'S BAG, 1970
Stoneware, reinforced with nylon fibres,
china paints and metal clasps • Marks: None
• H: 15 cm; W: 40 cm; D: 21 cm • Gift of
Len Dutton, G12.10.1

the summer of 1969, I wrote to DuPont requesting samples of various fibers. They sent me three types of fibres—chopped Dacron, chopped Nylon and some stretchy Nylon. Of those samples, 15 denier 'Nylon 120' was the best."[2] This stoneware body permitted Levine to construct her pieces just like they were composed of leather—cutting, building and shaping boots, suitcases, bags and Coca Cola bottles. The wet clay would be supported by interior frames. *The Doctor's Bag* is an early experiment in this process, and one can see that the surface finish is not as authentically 'leather-like' as the later *Suitcase with One Strap*. It is also smaller in scale, and lighter in colouration, demonstrating the still-experimental state of Levine's *trompe l'œil* sculptures which would grow larger and more astonishingly realistic over time.

So how did an analytic inorganic chemist take the ceramics world by storm? A year and a half before her death Levine argued that the story of her clay career was filled with "misinformation having deep roots".[3] Yes, it was true that when she moved to Regina, Saskatchewan, with her then husband Sidney, in 1961, she could not find a job teaching chemistry so she returned to her childhood love of art. Yes, she found the Regina clay scene

provincial, "[a]t that time very little was going on in ceramics there. The student body in Pottery classes were largely wives of the cabinet members and deputy ministers, and housewives."[4] And yes, she was drawn to the functional work of Jack Sures, who had come to the University of Saskatchewan, Regina, in 1965 to teach ceramics. "Jack... had an exquisite sensitivity to the plastic nature of clay, which along with his disciplined work habits became very influential to myself and other students."[5] But this is where the story behind *The Doctor's Bag* and the *Suitcase with One Strap* requires clarification. Levine's leap into sculptural ceramic hyper-realism should not be "credited to David Gilhooly [he is not] the pivotal influence".[6] Instead it developed in Regina, then sprang into action in California. In Levine's own words, "In 1967, Jack [Sures] moved into more sculptural forms, made from clay reinforced with fibreglass strands. At about the same time, I had heard from Rick Gomez that something exciting was going on in clay on the west coast, so in 1968, I applied for and won a Canada Council [of the Arts] Short Term Grant, for the purpose of exploring the ceramics on the west coast in Canada and the United States.[7] It was on that trip that I met Gathie Falk,

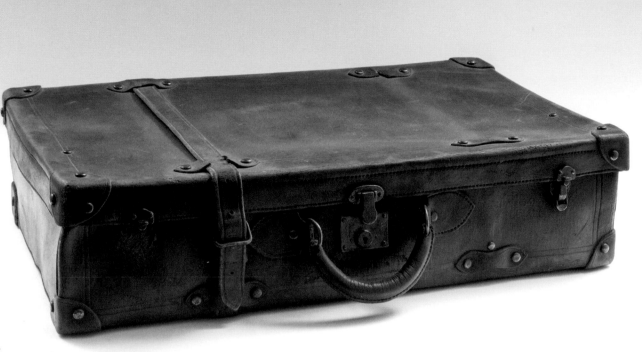

John Mason, Stephen De Staebler, James Melchert, Peter Voulkos, Ron Nagle, and saw their studios and their work...." It took Levine some time to adjust to sculptural clay, as she had spent the previous seven years perfecting her utilitarian ware. However, once she made the leap tremendous critical success followed."[8]

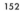t is funny to think that Marilyn Levine's famous body of ceramics, called "a three-dimensional equivalent of Photo Realism" by the *New York Times* art critic Roberta Smith, almost did not happen due to her initial fear of moving away from functional ceramics.[9] *The Doctor's Bag* is significant in that it represents an early transition into sculpture, but can be read as a cautious piece in relation to her later work. She switched gears so successfully that by the time she created *Suitcase with One Strap* in 1979 she was a woman fully in control of her personal aesthetic. Unfortunately for the Canadian clay scene Levine felt ostracized in her own country, "Actually, you know, my work wasn't accepted all that well in Canada... I came back to Canada and it was out of the mainstream or something there. I don't know, it was just—I couldn't get a job in Canada."[10] Imagine how different ceramics might have looked across this nation if she had taken the helm at an art school. Regardless, she became a

powerful force that influenced the next generation of North American sculptural ceramists. And it all started in a small clay studio in Saskatchewan.

SANDRA ALFOLDY received her PhD in Craft History from Concordia University in 2001 and completed her postdoctoral fellowship at the University of Rochester before becoming Professor of Craft History at Nova Scotia College of Art and Design University. Her publications include *The Allied Arts: Architecture and Craft*, 2012, *Neocraft*, 2007, and *Crafting Identity: The Development of Professional Fine Craft in Canada*, 2005.

NOTES

1 Archives of American Art, Oral History Interview with Marilyn Levine, 5 May 2002, interviewed by Glenn Adamson. www.aaa.si.edu/collections/interviews/oral-history-interview-marilyn-levine-12144.

2 Marilyn Levine, email correspondence, Monday, 20 October 2003. Levine said that as she travelled around Canada and the United States "demonstrating the process, DuPont evidently was becoming barraged by ceramic folk asking to buy small amounts of Nylon fibre". Around 1975 DuPont worked with Levine identifying outlets where they could sell small amounts directly to ceramists.

3 Marilyn Levine, email correspondence, Sunday, 16 November 2003.

MARILYN LEVINE (CANADIAN, 1935–1956)
SUITCASE WITH ONE STRAP, 1979
Ceramic and mixed media • Promised gift
from the Raphael Yu Collection

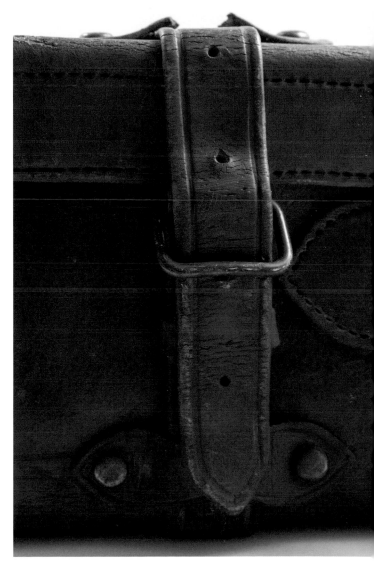

4 Marilyn Levine, email correspondence, Sunday, 16 November 2003.

5 Marilyn Levine, email correspondence, Tuesday, 25 November 2003.

6 Marilyn Levine, email correspondence, Sunday, 16 November 2003.

7 Then Head of the Art Department at the University of
 Saskatchewan, Regina.

8 Marilyn Levine, email correspondence, Tuesday 25 November 2003.

9 Roberta Smith, "Marilyn Levine Dies at 69; Sculptor of
 Leathery Works", *New York Times*, (10 April 2005). www.
 nytimes.com/2005/04/10/arts/design/10levine/html?_
 r=0&pagewanted=print&position=.

10 *Archives of American Art*, "Oral History Interview with Marilyn
 Levine", (5 May 2002), interviewed by Glenn Adamson. www.
 aaa.si.edu/collections/interviews/oral-history-interview-marilyn-
 levine-12144.

NOT STRICTLY A POT

PAUL GREENHALGH

NOT STRICTLY A POT

LUCIE RIE (AUSTRIAN, 1902–1995)
VASE WITH FLARED RIM AND
TERRACOTTA-BANDS, C. 1975
Porcelain, manganese and terracotta glazes
• Marks: Entwined "LR" • H: 21 cm; D:
13 cm • Gift of Ann Mortimer, C.M., G11.4.1

I t is a strange looking vessel at first sight. A bottle form with a wildly exaggerated top—a flared lip —that gives it its title, and guarantees us without further investigation that it can never be used for anything remotely bottle- or vase-like.

Vase with Flared Rim and Terracotta-bands has all the wrong proportions for storage, pouring, drinking or holding plant life. Its surfaces have a mud-like opacity, in places blistered and pot-marked as though they were formed volcanically. This primordial earthiness is tempered—controlled, framed, divided —by a mixture of hard lines, in places sgraffitoed (scratched) into its surfaces, and in others painted in bands. Not strictly a pot then, in any direct sense, but rather a work of art based on the ceramic vessel, a physical discourse on the history of pottery, and a sublime work of ornamental art.

The oeuvre of Lucie Rie is often described as and commended for being profoundly simple, of being a symmetric flow of variegated curves and puckered surfaces, without extraneous symbols or messages to tell us what it is about. And *Vase with Flared Rim and Terracotta-bands* shows us this is not an unfair way of thinking about her work: more than with any other artist of the last 50 years, her pots appear never to contain anything extra, nor

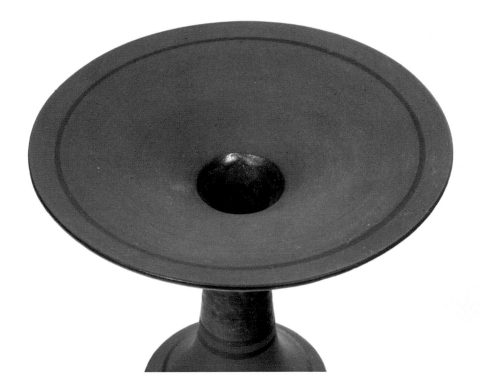

anything missing. One is reminded of Jean-Paul Sartre's writings on art that were near contemporary with her, and which would suggest that in an existentialist kind of a way, somehow her pots just are. But having said this, these are neither simple nor pure creatures. Her life and work are perhaps better described as having a complexity borne of a marriage of toughness and delicacy.

We tend to think of London when we think of her life, and while this is fair, her work does not really come from there, but exudes a sophistication and hedonism that resonates with the richness of mainland Europe. The London she landed in in 1938 still regarded wine, pasta, olive oil and coffee as foreign exotica, and the Channel as God's greatest invention. In the pottery world at least, over the following 50 years, she helped change all that.

She was born in *fin-de-siècle* Vienna in 1902, the headiest and most dangerous of ages. Her father was in the medical profession, and so her first decades were spent in a comfortable, well-read and well-heeled environment. Her parents were liberal and forward-looking, and so she enjoyed the still unusual advantages (for a woman) of education and inclusion in the intellectual milieu they resided in. She came to know luminaries such as Sigmund Freud, and was cognizant

of the intellectual vibrance of her times. She grew up in an age in which cultural modernity provided the environment for unprecedented artistic achievement, and industrial modernization created the tools for unspeakable barbarity. Her early life was framed by the Vienna Secession and the First World War. After that darker forces came to play, because at the end of the day, the only reason she ended up part of the London ceramic scene is because she was Jewish.

All her life she enjoyed a reputation for single-mindedness, and so it is no surprise that she was able to persuade her parents that she should be allowed to train as an artist: she enrolled at the Vienna Kunstgewerbeschule in 1922. Though not especially a centre for ceramic art, it was there that she developed her love of the medium, and the core skills of chemistry and throwing at the wheel. Reading her biographers, one picks up the powerful impression that it was then she determined with unnatural certainty that she was a potter, and dug in to learn her trade. It was a rich environment. Most certainly she was constantly in the presence of the Antique and of Classical approaches to form, composition and decoration. And as already hinted, the Viennese Secession, a first-generation movement

of Modernists in art and design, usually understood as being part of European Art Nouveau, also soaked into her. Her father's surgery and waiting room were Secessionist in feel, and more importantly, the great Secessionist architect-designer, Josef Hoffmann (1870–1956), was one of her teachers at the Kunstgewerbeschule. The linear patterns, exaggerations and distortions of Classical composition, informal geometry and the underpinning of nature that are a constant presence in Hoffmann and other Secessionists, have an ongoing, quiet presence in Rie, as is evidenced in *Vase with Flared Rim and Terracotta-bands.*

Hoffmann was designing furniture in 1902 that already had the potent feel of Art Deco and the Modernism of the 1920s. But tellingly, by the time Rie came under his influence, he was far from being part of the avant-garde, but rather was the grand old man, definitely classic, and perhaps rather conservative. One gets the impression that this would not concern Lucie, who was temperamentally no radical or breaker of moulds. Rather, from the earliest days, she sought a

certain mode of the sublime. Her oeuvre does not shout, or even have aggressively distinct phases, but rather is an organic unfolding that led her steadily to novelty, as her works in the Gardiner Museum collection show. She became a successful maker in Vienna, and won recognition in major European arenas.

We can only muse on the desperate trauma of having to flee one's home to escape the storm of Fascism. But once settled in London, she steadily established herself, and became one of the major figures of the British scene. She looked after and brought on the great Hans Coper (1920–1981), also an escapee from the Fascist nightmare, and the two of them ultimately became recognized, in their own different ways, as world figures in modern ceramics. Coper is also represented in the Gardiner Museum collection. Before she died, a grateful Britain fashioned her Dame Lucie Rie, a woman whose life and work showed that the civilization of grace and beauty ultimately can succeed over the venal forces of barbarism.

PAUL GREENHALGH

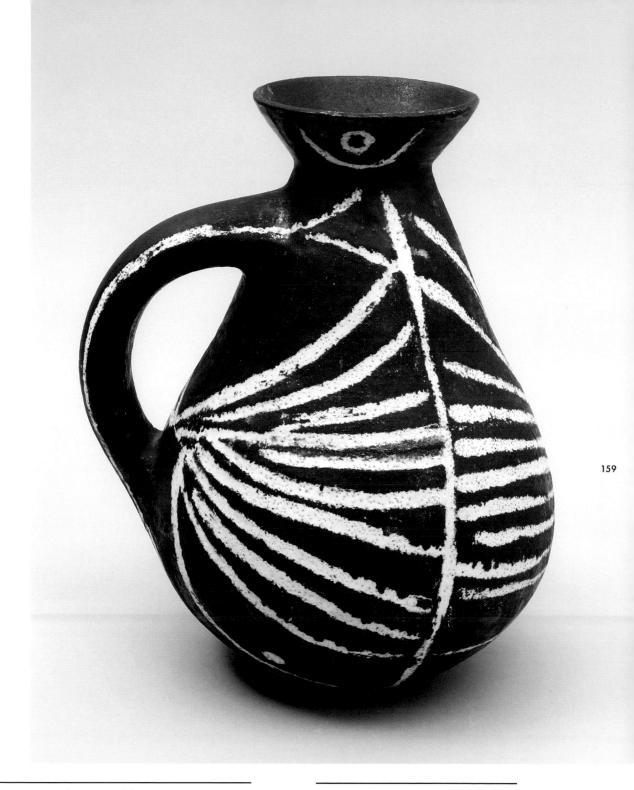

PAUL GREENHALGH is the Director of the Sainsbury Centre for Visual Arts. He served as Director of the Corcoran Gallery of Art between 2006 and 2010, was President of the Nova Scotia College of Art and Design University from 2001 to 2005, and is a previous Head of Research at the Victoria and Albert Museum, London.

HANS COPER (BRITISH, 1920–1981)
JUG, C. 1955
Stoneware with sgraffito design • Gift of Christine and Claude Bissell, G03.2.1

NOT STRICTLY A POT

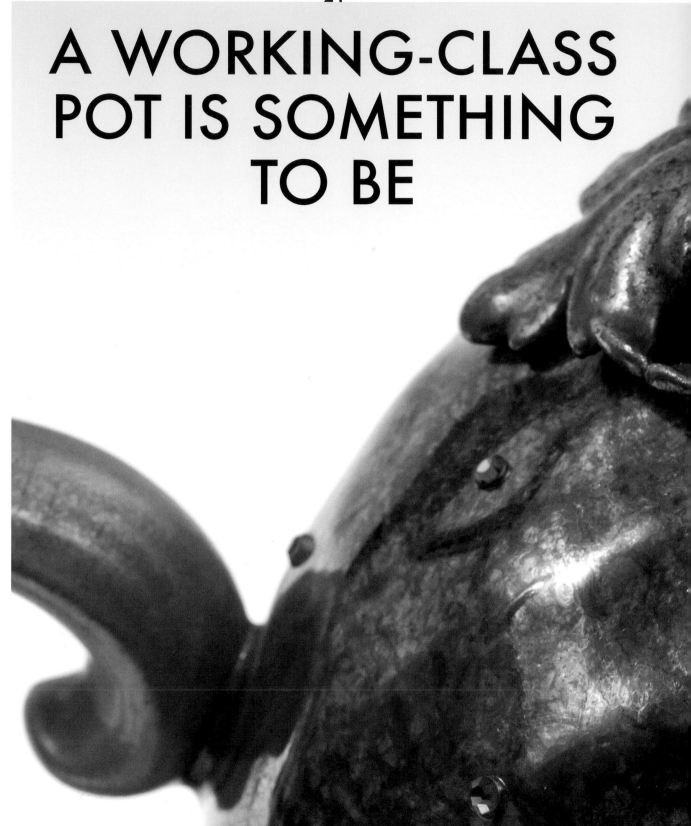

A WORKING-CLASS POT IS SOMETHING TO BE

EZRA SHALES

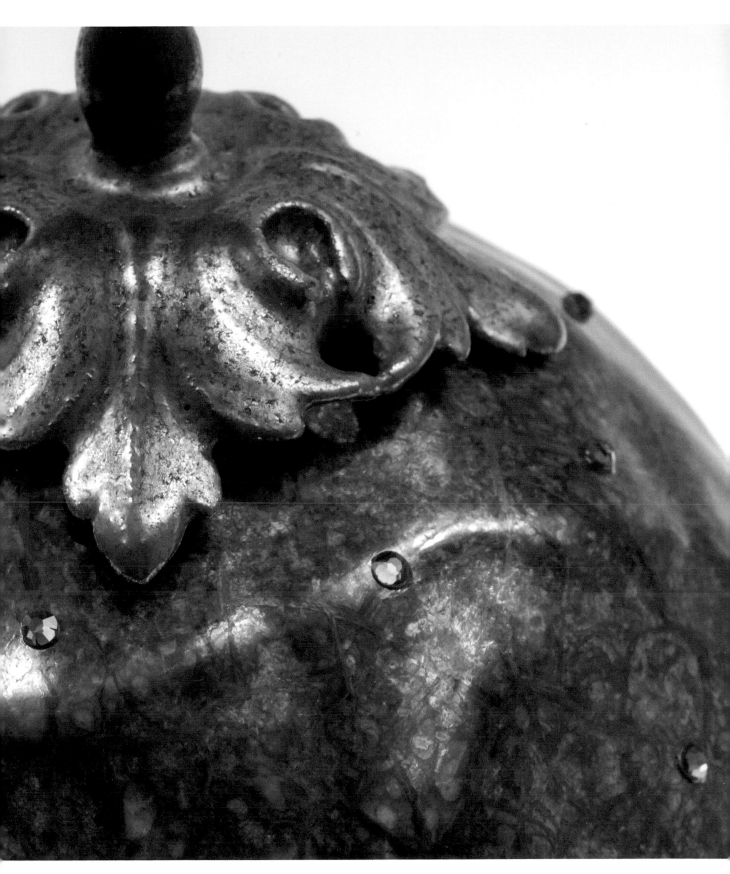

A WORKING-CLASS POT IS SOMETHING TO BE

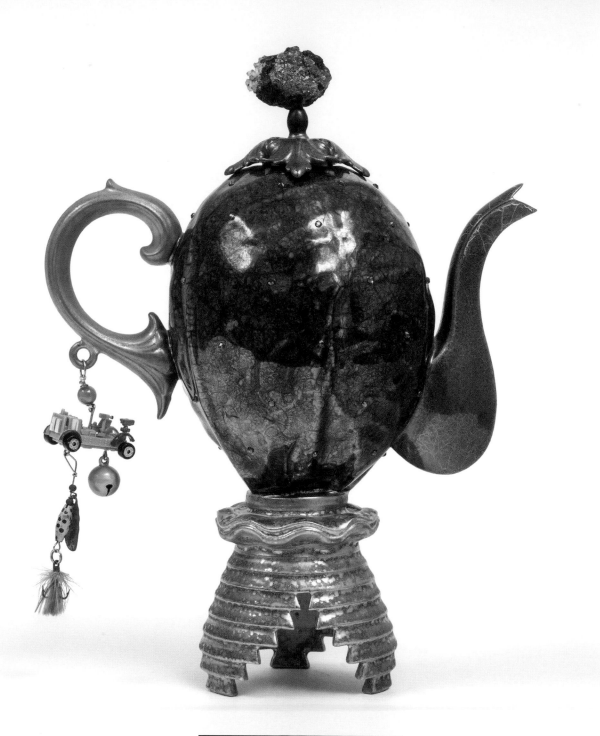

ADRIAN SAXE (AMERICAN, B. 1943)
***MOONROCKS*, 1996**
Glazed porcelain, lustre and found objects •
Marks: Inscribed "Saxe", and ink-stamped
"Saxe 96" on base • H: 22.6 cm; W: 21 cm;
D: 11.6 cm • Gift of Aaron Milrad in memory
of Bella and Joseph Milrad, G99.6.62.1-2

EZRA SHALES

If only we had strong stomachs, we might eat Adrian Saxe's bejewelled porcelain cabbage and eggplant ewers; this essay seeks to go beyond fingering them as Postmodernist pastiche and insist on carnal gustation. The cheerful lead green glazes on Wedgwood's cauliflower pots and Worcester's cabbage pitchers elided the fertility of the English country house with the generative potential of social climbing, and the vegetable core of *Moonrocks,* 1996, enacts a similarly symbolic masquerade—the millennial mistaking of body piercing for the acquisition of wealth, body sculpting for the pursuit of health. The swaggering spout and over-accessorized handle of *Moonrocks* evoke all of Las Vegas that is faux-regal and melts in the air (or under the censor's prudish eye). *Ancien régime en ménage à trois, mes amis?* The pots seemingly cajole onlookers, as if they were hustling up business for some imaginary bistro of delectation and self-deprecating pretension. Are these pots only semiotically over-sexed or truly louche? Is *Moonrocks* revelling in self-indulgence or coolly embalming it? If cars are body-doubles and axiomatic expressions of class identity, then Adrian Saxe's pots might not be as aristocratic as their sources and, in fact, might be paeans to the notion of visualizing 'working-class' taste and the social-climbing pretensions of art pottery. What pot other than a Saxe, after all, could be said to embrace all the confusion and hyperbole of a Thomas Kinkade fairyland with the rhinestone-gauntlet-wearing Michael Jackson's moonwalking through it? Maybe Saxe is Americana of the hood-ornament type.

Those who have endeavoured to be a matchmaker for Saxe's work, especially sad-sack academics like myself, know that earnest young potters find his ewers too full of regal emblems, too superficially about luxury, and too gilt to be anything but elitist (the very same status that the majority of young functional potters are trying to efface from their own identity when they call themselves "potters"). Many who play with clay simply do not *do* irony (so much for play). Pottery students usually learn to savour Ken Price or Ron Nagle works, but those are pots that embody 'good taste'; Saxe makes pots about who 'owns taste'. Unfortunately, most ceramists seem to take years to come around to appreciating artifice with Saxe's degree of refinement. They have a peculiarly self-punishing birthright, a preponderance of ceramics that are allegories for 'centring' and the self being more plentiful than those engaging *bricolage.*

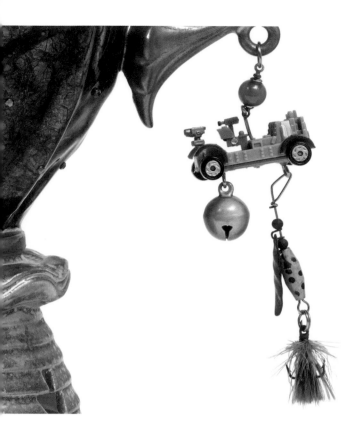

Saxe's teapot is a basic lesson: the exquisite corpse of Surrealism. *Moonrocks* is a veritable vocabulary chest of china cabinet ornament gone steam punk, with equal parts thrown, hand-built and cast. It has glaze and lustre, complex textures and a precarious sense of balance. The handle is a crisp quotation of a Rococo C-scroll, while the spout resembles a heavy Art Deco faucet mid-transformation à la Max Ernst or, more precisely, Salvador Dali. Is it a hood ornament endowing itself with a scrotum? Ever grab one of those over-built streamlined American faucets cast in Chicago and wonder if the modeller had their head inside the covers of something like André Breton's *L'Amour Fou* or swimming in some covert indecencies of their own design? A peculiar anthropomorphic quality carries over into Saxe's plastic baubles and feathered fishing tackle hung like earrings. The stepped tripod foot takes its cue from a much calmer wooden ancestor but has sprung up into goofy roadside Googie architecture. Each unit teases the mind down different alleyways of a Krazy Kat auction house, pulling towards the thrift shop here and museum there.

 Moonrocks is interesting to probe in terms of workmanship and pedagogical rebellion. The last generation of ceramics students that was taught to copy and imitate historic forms passed through schools in the early 1950s, when it was standard fare to do what Saxe does here, hand-build the body of a teapot to match a wheel-thrown lid and a cast spout and handle. But Saxe is not that old to have suffered through that sort of vocational training for industry. He was a student encouraged to be 'creative', 'original' and 'unique'—a mantra that seems to be at odds with his own method of working. His reaction against these 1960s educational ideals explains why Peter Schjeldahl labelled Saxe's work "smart pots"— but this smug backhanded compliment suggests, of course, that your average pot is dumb more than it explains Saxe's pots' peculiarly over-sexed physiques.[1] If seen as semiotics first and only secondly experienced as a *schvitz*[2] in historicist ornament, the pots seem headstrong. Make no mistake, they are arm-strong too, a dazzlingly complex choreography of 'stacked pots'. You cannot judge them by brassiere cup-size, as if they were Peter Voulkos' jugs; you can only size them up if you have an encyclopedic understanding of ceramic history. They swim upstream against the recurring Puritanical tendency to dismiss ornament by effeminizing it. The vase flexes its biceps and bejewelled middle finger at any

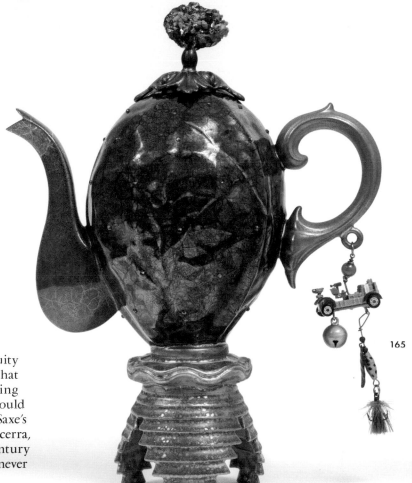

ascetic who might try to wave off "a superfluity of elegant whim-whams" (the snooty words that Thomas Carlyle used to describe the drawing room of his future wife, Jane Welsh—she should have known he would be little fun).[3] Perhaps Saxe's closest ceramic relative was the late Ralph Bacerra, a fellow Californian whose late twentieth-century ornamental *Japonisme* also was indulgent but never approached Saxe's irony or eclecticism.

Reflect on how the title *Moonrocks* exposes the suggestive eroticism latent in our idiomatic expression, "That *rocks*". Talking about these pots as if they were galumphing VW vans, parked in a quiet spot to do their thing, might be a way to break the ice with the woefully moralistic, or at least open up for discussion clay's endless capacity to form metaphorical bodily orifices. Saxe has several titles with puns on the word "orgasm", and usually ample imagery that helps sustain such visualization. I am quite fond of his gilt tumescent ginger. Los Angeles and 'the industry', Hollywood entertainment writ large, have defined and sustained and confused our pornosophical North American landscape of sex symbols, sex signs and sex signification for about a

century; Saxe gilds this stew. Figurines from popular culture, such as lethal football players, have made momentary appearances, but he mainly conjures bawdiness from precise conjunctions of cool quotations, forms cribbed from Qing dynasty China or Louis XIV Versailles. Instilling appreciation for Saxe's 'ampersand aesthetics' and poly-lingual artifacts is no small order: one needs to whirl together the Huntington's Sèvres, Hollywood luxe and Walt Disney genius at their best.[4]

Unfortunately, Saxe's promoters have worked assiduously to distance him from craft and ceramics, but he might better epitomize the pottery workhorse, the one-man production line, than dear old saintly Warren MacKenzie. To think of Saxe in relation to a nineteenth-century factory, his repertoire requires him to span a remarkable number of specialists' techniques. Individual works range from moulded and thrown components to raku, lustring, enamelling and gilding. Pieces of Saxe's complexity required factories to train platoons of craftsmen dedicated to each step, be it luting, casting or gilding. Instead of working towards a signature style, Saxe spent the 1970s studying the ages, from French seventeenth-century court life to Momoyama Japan—always eyeing the elite wares and aping a specific move to fake out history. Like a musician hitting distinct notes in a scale, Saxe was first miming the past that he would later surgically graft together into mutants. In that decade of journeyman work, Saxe cranked out thousands of mugs and other tableware as well as producing scores of *jardinières* for the Huntington Museum in Pasadena on commission. He is a potter's potter, to reuse that stupid phrase so often accorded painters. If only those moralistic Leachian potters knew better they would value his labour as craft. The earnest potters still emerging from the highways and byways of America often fail to appreciate Saxe's satirical wit, and, more criminally, accord figures like MacKenzie the trait of workmanship. *Moonrocks* is the working stiff's pot, or the one that his wife buys for herself because it is nice *and* naughty.

At the end of the day, if Saxe's innuendo does not seem erotic, then let us be more frank about the scale of the teapot. These are crotch-shot pots. We are not accustomed to looking at other things on this scale except genitalia. We move from stroking cars to fondling smart phones

and laptops; does this mean old-fashioned pots on a non-arty scale are poised to grow in importance? Instead of thinking of Saxe as making the "smart pot", I suggest that his genre be christened the "crotch-shot pot", for Saxe is as evocative of his *zeitgeist* as Mapplethorpe's velvety gelatin-silver dildos. The best proof of Saxe's legacy as a link in the great porn-pot genre is the arrival and success of two ceramists travelling in his wake. Nicole Cherubini is transgressive because she pierces her clay aggressively and bedraggles it with cheap jewellery, but way back in the 1990s, Saxe attached faceted zirconia and rose and sapphire rhinestones to his pots. Another successor is the great and deservedly acclaimed Kathy Butterly, whose tender day-glow miniaturizations shrink Georgia O'Keeffe abstractions back to Gustave Courbet's *L'Origine du monde*'s (1866) actual life-size rendition. Butterly folds ceramic flesh into even more diminutive pint-sized pudenda than Saxe. Whose work is more ribald, Saxe or these women, is too subjective a zone to venture into. Admitting the crotch-shot pot as a real American aesthetic genre is the more pressing and useful conclusion. In an age that accepts that cell-phones habitually induce sweaty-palms and that communications networks' main utility is to sell porn, it is good to realize how well clay can continue to embody the deep human need to confuse the useful and useless, the functional and dysfunctional conduits of human nooks and kooks. So now croon along with *Moonrocks*, "A working-class pot is something to be."

EZRA SHALES, Associate Professor in the History of Art department at the Massachusetts College of Art and Design, is currently working on *The Shape of Craft*, a book that seeks to think through the contours, texture and materiality of things.

NOTES

1 Peter Schjeldahl, "The Smart Pot: Adrian Saxe and Post-Everything Ceramics", in *The Hydrogen Jukebox: Selected Writings of Peter Schjeldahl, 1978–1990*, MaLin Wilson, ed. (Berkeley and London: University of California Press, 1991), pp. 256–261. That a critic would find "smart pots" acceptable and "dumb paintings" slightly less appealing might suggest his deeply ingrained bias.
2 A *schvitz* is a Turko-Russian sweat bath.
3 Phyllis Rose, *Parallel Lives* (New York: Knopf, 1983), p. 28.
4 Jim Collins, "Adrian Saxe and the Postmodern Vessel," in *The Clay Art of Adrian Saxe*, Martha Drexler Lynn (New York: Thames and Hudson in association with the Los Angeles County Museum of Art, 1993), p. 124.

VARIATION OF A THEME

LÉOPOLD L. FOULEM, *ABSTRACTION 4111 (RED)*

PAUL BOURASSA

VARIATION OF A THEME

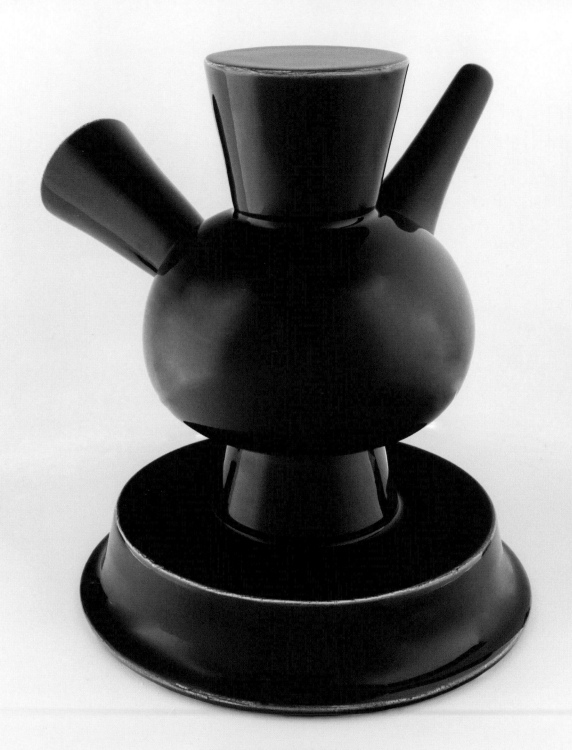

LÉOPOLD L. FOULEM (CANADIAN, B. 1945)
ABSTRACTION 4111 (RED), 1998
Earthenware with glazes • Marks: Inscribed
with an entwined "LF" and "98" on base •
H: 21.6 cm; W: 22.2 cm; D: 22.2 cm • The
Raphael Yu Collection, G11.6.28

PAUL BOURASSA

Time after time, Léopold L. Foulem in his numerous solo exhibitions proposes an ensemble of pieces based on the principle of 'series'. And each time he startles us with the diversity of his approaches—one might even say by the complete reversal of his aesthetic propositions. He passes from completely unbridled and baroque in one exhibition to pieces that are almost minimalist and classical in the next.

The concept of the series is interesting twice over. In modern and contemporary art, it laid the basis for the disappearance of the very notion of masterpiece and for a radical change in the way we think about art. Appearing with Impressionism (Monet's cathedrals, for example), the series, in Itzhak Goldberg's formulation, is "most often seen as a means of passing from the representational to the abstract, entering common practice at the time of abstraction's birth".[1] In the case of ceramics, a discipline usually associated with the fine crafts, the series is understood as the identical repetition of a model on a large or small scale. In the former case we are dealing with variations and in the latter with repetitions. Foulem's series obviously belong to the first group.

Abstraction 4111 (Red) is indeed part of a series, that of his *Monochrome Abstractions*, a group of works which are remarkable for all the interpretations they make possible. First of all, how is it possible to think of an object, whether in ceramic or any other material, as an abstraction? Could anything be more concrete? Is an object not the complete contradiction of the operation which consists, precisely, in calling up a mental image of an object out of its characteristics? Further, is not abstraction (monochrome abstraction at that) the prerogative of painting, of Great Art, of an art free from any material contingency? Moreover, the use of a number and a colour identified in brackets is a method employed by the champions of abstract art. Jackson Pollock, for example, decided in 1948 to stop using evocative titles in favour of neutral and affectless numbers. Here, as we have seen, is where reference to the codes of abstraction in a group of work forming a series takes on its full meaning.

Foulem's piece can be identified as a teapot. As is always the case in his work, it is non-functional, without an opening, unable to contain any kind of drink whatsoever. A teapot is not something that is used to serve tea (a coffee pot or ewer could just as easily be used) but something which, by tradition, takes a recognized form. And yet the teapot in question refers to no model in particular,

as is sometimes the case in Foulem's work. With its lateral handle, it assumes the general configuration of a pouring vessel. In fact, here Foulem took the liberty of formal exploration by placing cones inside the sphere of the vessel. The whole thing rests on a base, which is an integral part of the object. We should recall that Foulem has referred on numerous occasions to the eighteenth-century European tradition of adding metal bases and mounts to Oriental ceramics in order to "set them off". By bringing the base back to the same material and visual level as the object, its role is substantially modified. This base, contrary to its physical function, destabilizes our perception in a sense. It is increasingly less evident that the object is 'really' a teapot or even an object *per se*. It is a simplification and, ultimately, an object to the second degree. Or, to use an oxymoron, it is a three-dimensional image of the object.

Another element to consider is the work's monochrome quality. This red, even though it is a commercial glaze marketed to amateur ceramists, evokes the oxblood of Chinese ceramics. But Foulem is not so much trying to suggest this classic (his work does not have a commemorative objective) as he is pointing to the specificity of the concepts found in ceramics.

Monochromes have existed there for millennia, while in painting they only appeared in the twentieth century, as one of the most 'advanced' forms of abstraction. Different artistic traditions call for different analytical frameworks. Once again, however, there is a dichotomy between the neutral quality of a so-called uniform colour and its material dimension, which reveals blemishes and variations in texture and tonality. Foulem never denies the ceramic quality of his objects, but he goes further to assert what he calls "ceramicity", a neologism he uses to speak of ceramics figuratively, of ceramics about ceramics.

Abstraction 4111 (Red) is a piece in a series of variations on a theme. While working with series enabled some painters, such as Mondrian, to 'evolve' towards abstraction, gradually eliminating all reference to reality, Foulem's series are tenacious explorations of the very concept of abstraction and its reification. They are undoubtedly among the most radical artistic efforts by this whimsical New Brunswick ceramist and fully deserve a place in the artistic Pantheon!

Translated by Timothy Barnard.

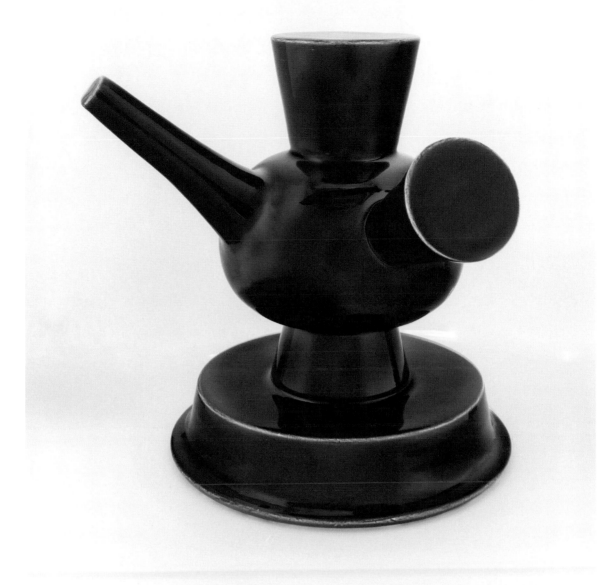

PAUL BOURASSA has been Director of Collections and Research
at the Musée National des Beaux-Arts du Québec since September
2011, where he was previously Curator of Decorative Arts, Craft and
Design for 18 years. He has curated numerous travelling exhibitions—
as well as authored accompanying catalogues—including *Trajectoires :
la céramique au Québec des années 1930 à nos jours*, *Picasso and
Ceramics*, *Québec in design*, and *Léopold L. Foulem: Singularities*. He
was also curator of *Kaléidoscope: Variations sur le verre*, and author
of *Le design au Québec* (publication at Éditions de l'Homme).

NOTES

1 Itzhak Goldberg, *Jawlensky ou le visage promis* (Paris:
 L'Harmattan, 1998), p. 88.

GREG PAYCE

EXPLORING THE VOID

HELEN DELACRETAZ

GREG PAYCE

GREG PAYCE (CANADIAN, B. 1956)
APPARENTLY, **1999**
Earthenware with glazes • Marks: Signed
"Payce" • Overall: H: 87.6 cm; W: 102.2 cm;
D: 34.3 cm • Purchased with the support of
the Canada Council for the Arts Acquisition
Assistance Program, G04.19.1.1-2; Gift of
the Artist, G05.13.1

HELEN DELACRETAZ

Standing before Greg Payce's earthenware work *Apparently*, 1999, one is presented by two intricately formed vessels, one black, the other multicoloured and striped. They are obviously a pair, despite their different contours, linked instead by the deliberate nature of their crisp profiles, considerable scale, spatial relationship and overall aesthetic impression. At initial glance, their profiles might appear somewhat strange. Reminiscent of the traditional baluster form, as well as historical Italian *albarelli* or large apothecary jars, they nonetheless feature unexpected indentations and irregular projections.

Although one could choose to appreciate each of the vessels as independent entities, to do so would be unfortunate, for one would be missing a great deal of the experience Payce's work provides the viewer. His ceramic installations require one to not merely view the objects presented, but to experience them; to contemplate their careful positioning and alignment, and their interaction with their surroundings and nearby objects; to consider the voids created in their midst and to ponder the overlay of colour and glaze, the optical illusions afforded by the animation they offer. Nothing is accidental, spontaneous or coincidental. All is carefully articulated towards the goals of impact and interaction with the viewer.

When viewed in this light, the profile silhouette of a young girl emerges from the negative space between the vessels. She stands in that characteristic stance of a three- or four-year-old: chin, chest and tummy thrust out. The immaculate rendering of the vessel's contours are now explained, as is the deliberate placement of the vessels side-by-side, their lips touching. The void between the vessels becomes as important and intrinsic to the piece as do the actual vessels themselves. Payce achieves his precise delineation of form by throwing the vessel on a wheel and modifying its silhouette through the application of specific templates (of the negative impression) held against the spinning vessel.

In 2011 Payce remarked: "When eyes are fooled, imaginations are thrown wide open. Realms between the virtual and the real contain unique narrative possibilities. The negative spaces between ceramic *albarelli* become strange, non-dimensional, yet oddly three-dimensional images. Archetypal relationships between human and vessel cannot help but materialize."[1]

This focus on profile has been longstanding in Payce's work. He enjoys the paradox it presents; that despite the object being a three-dimensional, physical entity, it is often viewed or appreciated for its 'edge'

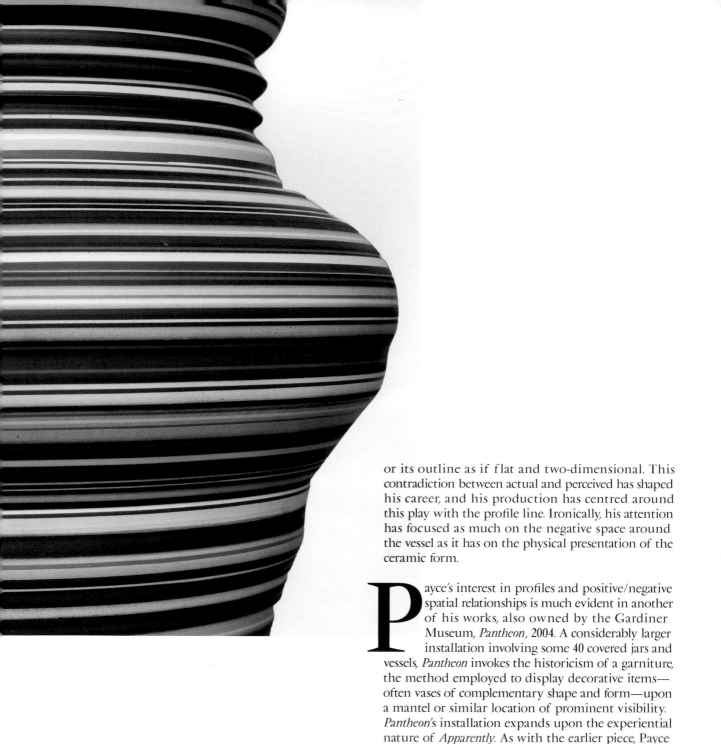

or its outline as if flat and two-dimensional. This contradiction between actual and perceived has shaped his career, and his production has centred around this play with the profile line. Ironically, his attention has focused as much on the negative space around the vessel as it has on the physical presentation of the ceramic form.

Payce's interest in profiles and positive/negative spatial relationships is much evident in another of his works, also owned by the Gardiner Museum, *Pantheon*, 2004. A considerably larger installation involving some 40 covered jars and vessels, *Pantheon* invokes the historicism of a garniture, the method employed to display decorative items—often vases of complementary shape and form—upon a mantel or similar location of prominent visibility. *Pantheon*'s installation expands upon the experiential nature of *Apparently*. As with the earlier piece, Payce explores the idea of the void, creating silhouettes of adult men and women. However, he does not stop here, instead he layers the intensity of the experience by staggering the vessels to create vignettes of interaction between the figural components. The men and women unite in a flirtatious dance, a rhythm that plays out as the viewer moves around the periphery of the piece, exploring it from multiple perspectives.

To this, Payce masterfully manipulates the placement of solid-coloured versus striped vases to invest the installation with a sense of dynamism. The polychrome vessels, in particular, appear to spin and whirl due to the tight concentric bands of complementary colours that run the height of each. What could be understood as a static arrangement of vessels becomes an animated tableau of human sexuality with a frenetic sense of pace and motion.

Animation caused through optical illusion is another area of fascination for the artist, one enjoyed since early childhood. He recalls collecting lenticular photographs and books on optical illusions as a young boy. It was at this same time that Payce realized he wanted to work with clay. At age five, he watched a television show featuring a man throwing a pot on the wheel. Struck by a sense of awe, equating it to magical proportions, he was compelled to learn, and master, the same. Indeed this drive, coupled with insatiable curiosity of "what if..." has led Payce to his BFA (University of Alberta, 1977) and MFA (Nova Scotia College of Art and Design University, 1987), and teaching at Alberta College of Art and Design since 1988.

GREG PAYCE

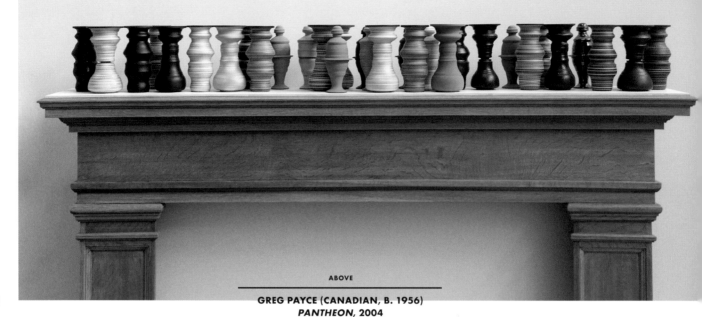

ABOVE

GREG PAYCE (CANADIAN, B. 1956)
PANTHEON, **2004**
Earthenware with glazes • Promised gift
from The Raphael Yu Collection

Though rooted in clay, Payce's work has consistently stretched the expectations and limitations of the medium—physically, conceptually and experientially. His interdisciplinary approach has seen him investigate its potential as it interacts with other artistic practices: lenticular photography and video, most recently. As a result, his work has expanded into disciplines not traditionally associated with ceramics including cinema, optics and sensory perception and material culture. Choosing to remain linked to the historicism of the functional form and its cultural mores, he has refreshed contemporary discourse with playful conceptualization and innovative multidisciplinary approaches. ᔥ

HELEN DELACRETAZ (MA, Sotheby's Institute London, 1996 and MA, University of Victoria, 1997) is Chief Curator at the Winnipeg Art Gallery, where, in the past 15 years, she has curated a number of solo and group exhibitions. She also teaches courses on Islamic, Hindu and Buddhist art at the University of Winnipeg.

NOTES

1 Greg Payce, "Artist Statement", in *Precise: Craft Refined*, exhibition catalogue curated by Helen Delacretaz (Winnipeg: Winnipeg Art Gallery, 2011), p. 38.

HELEN DELACRETAZ

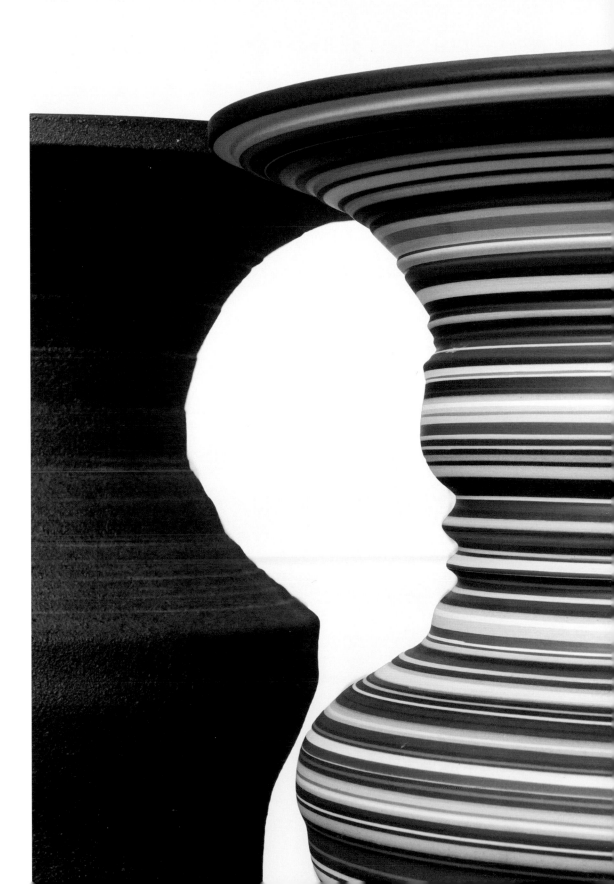

A LESSON IN JOY

RACHEL GOTLIEB

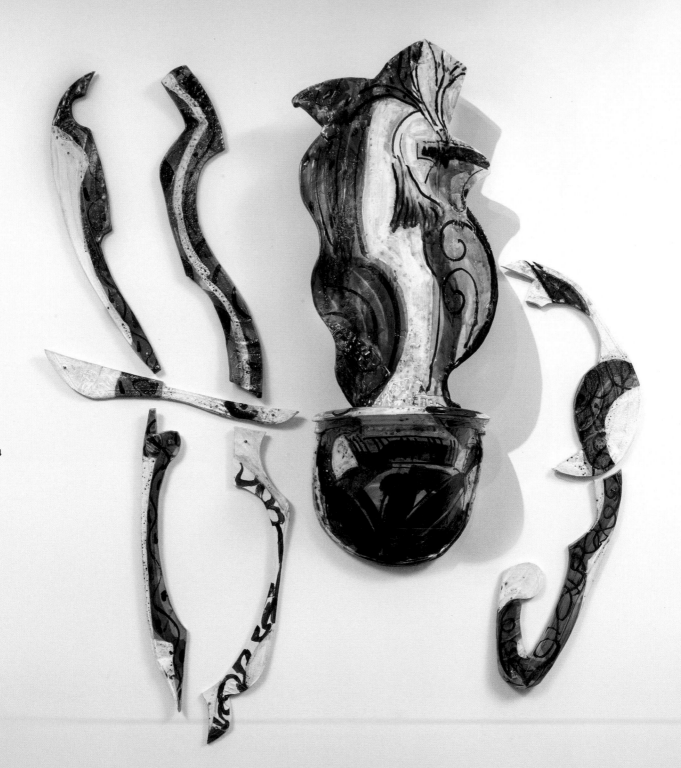

BETTY WOODMAN (AMERICAN, B. 1930)
BALUSTRADE RELIEF VASE, 2000
Glazed earthenware, epoxy, lacquer and
paint • H: 158.8 cm; W: 141 cm; D: 24.1 cm
• Gift of Allan Mandell, G11.7.1

RACHEL GOTLIEB

My engagement with *Balustrade Relief Vase* is coloured by a lecture Betty Woodman gave in conjunction with the Gardiner Museum exhibition of her work in 2011.[1] At the end of the thoughtful and careful presentation about her practice, a young woman artist asked Woodman where she found inspiration for happiness to make such joyful art. Woodman took a long pause and the room went silent waiting for her response. Finally she answered, expressing that while she was glad joy could be found in her work, she was not a particularly joyful person, that those close to her certainly didn't think so, and that she had known personal tragedy.

How then to view Woodman's *Balustrade Relief Vase*, a joyful and decorative composition hanging on the wall of the Gardiner Museum's modern and contemporary gallery with this knowledge of the artist's personal sorrow? Its title suggests a single vase but there are actually a number of vessels in the configuration, some prominent and others hidden creating a balance between volume and surface, solid and void. An undulating clay canvas rests on a bow-curved shelf and depicts an image of two vases, one of which contains bright red and yellow flowers,

and a single wilted flower. Hiding behind the panel and fused on to the back is a tall three-dimensional cylinder vase that can be seen only from the profile. More vases appear in the negative spaces between the calligraphic-like shards that comprise the balustrade which frames the work.

With *Balustrade Relief Vase* Woodman lives up to art critic Peter Schjeldahl's comment that "she is a vase artist, first and last".[2] Clearly for Woodman the more vases the better—they connect her directly to the traditions of craft and the decorative arts but the baluster structure and its placement on the wall reference the genre of still life painting. This masterful synthesis of art, architecture and craft all in the twin media of clay and glaze is characteristically Woodman. Yet she deliberately does not fetishize or privilege her art. The nails that affix *Balustrade Relief Vase* to the wall are visible. So too are the treads of her shoes which form raised patterns in the clay and evidence her making. She throws the clay, which she has first shaped on the wheel, on to a tarp on the floor, cuts, stretches it and then walks on it to patch together, all in her quest to attain flatness to link her ceramic art with painting.[3]

Size and dimension also matter to Woodman. As Arthur Danto notes, the increased scale of the domestic vase exalts her work to visionary ceramics.[4] The discovery of the ancient funerary terracotta warriors and horses in China in 1974 was a historic moment, especially in contemporary ceramics, and inspired a new direction for artists like Woodman to move away from tabletop pottery and go big, even monumental.[5] Woodman, however, is a physically small woman and in order for her to work in large-scale for the *Balustrade* series, which she started in the mid-1990s, she employs the technique of assembling fragments.[6] "With such fragments, I could suddenly deal with large pieces, but in small parts which were totally within my ability," explains Woodman. She adds, while "potters make parts and put them together. I make parts and leave them apart."[7]

In 2006, the Metropolitan Museum of Art celebrated Betty Woodman with an exhibition. *New York Times* writer, Grace Glueck wryly observed that it was a first for the Met, "a collector of pots from all ages that has until now never given a solo retrospective to a living maker of them".[8] Woodman trained at the School for American Craftsmen at Alfred University in Alfred, New York, just after the Second World War when studio pottery in America was in its nascence.

She originally thought that she was going to be a potter and make "ordinary things for ordinary people" but she adopted a more "painterly perspective" from her husband, George Woodman who is also an artist and a painter.[9] A visit to Italy in the 1950s introduced her to the brilliant sun and hues of the Mediterranean and an abundance of antiquities, further shaping her aesthetic towards colour and light.[10] To this day, she resides in Italy several months a year.

Woodman's use of bold colours and expressive decorative brushstrokes emerged in the context of the 1970s Postmodern Pattern and Ornament Movement in New York City. Her gestural, curvaceous forms and azures of blue recall Henri Matisse and Fauvism. Not surprisingly, then, scholars and critics often employ the word "exuberant" to describe Woodman's ceramics,[11] and Schjeldahl calls her art a visual "Hallelujah Chorus".[12] Woodman, in conversation with critic Janet Koplos, concedes that her work is not angry or ironic but makes you "feel good" and, Koplos observes that, though it is not about difficulty, it does convey complexity.[13] *Balustrade Relief Vase*, as with most of Woodman's installations, invites multiple

A LESSON IN JOY

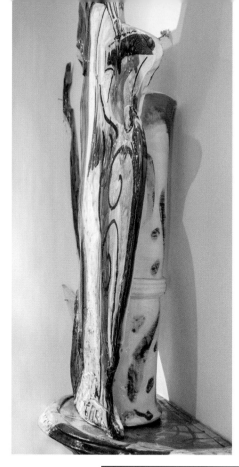
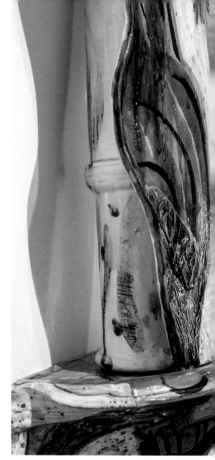

readings and encourages the viewer to look, walk about, to peek behind the work and look again. Optical deception and intricacy are both significant elements that define the piece. *Balustrade Relief Vase,* therefore, reflects time and place as it is very much a consumation of complexity, pastiche and ornament, all tenets of Postmodernism yet without the usual accents of irony and cynicism which Woodman consciously avoids.

All this said, the revelation of Betty Woodman's sorrow at her Toronto lecture informs how I see her work. While she did not mention it then, she was alluding to the suicide of her daughter, the renowned photographer, Francesca Woodman.[14] Some may argue that an artist's personal life should not interfere with the appreciation of the art she creates, but my encounter with *Balustrade Relief Vase* is seen through the filter that though it is a joyful composition, it is by an artist who does not think of herself as a particularly joyful person. Perhaps there is some significance to the fallen red flower—a vanitas symbolizing mortality—perhaps not. For me *Balustrade Relief Vase* is experienced as a lesson in the meaning of joy.

RACHEL GOTLIEB is Chief Curator of the Gardiner Museum. She served as the founding Curator of the Design Exchange between 1990 and 2002. She received her MA in Design History at the Royal College of Art and the Victoria and Albert Museum in 1987, and is a PhD candidate in Art History at Queen's University in Kingston, Ontario. She co-authored *Design in Canada*, 2001, *On the Table 100: Years of Functional Ceramics*, 2007, and *The Art of Clairtone*, 2008.

NOTES

1 Betty Woodman artist talk, 2 March, 2011 at the Art Gallery of Ontario, in conjunction with the exhibition *Betty Woodman Places, Spaces & Things*, Gardiner Museum, 3 March to 5 June, 2011.

2 Peter Schjeldahl, "Decoration Myths: Betty Woodman's Ceramics", *New Yorker* (15 May 2006).

3 Nancy Princenthal, "Betty Woodman: Useful Fictions", in *Betty Woodman* (Sedalia, Missouri: The Dawn Museum of Contemporary Art, 2002), p. 13.

4 Arthur Danto, "Visionary Ceramics", *American Ceramics* vol. 1, no. 2 (2007), p. 23.

5 Danto, "Visionary Ceramics", p. 23.

6 Garth Clark and Cindi Strauss, *Shifting Paradigms in Contemporary Ceramics, The Garth Clark & Mark Del Vecchio Collection* (New Haven and London: Yale University Press in association with The Museum of Fine Arts, Houston, 2012), p. 244.

7 Emily Galusha and Mary Ann Nord, eds., *Clay Talks: Reflections by American Master Ceramists*, (Minneapolis, MN: Northern Clay Center, 2004), p. 79.

8 Grace Glueck, "Betty Woodman, Turning the Humble Vase into High Art", *New York Times* (April 2006).

9 Galusha and Nord, *Clay Talks: Reflections by American Master Ceramists*, p. 77.

10 Galusha and Nord, *Clay Talks: Reflections by American Master Ceramists*, p. 77; Andrea Miller-Keller, *Betty Woodman/Matrix 119*, Wadsworth Atheneum, Hartford Connecticut, May 24– August 23, 1992, p. 2; Arthur Danto, *The Vase as a Form and Subject: Craft and Meaning in the Work of Betty Woodman*, (Amsterdam: Stedelijk Museum, 1996), pp. 19–26.

11 For example, the word 'exuberance' to describe Woodman's work is used by Grace Glueck, Nancy Princenthal, Cindy Strauss and Judith Tannenbaum. Judith Tannenbaum, *Betty Woodman: Somewhere between Naples and Denver* (Pennsylvania: Institute of Contemporary Art, University of Pennsylvania, 1992).

12 Schjeldahl, "Decoration Myths: Betty Woodman's Ceramics".

13 Betty Woodman in conversation with Janet Koplos and Cliff Garten, "What's Clay Got to Do With It? Criticism and the Ceramic Art", *Studio Pottery* vol. 24, no. 1 (1995), p. 11.

14 Galusha and Nord, *Clay Talks: Reflections by American Master Ceramists*, p. 79.

THE EXACT BEAUTY OF A MOVEMENT

STEVEN HEINEMANN'S *PLAYA (SELF PORTRAIT)*

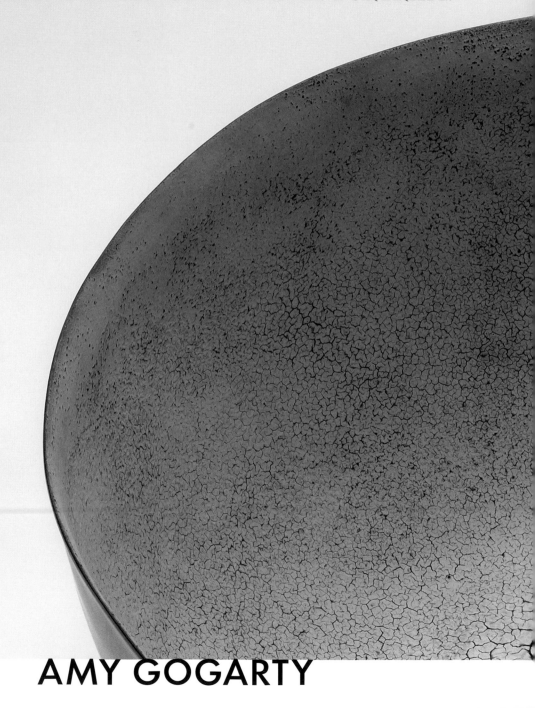

AMY GOGARTY

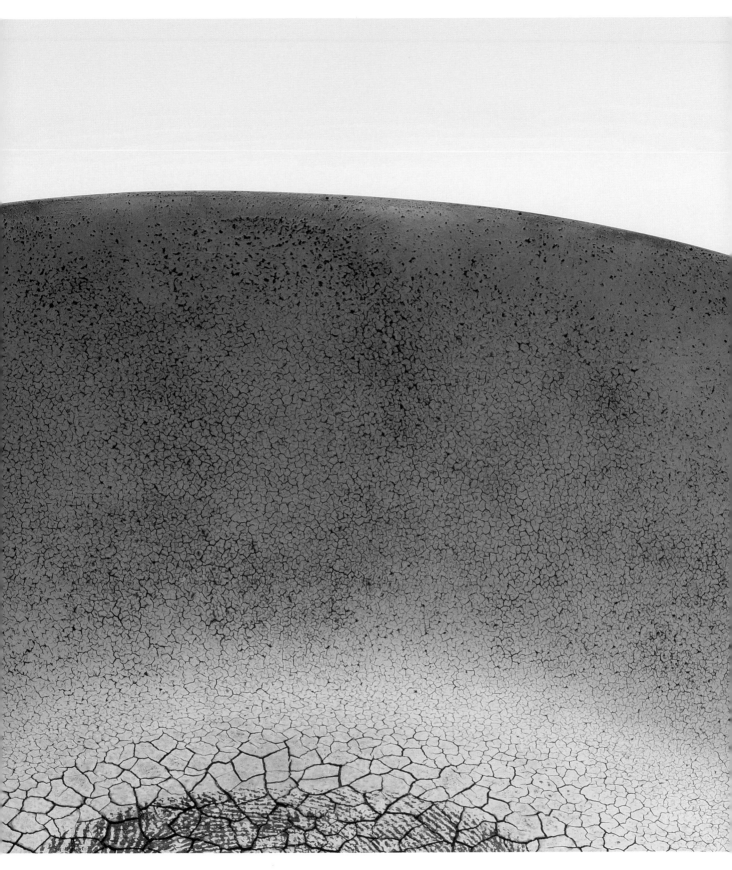

THE EXACT BEAUTY OF A MOVEMENT

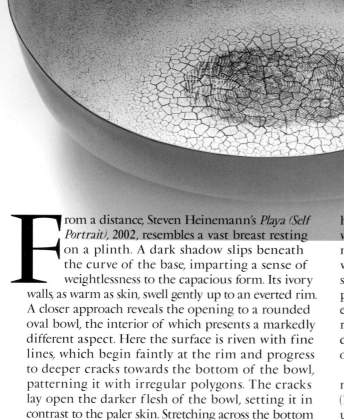

From a distance, Steven Heinemann's *Playa (Self Portrait)*, 2002, resembles a vast breast resting on a plinth. A dark shadow slips beneath the curve of the base, imparting a sense of weightlessness to the capacious form. Its ivory walls, as warm as skin, swell gently up to an everted rim. A closer approach reveals the opening to a rounded oval bowl, the interior of which presents a markedly different aspect. Here the surface is riven with fine lines, which begin faintly at the rim and progress to deeper cracks towards the bottom of the bowl, patterning it with irregular polygons. The cracks lay open the darker flesh of the bowl, setting it in contrast to the paler skin. Stretching across the bottom and echoing the shape of the bowl is a thumbprint, magnified many times over so that the ridges of the print suggest a spiral galaxy unfolding slowly across space. A thin dark rim encircles the bowl with restless energy, barely separating inside from outside. Interior and exterior present a conundrum of similarity and difference.

Playa is but one in an extended series of formal meditations Heinemann has created over the last several decades; it takes its place in a continuum circumscribed both by the life of the artist and the whole of human culture. A student of ceramics history, Heinemann used to begin talks about his work with an image of an ancient Anasazi bread-making bowl, and he regularly visits museums to view their collections of ceramics.[1] The burnished surfaces of his pots recall those found on Mimbres pots from the American Southwest, and a number of early works echoed dippers or other utensils from that region.[2] He is deeply invested in the 'stuff' of ceramics, commenting that he has "no ideas independent of material".[3]

Forms are concrete manifestations of specific materials and technologies. In *The Life of Forms in Art* (1934), French art historian Henri Focillon reminds us that works of art are at once unique expressions and participants in systems of "highly complex relationships... both matter and mind, both form and content".[4] For Focillon, materials and techniques constitute a "whole poetry of action and... the means for the achievement of metamorphoses".[5] His reflections on these matters contribute to understanding *Playa* precisely because Heinemann is a master both of technique and form.

Playa is slip-cast earthenware, created from a plaster mould cast from a clay model sculpted by the artist. Slip-casting allows for paper-thin walls that appear to defy gravity and for sustained interaction

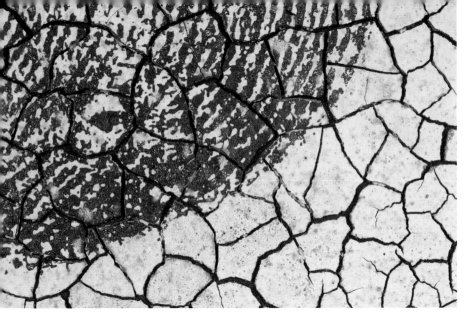

STEVEN HEINEMANN (CANADIAN, B. 1957)
PLAYA (SELF PORTRAIT), 2002
Cast earthenware, multiple firings • Marks:
None • H. 32.4 cm; W. 90.2 cm; D. 76.8 cm
• The Raphael Yu Collection, G11.6.31

as the form moves from an idea in the artist's mind
to a finished work. *Playa* is essentially a bowl, one
of the most ancient, if simple, of functional pottery
forms, found with surprising regularity across cultures.
The monumental scale and fragility of *Playa* remove
it from the realm of function, fostering its symbolic
and expressive potential and offering Heinemann
opportunities to explore his enduring interest in
containment and interior space.

One of Canada's pre-eminent ceramists,
Heinemann has taught and exhibited
his work nationally and internationally
since the 1980s. Operating from a studio
in rural Ontario, he often works on
and lives with a piece for years. Intermittently, he
applies layers of slip or glaze to either the interior or
exterior of the work, manipulating and subjecting
it to multiple firings that introduce an appealing
eccentricity or 'wobble' into the form. Throughout
this process, the work remains mobile and living,
open to possibilities as it evolves through successive
stages. Each stage leaves its trace, reflecting the
artist's ongoing experiments, adaptations and lived
experience. As Focillon notes:

A work of art is motionless only in appearance...
in reality, it is born of change, and it leads to
other changes. (Within the same shape there are
often many such changes, as in the preliminary
sketches of painters who, seeking the accuracy
or the exact beauty of a movement, will
superimpose the drawing of several arms on
the same shoulder)....[6]

laya embodies time in its recollection of the
earth's morphological processes and secret
connections between the workings of nature
and those of art. Playa lakes are closed drainage
basins found in certain arid regions, notably
the American Southwest, where their capacity to store
water makes them essential to the natural ecology. With
drought, the water evaporates, and the expandable clay
minerals and alkali salts forming the lake bed dry and
shrink, creating distinctive polygonal cracks.[7] *Playa*, the
bowl, is also a closed system. The various processes by
which the artist elaborates the bowl's complex interior
invoke nature, but they are not natural. Performed
by the artist, these processes assume semantic and
expressive power; they signify.

Playa is sub-titled "Self Portrait", and it is
as a portrait of the artist as a monumental bowl that

the work sustains my interest. "I am in the work and
the work is in me," Heinemann writes.[8] The indexical
thumbprint betokens identification with the intricate
interior, which so resembles an expansive landscape or
cosmos, yet the form's fragility foils simple division of
inside and out. Both emerge from the same impossibly
thin matrix, held in tension by the arcing loop of
the rim—"the exact beauty of a movement". The
expressively engineered interior attracts our attention
and is ostensibly the subject of the work, yet the naked
exterior shelters and gives birth to this space; it is the
mediating membrane through which the artwork
co-mingles with and embraces the outside world. *Playa*
is a self-portrait of the artist as male and female, mind
and matter, self and other, who reconciles oppositions
of nature and culture through art.

AMY GOGARTY

AMY GOGARTY is an educator, artist and writer who specializes in issues relating to contemporary art and craft. Previously teacher of visual arts history, ceramics history and contemporary theory at the Alberta College of Art and Design in Calgary, Alberta, she has contributed over 100 critical essays to journals and symposia in Canada and abroad. She is the co-editor of *Utopic Impulses: Contemporary Ceramics Practice*, and the third volume of *Craft Perception and Practice*. In 2013, she served as the juror for the Portage Award, New Zealand's premier ceramics prize.

1 Wendy Walgate, "Steve Heinemann", *Contact* 99 (Winter 1994/95), p. 16.
2 Léopold L. Foulem, "Between Shadow and Container: Recent Ceramic Vessels by Steven Heinemann", *Ceramics: Art and Perception*, 75 (2009), p. 18.
3 Forrest Snyder, "Talking with Steve Heinemann", *Critical Ceramics*, (28 June 1999). http://www.criticalceramics.org/oldsite/articles/haysta99/sheine.htm, accessed June 2013.
4 Henri Focillon, *The Life of Forms in Art* (1934), George Kubler, trans. (New York: Zone Books, 1992), p. 31.
5 Focillon, *The Life of Forms in Art*, p. 103.
6 Focillon, *The Life of Forms in Art*, p. 41.
7 See "Bedforms in cohesive sediments", University of Montana Department of Geosciences: http://www.cas.umt.edu/geosciences//faculty/hendrix/g432/g432_L9.htm; and "Playa Lakes", US Environmental Protection Agency: http://water.epa.gov/type/wetlands/playa.cfm (Accessed 15 July 2013).
8 Gardiner Museum label, *Playa (Self Portrait)*.

A GIANT COMPANION

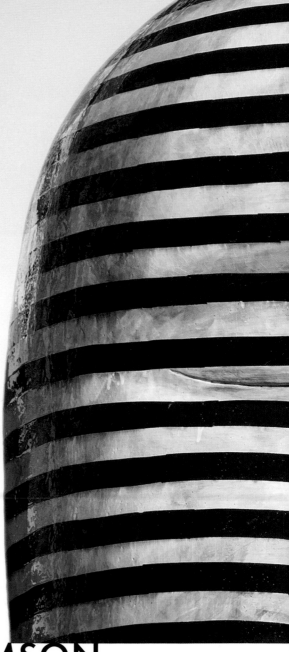

GLENN ADAMSON

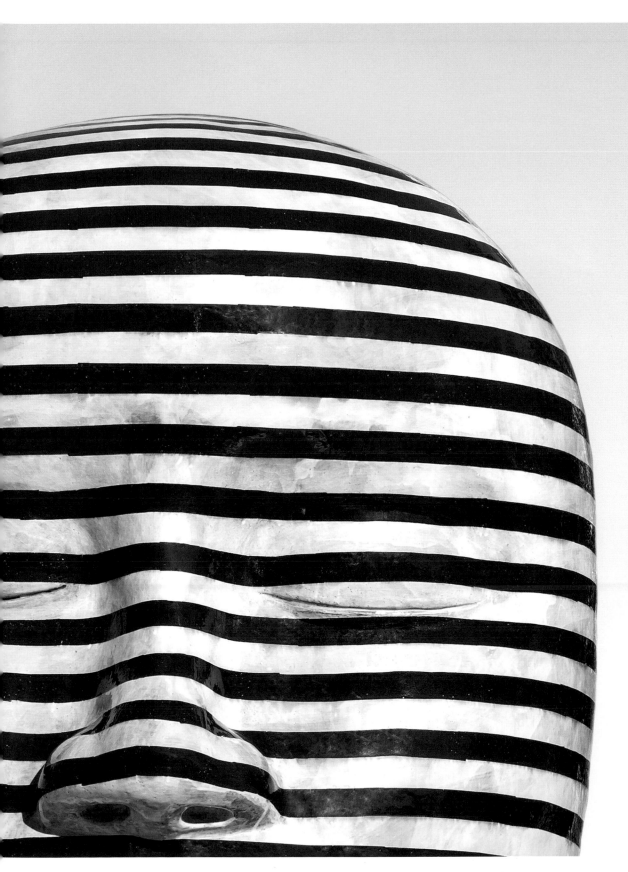

A GIANT COMPANION

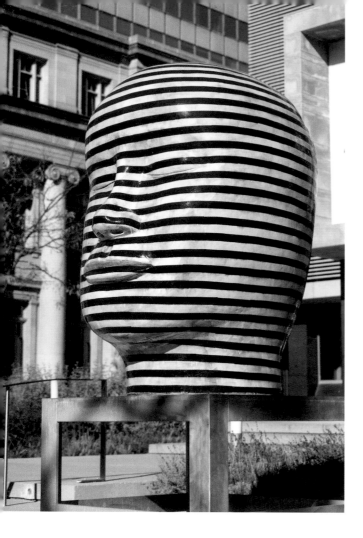

JUN KANEKO (JAPANESE, B. 1942)
UNTITLED (HEAD), 2002
Glazed ceramic and steel • Marks: Signed
"Kaneko 2002" • H: 256.6 cm; W: 124.5
cm; D: 142.2 cm • The Gardiner Museum
is grateful to the following donors for
their exceptional acquisition support, in
addition to many other generous members
who contributed to the Gardiner's 30th
Anniversary Jun Kaneko Acquisition
Campaign: Michael and Sonja Koerner
Charitable Foundation, Allan and Sondra
Gotlieb, Diana Reitberger, Donner Canadian
Foundation Acquisition Fund, Esther & Sam
Sarick, Margaret and Jim Fleck, Clarence E.
Heller Charitable Foundation, G13.13.1.1-2

sat in his studio. Giant companions, they grew on him. Finally he decided that they were indeed strong enough to go out into the world. Ever since, enormous heads of reductive form and glorious decoration— striped or polka-dotted or covered in patches of colour —have become a regular part of his repertoire.

When the instinct to make a figural sculpture first came to Jun Kaneko, sometime in the 1990s, he waited five years before acting on it. He was, he thought, an abstractionist. The simple, standing sculptures called *Dangos* that form the bedrock of his work are masterpieces of understatement. They may suggest the scale or presence of a body. But they are also pure shapes, simple objects of colour and pattern. He was reluctant to create anything that was too identifiable: "a head, hand or body already limits people's freedom of imagination".[1]

 Yet he could not shake the idea. Eventually, he gave in to his impulse and made a group of 12 large ceramic heads, each nearly two metres in height. For most artists that would be a career-defining project; but Kaneko, always prodigiously productive, could afford to wait until he was sure. And wait he did, for another five years, before showing anyone what he had done. Over this long period of time, the heads

All of this is to say that the great sculpture now standing in front of the Gardiner Museum is the product of long consideration. You feel this fact, standing in front of the great head with its eyes closed, a monument to introspection. It is public art, but it conjures an atmosphere of private reflection. That air of quiet stoicism may well remind you of other enormous heads from the art of the world: the monolithic stone *moai* of Easter Island, or the colossi of the pre-Columbian Olmec culture.

 The difference, perhaps, is that Kaneko's heads do not have the solidity of those ancient works, which are carved from solid stone. Its scale may be massive by the standard of ceramics, but even so there is something ethereal about the Gardiner head. This is partly the result of its striped decoration, which emphasizes the surface and breaks up the form. But one can also sense the volumetric quality of the

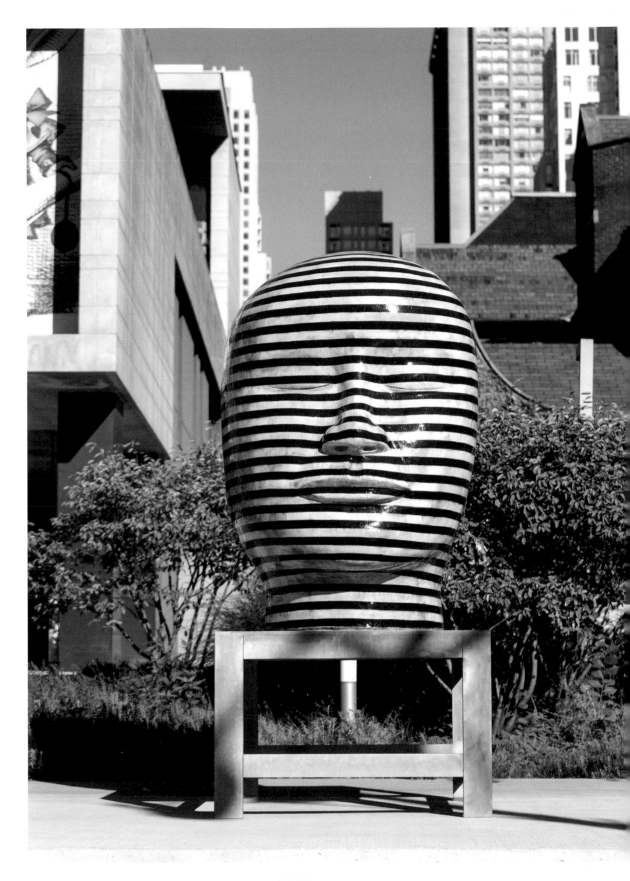

A GIANT COMPANION

work. It is, in fact, a hollow shell. The form is built up from clay slabs, thoroughly blended into one another at the edges as they are joined together. The wall of the head rises from a base some ten centimetres thick at the bottom and tapers upwards to a thinner dimension, much like the hand-built storage jars of Japan and Korea.

Kaneko is keen to emphasize the simplicity and directness of this technique. While he takes the lead on painting the work, physical fabrication is done by workshop assistants, who may only have an undergraduate degree in ceramics. He says that he can teach someone to make a monumental sculpture like this in less than a year; once they are up and running, the building process takes about two weeks. The more difficult stage is the drying, which takes about six months and must be carefully controlled in relation to temperature and humidity. Too quick, and the clay will crack. Too slow, and the bottom of the piece will collapse.

This matter of duration is a crucial factor, both technically and artistically. As with the first set of heads, which prompted so much uncertainty in him, Kaneko spends a long time with these works. There is, he says, a "natural rhythm" to this co-habitation. He is

in no hurry to finish them, or even to decide on the surface pattern they will have. By the time he adds the pattern to a certain work, it has already attained a personality in his mind. (He jokes that many of the heads look strangely like the workshop assistants who made them.) In the case of the Gardiner's head, the striped decoration enhances this individuality by establishing a gentle, rippling rhythm across the surface as it bends and curves across chin, lips, nose, eyes, forehead. The ripple seems to expand beyond the sculpture itself, finding echoes in the steps leading up to the plinth and the banded facade of the museum itself.

The rules of engagement for public art are different from those in a gallery. A public monument may be beautiful or provocative, but above all, it must be civic. The object must draw together the space around it, making it more of a place—more particular, more alive, more inhabitable. Judged by the standards of contemporary sculpture more broadly, Kaneko's head may seem rather traditional, more rooted in the past than the future. (As I have said, its closest comparisons are in the realm of ancient art.) But viewed as a twenty-first-century public artwork, it is, despite its closed eyes, absolutely forward looking. It infuses the Gardiner's plaza with the qualities of calm reflection and human presence that are so badly

lacking in many of our public spaces (to say nothing of our lives online and on-screen), and which people increasingly flock to museums to experience.

So Kaneko's silent sentinel is much more than a sculpture. It is a richly symbolic representation of the museum that commissioned it. At 30 years of age, the Gardiner is a relatively young institution, but it is dedicated to the world's oldest art medium, a medium that lends itself to both abstraction and figuration. Its collection is rich in vessels that contain, sculptures that embody. Taken as a whole, the Museum reminds us how much there is to be gained from the slow, skilled rendering of ideas into permanent material form. Its moment, which is also Kaneko's, is only transient within the deep life cycle of ceramic art. But like the Gardiner itself, this great work sits proudly within that history: it is one for the ages.

GLENN ADAMSON is the Nanette L. Laitman Director of the Museum of Arts and Design (MAD) in New York City. He was Head of Research at the Victoria and Albert Museum, London, where he was active as a curator, historian and theorist between 2005 and 2013. His publications include *Thinking Through Craft*, 2007, *The Craft Reader*, 2010, *Invention of the Craft*, 2013, and *Postmodernism: Style and Subversion 1970 to 1990*, 2011. He is also the co-founder and editor of the triannual *Journal of Modern Craft*.

NOTES

1 All quotes are taken from an interview with the artist, conducted by telephone on 23 August, 2013.

WHITE FRIGHT

SARAH MILROY

WHITE FRIGHT

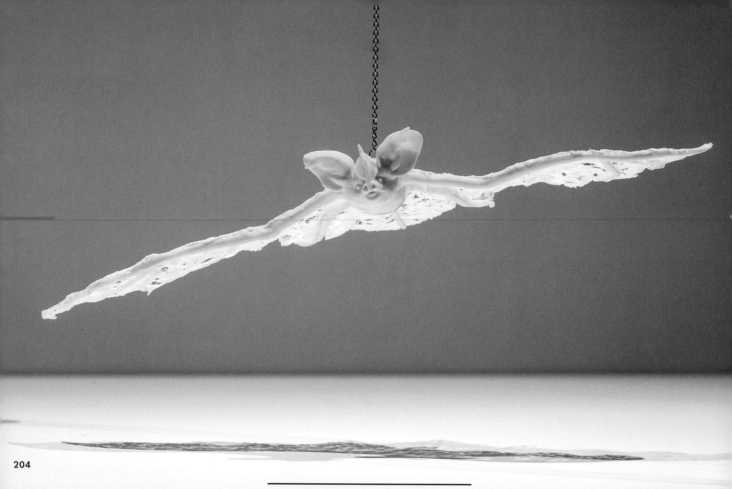

204

SHARY BOYLE (CANADIAN, B. 1972)
***WHITE FRIGHT*, 2009**
Glazed porcelain with gold chain • Marks:
None • H: 7.6 cm; W: 30.5 cm; D: 10.2 cm
• Purchased with financial support of the
Canada Council for the Arts Acquisitions
Assistance Program, and Funds from Lindy
Barrow, Burgundy Asset Management, The
Gardiner Museum Board of Trustees, Margaret
and Wallace McCain, McLean Budden and
Gretchen and Donald Ross, G09.11.1

Standing in front of her work *White Fright*, in the galleries of the Gardiner Museum, the Toronto artist Shary Boyle lets out a little sigh of contentment, just seeing the piece again—a little white porcelain bat, suspended in a glass vitrine by a fine gold chain. She remembers the work that was involved in making it, back in 2009. "It's definitely the most fragile thing I have ever made," she says. "Some parts of it are as thin as a strand of hair—it's incredible." The lacy wings were made, she says, by saturating dainty lace with porcelain slip, fitting the sodden material carefully over the hand-modelled porcelain wing structures, face and body, and firing the whole until the underlying cotton was burned away, leaving just the ceramic trace. "The trick", she explains, "was to achieve a consistent level of saturation in all the lace elements, or holes would emerge in the final product after firing. It took a lot of trial and error."

The effort, however, paid off. Boyle's little night flyer is a ceramic *tour de force*, but it is also a carrier of complex and poetic ideas about scientific knowledge and social order. His face, luxuriant with the fleshy, leaf-like formations that evolved to

SARAH MILROY

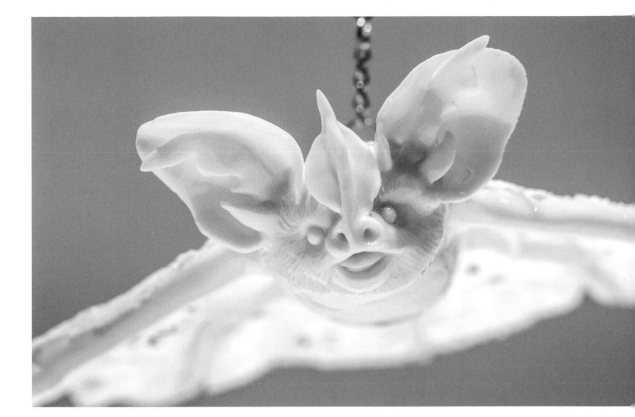

facilitate echolocation, is both endearing and grotesque, like much of Boyle's output. In this instance, she drew inspiration from the drawings of historic German naturalist Ernst Haeckel, whose compendious *Art Forms of Nature* (the first volume of which was published in 1899) catalogued the many wonders of the natural world as he saw it, emphasizing the unity of all living things. "Haeckel made these crazily detailed drawings of sea plants and mammals, fish and birds, putting forward the idea that there is an underlying order. Did he have some kind of weird premonition, I wonder, an impulse to catalogue the world before it would be destroyed? Did he have a sense that things were changing? Remember, this was all before photography." She adds: "There is this sense in his drawings of the sheer mystery and wonder of natural forms. He understood that the only way to really know something is to record it in every meticulous detail, to spend time with it." In particular, Haeckel, like Boyle, seemed drawn to the peculiarities of the bat's face, drawing them over and over again. "To me, it's like a flower" Boyle says, extolling the creature's eccentric charms. "And he does look kind of friendly."

Boyle became interested in bats while also researching honeybees in 2007, developing her ideas for a work titled *To Colonize the Moon*, destined for the Art Gallery of Ontario. "There was something called White Nose Fungus that was being reported by American naturalists at the time" she says, "a massive killer of bats in the northeastern United States. It was infecting huge colonies of hibernating animals, more easily because they live so close together. It was affecting their immune systems." The bats, she adds, were being aroused from their hibernation, presumably by some sort of discomfort, and they were flying out of their caves in search of food and then dropping out of the sky, dying in the snowy fields.

This worrying fate, and the general disdain for bats in popular culture, lent a melancholy cast to Boyle's meditations on the much maligned mammal. She describes to me in detail their close familial relations, detouring into a description of bat midwifery. "Female bats have to give birth inverted, so some other bat has to be there to catch the babies. As well, they are responsible for huge amounts of insect consumption" she says, pointing out that bats are deployed in many parts of the world to curb the spread of malaria. She adds wistfully: "They do us such good service."

LEFT

THE MONKEY ORCHESTRA
Meissen Porcelain Manufactory, Germany,
modelled by Johann Joachim Kändler and
Peter Reinicke, c. 1753–1765 • Hard-paste
porcelain, overglaze enamels and gold
• Gift of George and Helen Gardiner,
G83.1.675.1-18

206

Yet bats can also themselves be spreaders of disease, in particular rabies. Ultimately, though, "people just don't like them" Boyle says. "I see them as standing in for things that people want to reject, that thing that is not conforming", straddling as they do the categories of airborne bird and land borne mammal. "To me, they are the ultimate outsiders. This is why I wanted to make this one really, really beautiful, and to give him a golden chain." The delicacy of the object was significant to her. "It was important for me that he must be handled with the greatest care", she says, "where if it was a real bat, it would just be kicked into the garbage."

In her fascination with oddity, Boyle stands at the end of a long line of artists who have worked in porcelain, and she dances me through the galleries of the Museum in search of some of her favourite kindred spirits. Johann Joachim Kändler's *The Monkey Orchestra* (1753–1765) is a personal favourite of hers, a complete multi-part set of miniature apes attired like court musicians, created to amuse noble guests at their candle-lit dinners. Kändler, she says, was one of the great Meissen sculptor-modellers, and she shows me other examples of his sculptural prowess elsewhere in the galleries, objects that reveal his special gift for delicate gesture and psychological expression. "But Kändler also had a very sharp and sly sense of humour" she adds. "He makes things come alive. I look to that early work to see what was possible."

Boyle shows me Kändler's *The Mockery of Age* (c. 1740–1741), a small ornamental work depicting an elderly man and his buoyantly youthful wife attended by mischievous harlequins, the pair tenderly intertwining while the others cavort around them. Boyle is enamoured, too, of the pair of Meissen porcelain pugs from 1741–1745 displayed in another cabinet nearby, in which the quirky personalities and fleshy pleasures of the lapdogs are captured with humour and sensuous vividness. A delicate mid-eighteenth-century decorative clock featuring a bagpiping Harlequin and a pug, also modelled by Kändler, is last on her tour, its French floral embellishments an exquisite display of virtuoso modelling, painting and firing.

It leads me to think, this is Boyle's school, as any great museum should be for artists: a place where she can set her ambitions—both technical and creative—within the context of a history. Here, she makes that history her own.

SARAH MILROY

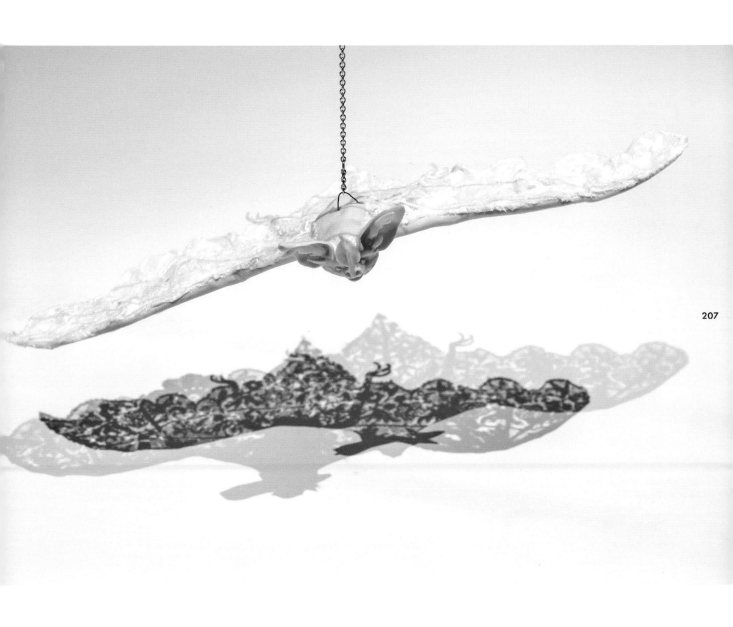

SARAH MILROY is a Toronto-based writer, art critic and curator. She writes for *The Globe and Mail* and *Canadian Art* magazine.

WHITE FRIGHT

The Gardiner Museum thanks the following catalogue sponsors:

• The Peter and Melanie Munk Charitable Foundation
• The Radlett Foundation
• The Hannon Family in Memory of Janet Hannon
• Richard Rooney & Laura Dinner
• The Clarence E. Heller Charitable Foundation
• The Macdonald Family Foundation
• Alan Shimmerman
• Michael & Tamara Root

With the support of The Ann Walker Bell Fund and The Helen E. Gardiner Fund.

Photography of the Gardiner Museum collections provided by Toni Hafkenscheid, with the following exceptions: pp. 12, 13, 23, 25, 79, 81, 159, 180: Gardiner Museum; p. 206: Melissa Shimmerman.

Cover image: Covered Tureen in the Form of a Rabbit, see p. 113; Title Page and Colophon Image; Léopold L. Foulem, *Abstraction 4111 (Red)*, 1998, p. 168.

© 2014 Black Dog Publishing Limited, the artists and authors. All rights reserved.

Black Dog Publishing Limited
10A Acton Street
London WC1X 9NG
UK

t. +44 (0)207 713 5097
f. +44 (0)207 713 8682
e. info@blackdogonline.com

All opinions expressed within this publication are those of the author and not necessarily of the publisher.

Designed by Rachel Pfleger at Black Dog Publishing. Edited by Rachel Gotlieb and Karine Tsoumis.

ISBN 978 1 908966 67 4

British Library Cataloguing-in-Publication Data.

A CIP record for this book is available from the British Library.

No part of this publication may be reproduced, stored in a retrieval system, or transmitted, in any form or by any means, electronic, mechanical, photocopying, recording, or otherwise, without prior permission of the publisher.

Every effort has been made to trace the copyright holders, but if any have been inadvertently overlooked the necessary arrangements will be made at the first opportunity.

Black Dog Publishing is an environmentally responsible company. *30 Objects 30 Insights: Gardiner Museum* is printed on sustainably sourced paper.

art design fashion
history photography
theory and things

www.blackdogonline.com london uk